D0053115

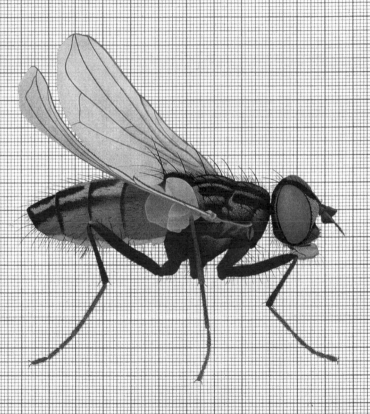

GRAND STREET

70

AGAINST NATURE

This issue of *GRAND STREET* is dedicated to
the memory of
KATHARINE GRAHAM, 1917–2001
HERBLOCK, 1909–2001
NORA SAYRE, 1932–2001
ISAAC STERN, 1920–2001
DAVID SYLVESTER, 1924–2001
ALICE STEWART TRILLIN, 1938–2001

FRONT COVER Peter Goin, *Railroad Trestle, Nevada Test Site,* from the series "Nuclear Landscapes," 1986–90. The only remaining section of an elevated railroad built for an above-ground test at Frenchman Lake, Yucca Flat. The detonation, code-named "Priscilla," generated thirty-seven kilotons of force. By comparison, the blast at Hiroshima measured thirteen kilotons. C-print. Copyright © Peter Goin. Courtesy of the artist.

BACK COVER Virginia Beahan and Laura McPhee, *Rooftop Garden, Lower East Side, New York,* 1997. Color photograph. Copyright © Virginia Beahan and Laura McPhee. Courtesy of the artists and Laurence Miller Gallery, New York.

TITLE PAGE Cornelia Hesse-Honegger, *House Fly (Muscidae),* 1985–86. Mutated by X rays at the Zoological Institute of the University of Zurich. Four mutations: yellow eyes and body, bent wings, and leg parts growing out of the feelers. Watercolor on paper, 17 5/16 x 21 5/8 in. Copyright © Artist Rights Society (ARS), New York/Pro Litteris, Zurich. Courtesy of the artist.

TABLE OF CONTENTS Peter Goin, *Nuclear Reactors D and DR, Hanford Nuclear Reservation, Washington,* from the series "Nuclear Landscapes," 1986–90. These reactors are now decommissioned. D Reactor was one of the three original reactors built between 1943 and 1945. The yellow posts mark the locations of buried radioactive waste and areas of potential surface contamination. C-print. Copyright © Peter Goin. Courtesy of the artist.

Durs Grünbein, *Childhood in the Diorama* copyright © Suhrkamp Verlag Frankfurt am Main 1996.

Volker Braun poems © Suhrkamp Verlag Frankfurt am Main 1999, 2000.

Ariane Mnouchkine first published as *Mnouchkine sous l'empire de la Chine* copyright © Le Nouvel Observateur 1999.

Roberto Bolaño, *Carlos Ramírez Hoffman* from *La literatura nazi en América* copyright © Editorial Seix Barral Barcelona 1996.

Grand Street (ISSN 0734-5496; ISBN 1-885490-21-6) is published by Grand Street Press (a project of the New York Foundation for the Arts, Inc., a not-for-profit corporation), 214 Sullivan Street, Suite 6C, New York, NY 10012. Tel: (212) 533-2944, Fax: (212) 228-9620. Contributions and gifts to Grand Street Press are tax-deductible to the extent allowed by law. This publication is made possible, in part, by a grant from the New York State Council on the Arts.

Volume Eighteen, Number Two (*Grand Street* 70—Spring 2002). Copyright © 2002 by the New York Foundation for the Arts, Inc., Grand Street Press. All rights reserved. Reproduction, whether in whole or in part, without permission is strictly prohibited. Second-class postage paid at New York, NY, and additional mailing offices. Postmaster: Please send address changes to Grand Street Magazine, 214 Sullivan Street, Suite 6C, New York, NY 10012. Single-copy price is $12.95 ($18 in Canada). For inquiries, please call (212) 533-2944

Grand Street is printed by Finlay Printing in Bloomfield, CT. It is distributed to the trade by D.A.P./Distributed Art Publishers, 155 Avenue of the Americas, New York, NY 10013, Tel: (212) 627-1999, Fax: (212) 627-9484, and to newsstands only by Bernhard DeBoer, Inc., 113 E. Centre Street, Nutley, NJ 07110, Total Circulation, 80 Frederick Street, Hackensack, NJ 07601, Ingram Periodicals, 1226 Heil Quaker Blvd., La Vergne, TN 37086, and Ubiquity Distributors, 607 Degraw Street, Brooklyn, NY 11217. *Grand Street* is distributed in Australia and New Zealand by Peribo Pty, Ltd., 58 Beaumont Road, Mount Kuring-Gai, NSW 2080, Australia, Tel: (2) 457-0011, and in the United Kingdom by Central Books, 99 Wallis Road, London E9 5LN, Tel: (181) 986-4854.

VISIT OUR WEBSITE AT www.grandstreet.com

GRAND STREET

EDITOR
Jean Stein

MANAGING EDITOR
David Grosz

ART EDITOR
Walter Hopps

POETRY EDITOR
James Lasdun

ASSOCIATE ART EDITOR
Anne Doran

ASSISTANT EDITOR
Michael Mraz

DESIGN
J. Abbott Miller, Roy Brooks
PENTAGRAM, NEW YORK

WEBMASTER
Vicky Carroll

COPYEDITOR
Radhika Jones

CONSULTING EDITOR FOR THIS ISSUE
Benjamin Anastas

INTERNS
Monica Ferrell, Sia Sanneh, Merida Lang

ADVISORY EDITORS
Edward W. Said, Charles Merewether

CONTRIBUTING EDITORS
George Andreou, Dominique Bourgois, Natasha Parry Brook, Frances Coady, Mike Davis,
Colin Deland, Kennedy Fraser, Stephen Graham, Nikolaus Hansen, Dennis Hopper,
Jane Kramer, Brigitte Lacombe, Peter Mayer, Michael Naumann, Meghan O'Rourke, Erik Rieselbach,
Robin Robertson, Fiona Shaw, Daniel Slager, Robert Storr, Michi Strausfeld, Deborah Treisman,
Katrina vanden Heuvel, Wendy vanden Heuvel, John Waters, Drenka Willen

FOUNDING CONTRIBUTING EDITOR
Andrew Kopkind (1935–1994)

PUBLISHERS
Jean Stein & Torsten Wiesel

FROM NAZI LITERATURE IN THE AMERICAS

ROBERTO BOLAÑO

CARLOS RAMÍREZ HOFFMAN
Santiago de Chile, 1950–Lloret del Mar, 1998

The professional career of the infamous Ramírez Hoffman must have begun in 1970 or 1971, when Salvador Allende was president of Chile.

It can be said with almost absolute certainty that he attended a literature workshop led by Juan Cherniakovski in Concepción, in the south. He called himself Emilio Stevens at the time, and wrote poems that Cherniakovski did not dislike, although the stars of the workshop were María and Magdalena Venegas, twin sisters from Nacimiento, seventeen, maybe eighteen years old—a sociology and a psychology student, respectively.

Emilio Stevens and María Venegas were sweethearts (the word "sweetheart" makes my skin crawl). But he frequently dallied with both sisters—going to the movies, to concerts, to the theater, to lectures; sometimes they took the Venegases' car, a white Volkswagen Beetle, to the beach to watch the sun set over the Pacific and smoke weed. I suppose that the Venegas sisters also went out with other people, and I suppose that Stevens went out with other people; in those years everybody went out with everybody and everybody thought they knew everything about everybody. Why did the Venegas sisters become involved with him? It is a mystery without great depth, an everyday accident. I suppose that the so-called Stevens was good-looking, intelligent, and sensitive.

A week after the coup d'etat, in September 1973, in the midst of the prevailing confusion, the Venegas sisters left their apartment in Concepción and went back to their house in Nacimiento, where they lived alone with an aunt. Their parents, who were painters, had died when the girls were not yet

fifteen, leaving them the house and some land in the province of Bío-Bío, which allowed them to live well. The sisters often talked about their parents, and their poems frequently portrayed painters in southern Chile, embarking on a desperate task and in a desperate love. Once, only once, did I see a photograph of the parents: The father was dark-skinned and thin, with the sad, perplexed countenance that only those born on this side of the Bío-Bío river possess; the mother was taller than he, a bit chubby, with a sweet and trusting smile.

So the Venegas sisters went to Nacimiento and shut themselves up in their house, one of the biggest in the town, a two-story wooden house on the outskirts, which had remained in their father's family. It had more than seven rooms and a piano and was filled with the powerful presence of their aunt, who shielded them from evil—though the Venegas sisters were not what you would call cowardly girls; on the contrary.

And one fine day, let's say two weeks or a month later, Emilio Stevens appears in Nacimiento. It had to have been like that. One evening, or perhaps it was a melancholic late afternoon in the middle of spring, someone knocks on the door, and there is Emilio Stevens, and the Venegas sisters are happy to see him, they hound him with questions, they invite him for dinner and later they tell him he can stay overnight, and after dinner they read poems, but not Stevens, he doesn't want to read anything, he says he's working on something new, he smiles, assumes a mysterious attitude; or maybe he doesn't smile, he just says dryly that he won't, and the Venegas sisters assent, they think they understand, naive as they are, they understand nothing, and so they read their poems, very good ones, dense, an amalgam of Violeta Parra and Nicanor and Enrique Lihn, as if that amalgam were possible, a devil's alloy of Joyce Mansour, Sylvia Plath, and Alejandra Pizarnik, the perfect cocktail to bid the day farewell, this day of the year 1973 that is irrevocably passing. And late that night Emilio Stevens gets up like a sleepwalker, maybe he slept with María Venegas, maybe not, but what is certain is that he gets up with the single-mindedness of a sleepwalker and goes to the aunt's bedroom, listening to the engine of a car that is approaching the house, and then slits the aunt's throat, no, plunges a knife in her heart, clean, fast, he covers her mouth and buries the knife in her heart and goes downstairs and opens the door, and two men enter the house of the stars of Juan

Cherniakovski's poetry workshop and with them the snarled night enters the house and then departs almost immediately, enters, exits, effective and swift.

And there are no corpses. Or actually, there is *a* corpse, Magdalena Venegas's corpse, but only that one, a corpse that will appear years later in a common grave, as if to suggest that Ramírez Hoffman is a man and not a god. During those times more people disappear: Juan Cherniakovski, the Jewish poet from the south, disappears, and everybody thinks that it is normal that this red son of a bitch disappears, even though afterward Cherniakovski reappears in all the hot spots of America like a Russian-Jewish uncle, a legend, the paradigm of the Chilean airman, in Nicaragua, in El Salvador, in Guatemala, with a rifle and a fist held high, saying *Here I am sons of bitches, the last Jewish Bolshevik from the southern Chilean forests,* until the day he disappears definitively, probably killed in the last FMLN offensive. And Martín García, a friend and rival of Cherniakovski's, also disappears. They were always together, discussing poetry until Chile's sky came tumbling down: Cherniakovski, tall and blond, Martín García, small and dark-skinned; Cherniakovski in the orbit of Latin American poetry, Martín García translating French poets whom nobody in Chile knew about. And that vexed many people. How was it possible that a small and ugly Indian translated and corresponded with Alain Jouffroy, Denis Roche, Marcelin Pleynet? For God's sake, who were Michel Bulteau, Matthieu Messagier, Claude Pelieu, Franck Vernaille, Pierre Tilman, Daniel Biga? And what was so good about that Georges Perc whose books the nitwit García carried around with him constantly? Many would have welcomed García's death. To write it now seems incredible. But García, like Cherniakovski (whom, by the way, he never saw again after his disappearance), reappeared in Europe, exiled in East Germany, which he left at the first opportunity, and then in France, where he survived by teaching Spanish and translating some eccentric early-twentieth-century Latin American writers, mostly obsessed by mathematical or pornographic problems. But that story has nothing to do with this one.

In those days, when the flimsy power structure of the Poder Popular was being dismantled, I was taken prisoner. The circumstances that led to my stay in the detention center are banal, if not grotesque, but they enabled me to be present at Ramírez Hoffman's first poetic act, although at the time I didn't know who Ramírez Hoffman was, nor did I know the Venegas sisters' fate.

It happened late one afternoon around sunset—Ramírez Hoffman loved sunsets—while we killed time in our improvised prison in the Centro La Peña, playing chess on the patio. Shreds of clouds were starting to form in the eastern sky, which had been absolutely clear. The clouds, like needles or cigarettes, first seemed black and white, then pink, and finally turned a brilliant vermilion. I think I was the only prisoner who took notice of them. Slowly, among the clouds, an airplane appeared. An old airplane. At first, it was no bigger than a mosquito. Silent. It came from the sea and little by little it approached Concepción, giving the impression of moving as slowly as the clouds. It sounded like a broken washing machine when it passed overhead. Then it raised its nose and headed higher into the sky, where it started to write a poem in letters of dark gray smoke on the blue-pink sky. The poem astonished those who saw it. YOUTH . . . YOUTH, I read. I had the impression—the crazy certainty—that the words were galley proofs. Then the plane came back in our direction and turned to pass over us once more. This time the verse was longer and must have required greater expertise on the part of the pilot: IGITUR PERFECTI SUNT COELI ET TERRA ET OMNIS ORNATUS EORUM. For a while, it seemed as if the plane were on its way to the mountain range, where it would disappear in the horizon. But it returned. One of the prisoners, Loco Norberto, tried to climb the wall that separated our patio from the women's patio and shouted: It's a Messerschmitt, it's a Luftwaffe-fighting Messerschmitt! All the prisoners stood up. There were two guards by the door to the gym where we slept; they stopped talking and looked up at the sky. Loco Norberto, clutching the wall, was laughing and saying that World War II had returned to Earth. It was our turn, the Chileans' turn, to receive it, to put out the welcome mat. The plane came back to Concepción: GOOD LUCK TO EVERYONE IN DEATH, I read, with difficulty. For a moment I thought that if Norberto tried to escape, nobody would have prevented it. Everyone except him was immobile, face turned to the sky. I had never seen so much sadness before. The plane passed over us again, completed the turn, rose still higher, and returned to Concepción. What a pilot, Norberto was saying, the inimitable Hans Marseille reincarnated. I read: DIXITQUE ADAM HOC NUNC OS EX OSSIBUS MEIS ET CARO DE CARNE MEA HAEC VOCABITUR VIRAGO QUONIAM DE VIRO SUMPTA EST. Toward the east, lost among the clouds that soared over the

Bío-Bío, the last letters. The plane disappeared completely from the sky. What have you done, comrade? I heard a miner from Lota say. Haven't the slightest, another answered him. Still another said: Nonsense, but his voice trembled. The guards standing by the gym door had multiplied, and now there were four. Norberto, in front of me, clutching the wall, whispered: This must be the blitzkrieg. Then he sighed heavily and quieted down. At that moment the plane emerged from the clouds again. We had not seen it turn around. Heaven help us, Norberto said, forgive us our sins. He said it out loud, and the other prisoners and the guards heard him and laughed. But I knew that, deep inside, nobody felt like laughing. The plane passed over us. The sky was getting dark, the clouds seemed black. Above Concepción, the plane's silhouette could hardly be seen. This time it wrote only four words: LEARN FROM THE FIRE. The words rapidly dissolved in the night and disappeared. For a few seconds nobody said anything. The guards were the first to react. They ordered us to form a line and then began the nightly head count before locking us up in the gym. It was a Messerschmitt, Bolaño, I swear to God, Norberto told me as we were going into the gymnasium. Sure, I said. And it wrote in Latin, Norberto said. Yes, I said. I didn't understand any of it. I did, Norberto said. It talked about Adam and Eve and about the Holy Virgin, and of the Garden of our minds, and it wished every one of us good luck. A poet, I said. An educated person, yes, said Norberto.

The joke, I discovered years later, cost Ramírez Hoffman a week in jail. When he came out, he kidnapped the Venegas sisters. On New Year's Eve of 1973, he returned to do another show of aerial writing. Above the military airport in Córdoba, he drew a star that competed with the first stars of dusk, and then he wrote a poem that none of his superiors understood. One of the verses spoke of the Venegas sisters. Anyone reading it properly would surmise that they were dead. In another, he mentioned someone called Patricia. APPRENTICES OF FIRE, he wrote. The generals who could read the smoky words thought that they were about their girlfriends, their lovers, or some hookers in Talcahuano. Some of Ramírez Hoffman's friends knew, however, that he was conjuring dead women. He performed two more aerial shows. The generals used to say that he was the most intelligent of his group, and the most impulsive. He could pilot a Hawker Hunter or a combat helicopter without any problem, but what he liked most was to take an old

plane loaded with smoke, soar into the empty skies of the fatherland and, in enormous letters across the sky, write its nightmares, which were also our nightmares, until the wind undid them.

In 1974, he convinced a general to fly with him to the South Pole. The trip was difficult and they frequently had to land, but every place they stopped Ramírez Hoffman wrote his poems in the sky. They were poems for a new Iron Age of the Chilean race, said his admirers. Nothing remained of that Emilio Stevens who had been reserved and insecure. No, this Ramírez Hoffman was audacity personified. The flight from Punta Arenas to the Arturo Prat Antarctic base was fraught with danger and almost cost him his life. When the journalists asked him, upon his return, what had been the greatest danger, he answered: Traversing that silence. The waves of Cape Horn licked the plane's belly, enormous, mute waves, as in a silent movie. Silence is like a siren's song, he said, but if you cross it bravely, nothing can happen to you afterward. In the Antarctic everything went well. Ramírez Hoffman wrote: THE ANTARCTIC IS CHILE, and they filmed it and photographed it, and then he returned to Concepción, alone, in a small plane that, according to Loco Norberto, was a Messerschmitt from World War II.

He was on the crest of a wave. They called him from Santiago to do something spectacular in the capital, something that would express the new regime's interest in the avant-garde. Delighted, Ramírez Hoffman agreed. He stayed in the apartment of one of his friends and attended training at the Capitán Lindstrom Aerodrome during the day. At night, he devoted himself to preparing a photography show in his friend's apartment; its opening would be accompanied by a performance of aerial poetry. The owner of the apartment would claim, years later, that he did not see the photographs Ramírez Hoffman intended to show until the very last minute. He said that Ramírez Hoffman told him they were a surprise. He had anticipated the show would be concerned with visual poetry, experimental, pure art— something that everybody was going to have fun with. The invitations to the opening, of course, were restricted to pilots, young military men (the oldest would never reach the rank of commander), the cultural elite— a trio of journalists, a small group of civil artists, a young, distinguished lady (only one woman, Tatiana von Beck Iraola, is known to have gone to the show), and Ramírez Hoffman's father, who lived in Santiago.

It started badly. The day of the aerial show, heavy black cumulus clouds came down from the valley toward the south. More than one superior advised him not to fly. Ramírez Hoffman did not listen to their warnings. He took off and performed some preliminary stunts, which the spectators watched with more expectation than admiration. Then he went higher, disappearing into an immense dark gray cloud that was moving slowly over the city. He reemerged far from the Aerodrome, in a suburb in the outskirts of Santiago. Right there he wrote the first verse: *Death is friendship.* Then he glided over some railway storage buildings and abandoned factories and wrote the second verse: *Death is Chile.* He turned the plane toward downtown. There, over La Moneda, the Presidential Palace, he wrote the third verse: *Death is responsibility.* Some passersby saw it. Very few managed to decipher the words: The wind undid them in just a few seconds. On the way back to the Aerodrome he wrote the fourth and fifth verses: *Death is love* and *Death is growth.* When he came within sight of the Aerodrome, he wrote: *Death is communion,* but none of the generals, or wives of generals, or the high command and military, civil, and cultural authorities could read his words. An electrical storm was forming in the sky. From the control tower a colonel asked him to hurry up and land. Ramírez Hoffman said "Roger" and soared higher. Then, as the first bolt of lightning struck, he wrote: *Death is cleanliness,* but the meteorological conditions were so unfavorable that few of the spectators could make out what was written. Those who did understand thought Ramírez Hoffman had gone mad. It started to pour and everyone scattered. A cocktail party was being thrown in one of the hangars; at that time of day everybody was starved and thirsty. The hors d'oeuvres were gone in less than twenty minutes. Some officials and ladies commented on how strange that writer-pilot was, but the majority of the guests just chatted about topics of national or even international importance. Ramírez Hoffman was still in the sky, struggling against the storm. Only a handful of his friends and the journalists that wrote surrealist poems in their free time continued to watch the plane. Ramírez Hoffman wrote, or thought he wrote: *Death is my heart.* And then: *Take my heart.* And then: *Our change, our advantage.* And then he had no more smoke with which to write, but still he tried to write: *Death is resurrection.* Those below couldn't make out any of it, but they did understand that Ramírez Hoffman was writing *something,* and knew that they were witnessing an event of importance for the art of the future.

Later, Ramírez Hoffman landed safely, was reprimanded by the official in charge of the control tower and by some from the high command, who were still at the cocktail party, then left for his friend's apartment to prepare the second act of his gala for the city of Santiago.

Perhaps all of the above took place like this. Or perhaps it didn't. It could be that the generals of the Chilean Air Force did not bring their wives to the airshow. It could be that there never was a performance of aerial poetry at the Capitán Lindstrom Aerodrome. Perhaps Ramírez Hoffman wrote his poem in the Santiago sky without asking for permission, without notifying anybody, though this is even more improbable. Perhaps it didn't even rain over Santiago that day. Perhaps everything happened some other way. The photography exhibition, however, took place just as it is described below.

The first guests arrived at nine o'clock. By eleven, there were some twenty people, all reasonably drunk. Nobody had yet gone into the guest bedroom, where Ramírez Hoffman's pictures were hung. Lieutenant Curzio Zabaleta, who would later publish a memoir, *With the Rope Around Your Neck*, a self-indicting narration about the years following the coup, says that Ramírez Hoffman behaved normally, taking care of the guests as if the house were his, cordially greeting comrades he hadn't seen for a long time, deigning to comment on the incidents in the aerodrome that morning, making jokes and taking those made by others in stride, as is typical of these kinds of gatherings. Every once in a while he would disappear, but his absences never lasted long. Finally, at precisely midnight, he called for attention and said (word for word, according to Zabaleta): It's about time to immerse ourselves in new art. He opened the door to his room and, one by one, let his guests enter. One by one, gentlemen; Chile's art does not allow for agglomerations. When he said this (according to Zabaleta), Ramírez Hoffman looked over at his father, who winked at him with his left eye, then his right.

The first one to enter the room was Tatiana von Beck Iraola, as expected. The room was perfectly lit. Forget about blue or red lights, no special ambiance. Outside, in the hallway and in the living room, the guests continued talking and drinking with the licentiousness peculiar to the young or the victorious. The smoke, especially in the hallway, was considerable. Ramírez Hoffman stood in the doorway. Two lieutenants argued by the entrance to the bathroom. By his own account, Zabaleta paced back and forth, his mind

heavy with ominous thoughts. The three surrealist journalists were talking to the owner of the house. At some point, Zabaleta overheard some of their conversation: They were talking about trips—the Mediterranean, Miami, beaches, and voluptuous women.

Not even a minute had passed when Tatiana von Beck emerged. She was pale and quiet. She looked at Ramírez Hoffman and headed for the bathroom. She didn't make it. She threw up in the hallway and then, staggering, left the apartment with the aid of an official, who gallantly accompanied her despite her protestations that she preferred to leave alone. The second to enter the room was a captain. He never came out. Ramírez Hoffman, standing by the door, smiled. In the living room, some were wondering what was wrong with Tatiana. She's drunk, that's all, said a voice that Zabaleta did not recognize. Somebody put on a Pink Floyd record. Another remarked that men should not dance with each other—this looked like a hangout for faggots. The surrealist journalists began whispering among themselves. A lieutenant proposed that they should all go whoring. But in the hallway, as in the waiting room of a dentist's office, or in a nightmare, nobody said a word. Ramírez Hoffman's father made his way through the crowd and entered the room, followed by the owner of the house. Almost immediately, the owner came out again and faced Ramírez Hoffman. For a moment it seemed as though he were going to strike him, but he turned his back and left the living room, looking for a drink. Then everyone remaining, including Zabaleta, pushed their way into the bedroom. The captain was sitting on the bed, smoking, and reading some notes. Ramírez Hoffman's father was looking at some of the hundreds of photographs that decorated the walls and part of the ceiling. A cadet, whose presence Zabaleta could not explain, started to cry, and some of the others had to drag him out of the room. The surrealist journalists looked disapproving but composed. It was silent except for the voice of a drunken lieutenant who was making a telephone call from the living room. He was apologizing incoherently to his girlfriend about something he had done a long time ago. The rest returned to the living room in silence, and some left immediately, without saying good-bye.

According to Zabaleta, there were eight people remaining in the apartment. A captain ordered everyone to leave the room and shut himself up with Ramírez Hoffman for half an hour. Ramírez Hoffman's father did not seem

particularly affected. The owner of the house, slumped down in a chair, looked over at him with resentment. If you want, Ramírez Hoffman's father said, I'll take my son away. No, said the owner of the house, your son is my friend and we Chileans know how to respect friendship. The owner was completely drunk.

A couple of hours later, three soldiers from Intelligence arrived. Zabaleta thought that they were going to arrest Ramírez Hoffman, but first they cleared the photos from the room. The captain went with them, and for the next few minutes nobody knew what to say. Ramírez Hoffman came out of the room and smoked by a window. The living room, Zabaleta remembers, looked like the refrigerator of a gigantic butcher shop that had been pillaged. Have you been arrested? the owner of the house finally asked. I suppose I have, said Ramírez Hoffman, his back turned to all, looking at the Santiago lights through the window. His father approached him in an exasperatingly slow manner, as if he didn't dare do what he was about to do, and finally hugged him, a brief embrace that Ramírez Hoffman did not reciprocate. People exaggerate, remarked one of the surrealist journalists standing by the fireplace. Jerk, said the owner of the house. And now, what do we do? asked a lieutenant. Sleep it off, answered the owner of the house. Zabaleta never saw Ramírez Hoffman again.

From that night on, news about Ramírez Hoffman has been confusing and contradictory. He appears and disappears in the canon of Chilean literature, with the elegance of a dragon enveloped in a mist. People speculate about his expulsion from the Air Force. The most fatuous minds of his generation imagine him wandering through Santiago, Valparaíso, Concepción, practicing various occupations and participating in bizarre artistic enterprises. He changes his name. He is linked with more than one ephemeral literary magazine where he publishes proposals for events that never happen, or, worse, that he performs secretly in bars and cabarets. In a theater magazine, a small piece appears signed by a certain Octavio Pacheco, about whom nobody knows anything. The piece is singular to an extreme degree and is set in a world of Siamese twins where sadism and masochism are children's games. Some say he works as a pilot for a commercial airline linking South America with the Far East. Cecilio Macaduck, the poet-clerk who works in a shoe store and who is an ex-member of the

Cherniakovski poetry workshop, follows Hoffman's steps thanks to a cubicle he stumbles on in the National Library; there he finds the only two poems published by Emilio Stevens together with photographs of Ramírez Hoffman's aerial poems, as well as Octavio Pacheco's plays, and additional texts that had appeared in diverse magazines in Argentina, Uruguay, Brazil, and Chile. Macaduck is enormously surprised: He finds at least seven Chilean magazines that came out between 1973 and 1980 that he hadn't known about. He also finds a thin book with a brown cover titled *Interviews with Juan Sauer*. The book bears the stamp of the Fourth Reich publishing company. It doesn't take him long to realize that the person in the interviews is Ramírez Hoffman; from his answers to questions about photography and poetry one can discern an outline of his theory of art. It is disappointing, according to Macaduck. In some Chilean and South American circles, nevertheless, Hoffman's flashing passage through the world of poetry turns him into a cult hero. But few have a really accurate idea of his work.

His passage through literature leaves a trail of blood and many unspoken questions. He also leaves one or two silent answers.

Time only confirms his mythic stature. Young and enthusiastic Chilean writers seek him out. After a long pilgrimage, they return defeated and broke. Ramírez Hoffman's father, presumably the one person who knows his whereabouts, dies in 1990. The idea that Ramírez Hoffman *is also dead*, in the end a comforting one, finds its way into Chilean literary circles. In 1992, his name comes up in a judicial inquiry concerning torture and disappearances. In 1993, he is linked with an "Independent Operative Group" responsible for the deaths of various students in Concepción and Santiago. In 1995, Zabaleta's book comes out; one of its chapters describes the night of the photography exhibit. In 1996, Cecilio Macaduck publishes an extensive essay about the fascist magazines from Chile and Argentina during the years 1972 and 1992, in which the most brilliant and enigmatic star is, undoubtedly, Ramírez Hoffman. Of course, a number of voices rise to Ramírez Hoffman's defense. A sergeant from Military Intelligence declares that Lieutenant Ramírez Hoffman was a little strange, somewhat crazy and prone to unexpected rages, but reliable as few could be in his struggle against Communism.

He is called to serve as a witness in some trials, although no one expects him to show up. In others, he is summoned as a defendant. A judge in Concepción issues a search and capture order that fails. The trials, few of them, take place in the absence of Ramírez Hoffman's conjured presence. The memory of a multiple assassin who had disappeared a long time ago becomes shadier and shadier.

Chile forgets about him.

It is then that Abel Romero makes an appearance and that I make a reappearance. Chile has also forgotten us. Romero was one of the most famous policemen during the Allende years. I vaguely remembered his name in relation to a murder in Viña del Mar, "the classic murder behind closed doors," according to him, which he resolved with elegance and precision. And although he worked in the Homicide Brigade, it was also he who went to the Las Cármenes country estate with a pistol in each hand to rescue a colonel who had kidnapped himself and who was protected by various assassins from the group Fatherland and Liberty. For this, Romero received the Medal of Courage from Salvador Allende himself, which was the greatest professional satisfaction of his life. After the coup, he was jailed for three years, and then he left for Paris. Now he was following Ramírez Hoffman's tracks. Cecilio Macaduck had given him my address in Barcelona. How can I help you? I asked him. In poetry matters, he said. Ramírez Hoffman was a poet, I was a poet, Romero was not; to find a poet he needed the help of another poet. I told him that in my opinion, Ramírez Hoffman was not a poet, he was a criminal. Well, well, he said, perhaps in Ramírez Hoffman's opinion, or anybody else's, you yourself may not be a poet, or you may be a bad poet. It all depends, don't you think? How much are you going to pay me? I asked him. To the point, that's better. Enough. The person who contracted me has money.

We became friends. The following day he came over to my house with a suitcase full of literary magazines. What makes you think Ramírez Hoffman is in Europe? I've sized the man up, he said. Four days later, he showed up with a television set and a video. These are for you, he said. I don't watch TV, I said. Well, you should, you don't know all the interesting things that you're missing. I read books and I write, I said. I can tell, Romero said. And he added immediately, don't take it the wrong way, I've always had the greatest

respect for priests and writers who have nothing. You probably haven't met all that many. Then he explained that he couldn't install the TV in the boarding house on Pintor Fortuny Street, where he was living. Do you think that Ramírez Hoffman also writes in French or German? I asked. Could be, he replied, he was an educated man.

Among the many magazines that Romero left, there were two in which I thought I detected Ramírez Hoffman's hand. One was French and the other was edited by a group of Argentineans from Madrid. The French one, which was nothing but a fanzine, was the official publication of a movement called Barbarian Writing whose most venerable practitioner was an old Parisian ex-doorman. One of the activities of this movement consisted of performing black masses in which canonical books were defiled. The ex-doorman had started his studies in May 1968. As the students were erecting barricades, he locked himself in a small cubicle in the doorman's lodge of a luxury building on the Rue Des Eaux and devoted himself to masturbating on books by Victor Hugo and Balzac, urinating on books by Stendhal, smearing the pages of Chateaubriand with shit, and cutting several parts of his body and bleeding on beautiful editions of Flaubert, Lamartine, and de Musset. According to him, that is how he learned how to write. The magazine from Madrid displayed a higher level of literary sophistication and its collaborators could not be defined by a particular method or school. In its pages, I found texts devoted to psychoanalysis, studies on New Christianity, and poems written by prisoners in Carabanchel prefaced by brainy sociological statements. One of these poems—the best no doubt, and also the longest—was titled "The Photographer of Death," and was dedicated, mysteriously, *to the explorer*.

In the French magazine, I thought I saw Ramírez Hoffman's shadow in one of the essays that accompanied the works of the Barbarians. Signed by a Jules Defoe, the essay advocated, in a faltering yet ferocious style, a literature written by people alien to literature (in the same way that politics should involve people alien to politics). The pending revolution in literature, Defoe stated, will come about through its abolition—it will be poetry written by nonpoets and read by nonreaders. The article could have been written by anyone keen on setting the world on fire, but I knew it was by Ramírez Hoffman.

In the magazine from Madrid, there were no texts by Ramírez Hoffman, but he was *talked about* in "The Photographer of Death." The title could have

been taken from an old Powell and Pressburger movie, but it could also have referred to Ramírez Hoffman's old proclivities. In essence, the poem was simple: It described a photographer who sauntered through the world preserving crimes forever in his mechanical eye, it spoke of the sudden vacuum of the planet, of the photographer's boredom, of his ideals (*the absolute*) and his wanderings through unknown lands, of interminable afternoons and evenings spent contemplating love in its many manifestations: couples, trios, groups.

When I told Romero, he said: I think we have already located Señor Ramírez, and asked me to watch a few videotapes he had brought. At that moment, I felt frightened. We watched them together. They were low-budget pornographic films. Halfway through the second one, I told Romero that I couldn't swallow four pornographic movies in a row. Watch them tonight, he said as he was leaving. Should I recognize Ramírez Hoffman among the actors? Romero didn't answer. He smiled enigmatically and left after taking note of the addresses of the magazines that I had selected for him. I didn't see him for five days. In the meantime, I watched the movies, and I watched them more than once. Ramírez Hoffman didn't appear in any of them, but I felt his presence in every one. It's simple, Romero told me when we saw each other again: The lieutenant is behind the camera. Then he told me the story of a group who made pornos in a villa in the Gulf of Tarento. All of them were found dead one morning—six in total, three actresses, two actors, and the cameraman. The director and the producer were arrested. Police also arrested the owner of the villa, a lawyer from Corigliano connected to the criminal *hard core*, that is, porn movies featuring real crimes. They all had alibis and were set free. Where did Ramírez Hoffman come in? There was another cameraman. Someone who went by the name R. P. English. He could not be found.

And you, Romero asked me, would you recognize Ramírez Hoffman if you saw him again? I don't know, I responded.

I didn't see Romero for two months. Then he stopped by. I have found Jules Defoe, he told me. Let's go. I followed him without saying a word. It had been a long time since I'd left Barcelona. We took a train along the coast. Who pays you? I asked Romero. A compatriot, he said, without taking his eyes off the Mediterranean, which lay beyond the abandoned factories by the side of the train. A lot? Pretty good, he sighed. There are many people

getting rich in Chile. And what are you going to do with the money? I'm going back to Paris, it will help me start all over again. And when we find Ramírez Hoffman, I said, what will your compatriot do? Ay, my friend Bolaño, first you have to identify him.

We stopped in Blanes. In the station, we caught a bus to Lloret. Spring had just begun, but you could already see groups of tourists in the town concentrated around the entrances of the hotels or wandering through the streets. We walked toward a neighborhood where there were only apartment buildings. Ramírez Hoffman lived in one of those buildings. Are you going to kill him? I asked as we walked through an empty street. The tourist stores wouldn't open for another month. Don't ask me that kind of question, Romero told me, his face wrinkled with pain. All right, I said, I won't ask any more questions.

Ramírez Hoffman lives there, said Romero when we passed an eight-story building that looked empty. My stomach contracted. Don't look back, hombre, Romero admonished me, and we continued walking. Two blocks later there was an open bar. Romero took me to the door. Sometime soon he will come here to have coffee. Take a careful look at him. I will come to pick you up when it starts getting dark. We shook hands awkwardly and said good-bye. Have you brought anything to read? Yes, I answered. See you later, then, Romero said, and remember that twenty years have passed.

From the bar's windows, the sea and the vivid blue sky could be seen. There were a few fishing boats working near the coast. I ordered a *café con leche*. The bar was almost empty: A woman sat at a nearby table reading a magazine, and two men were talking with the bartender. I opened my book, the *Complete Works of Bruno Schulz*, translated by Juan Carlos Vidal. I tried to read. After a few pages, I realized the words were passing by like incomprehensible scribbles. Nobody came into the bar, nobody moved, time seemed to stand still. I started to feel sick: The fishermen's boats began looking like sailboats, the line of the beach was gray and uniform, and every so often I could see someone walking along the empty boardwalk or a cyclist pedaling by. I ordered a bottle of mineral water. Then Ramírez Hoffman came in and sat next to the window, some three tables away. He had aged. As much as I had, I'm sure. But, no—he had aged much more. He had gained more weight, was more wrinkled, and appeared to have ten years on me, I thought,

although he was only three years older. He stared at the sea and smoked. Like me, I thought with dismay, and I put my cigarette out and glanced down at the book. Bruno Schulz's words acquired a monstrous, almost unbearable dimension. When I looked back at Ramírez Hoffman, he had turned sideways. I thought he looked like a rough person, the way only some older Latin Americans can look. A roughness different from that of a European or a North American. A sad and hopeless roughness. But Ramírez Hoffman didn't seem sad, and that was precisely where his infinite sadness resided. He seemed in control of himself. And in his own way, within his own parameters, no matter what, he was more in control of himself than all of us in that silent bar. He was rough and he had nothing or very little and didn't seem to care. He seemed to be going through tough times. He had the expression of someone who knew how to wait without losing his nerve or becoming distracted. He didn't look like a poet. He didn't look like an ex-official of the Chilean Air Force. He didn't look like a legendary assassin. He didn't look like the guy who had flown to the Antarctic to write a poem in the sky. I ordered Catalan bread rubbed with tomato and a nonalcoholic beer.

After a while, Romero returned, and he and I left together. At first it seemed like we were walking away from Ramírez Hoffman's building, but in fact we had gone around it. Is it him? Romero asked. Yes, I told him. You have no doubt? I have no doubt. I was going to add something else, but Romero quickened his pace. Ramírez Hoffman's building stood against the moonlit sky, singular, different from the other buildings that seemed to fade before it. Romero pointed to a bench in the park. Wait for me here, he said. Are you going to kill him? The bench was in a dark corner. Romero grimaced. Wait for me here, or go to the Blanes station and take the first train. Don't kill him, please, that man can do no one any harm now, I said. You can't know that, Romero said, and I don't either. You can't kill anyone, I said. Deep inside, I didn't believe it. Of course he could kill. We could all kill. I'll be right back, Romero said. I stayed there, seated, looking at the dark bushes while I listened to the noise of Romero's steps as he walked away.

Twenty minutes later, he returned. Under his arm, he held a folder with papers. Let's go, he said. We took the bus that connects Lloret with the station in Blanes and then the train to Barcelona. We didn't speak until we got to the station in Plaza Catalunya. Romero took me home. There, he gave me an

envelope. For your trouble, he said. What are you going to do? I go back to Paris this very night, I have a flight at midnight, he said. I sighed. What an ugly business, I said, to say something. Of course, Romero said. It's the business of the Chilean people. I looked at him there, standing at the gate. He was smiling. He must have been at least seventy years old. Take care, Bolaño, he said after a few moments, and left.

Translated from the Spanish by Miguel Arisa

VIRGINIA BEAHAN AND LAURA MCPHEE

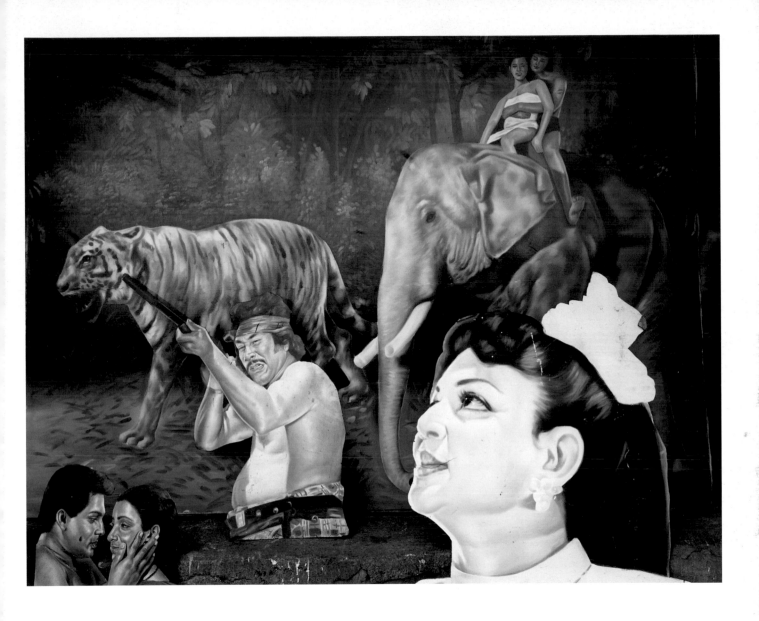

*Jungle Scene at Prem Jayanth's Movie-billboard
Painting Studio, Colombo, Sri Lanka, 1993.*

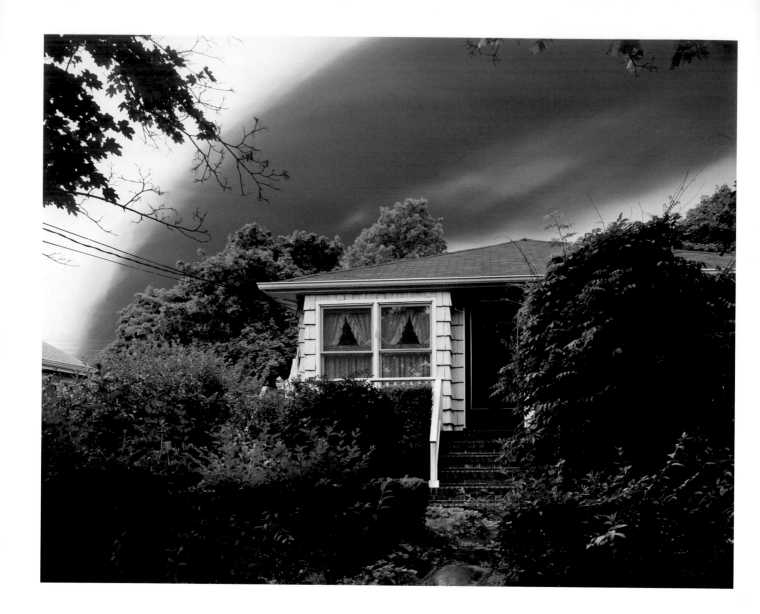

ABOVE:

*Evacuated House and Smoke From Three Million
Gallons of Gasoline Burning in a Shell Oil Fuel Tank Struck
by Lightning, Woodbridge, New Jersey, 1996.*

RIGHT:

Expansion of the Ulu Ko Subdivision, Lihue, Kauai, 1991.

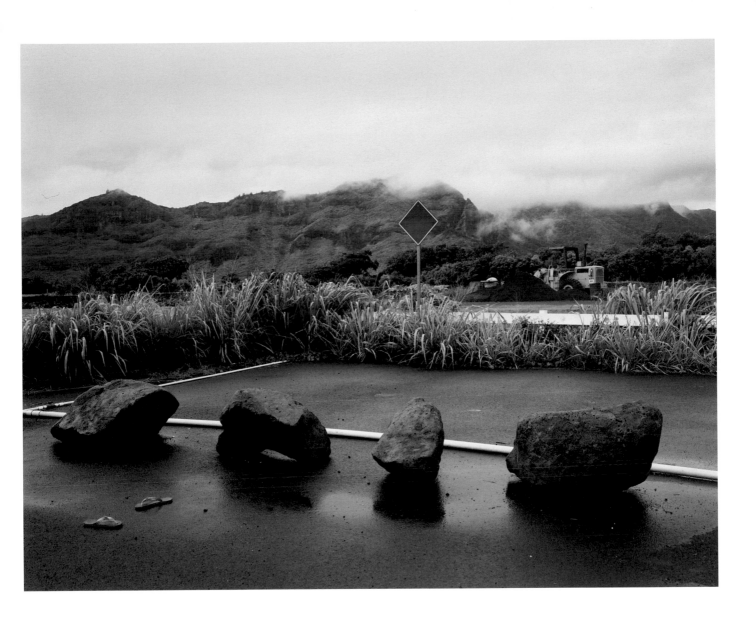

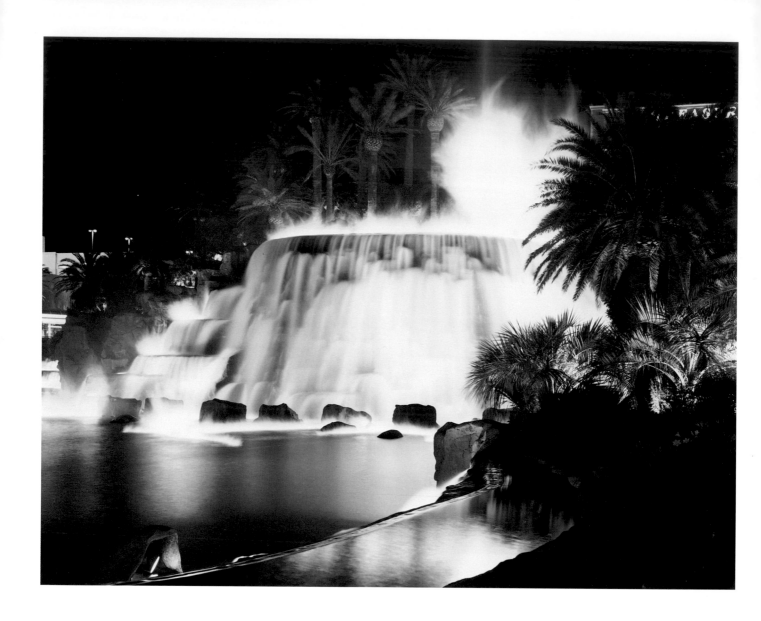

Artificial Volcano Erupting at the Mirage Hotel,
Las Vegas, Nevada, 1995.

Virginia Beahan and Laura McPhee

The terms of debate in postwar landscape photography—which is to say, post–Ansel Adams landscape photography—have presented themselves by and large as a dialectic between the pure and the spoiled. The purist landscapists, taking after Adams, offer us visions of wild splendor in which no trace of human occupation can be found. (Not even, it bears noting, any trace of the photographer's presence, which, like telephone wires and asphalt pavement, remains outside the frame and thus invisible.) The chroniclers of spoilage feel Adams to be dishonest; America, they demonstrate, is at best a postmodern frontier constituted of discarded beer cans, clear-cut forests, and smokestacks in the hazy distance. Their favorite trope: a nuclear power plant framed by early spring willows and scudding clouds, cast in a beguiling pink twilight.

As distinct as these modes of landscape are, however, they share an underlying premise: Human beings and nature are antithetical and incompatible. For the purists, the easy solution was to eliminate all trace of culture; the spoilists settled for depicting a diminished beauty that might remind us of, and reprove us for, a natural world we have corrupted. A similar dialectic took place in America in the nineteenth century, although the subject was only metaphorically nature: Photographers of the West largely disguised the presence of Native Americans on the land, preferring the illusion that they themselves were the first to happen upon the scene. At the same time, photographers sympathetic to Native Americans, most notably Edward S. Curtis, depicted them as a "vanishing race" soon to succumb to the conqueror's culture. The result, in both cases, was the same: Native Americans' claims to their own lands were erased visually as much as they were legally. Today, the hoary equation of nature equals good, culture equals bad needs to be teased apart.

Virginia Beahan and Laura McPhee have made their own pretty picture of a nuclear plant, I admit, but their collaborative work represents something different in terms of the discourse of landscape photography. One clue to this difference is its sense of humor; traditionally, landscape photography has been so deadly serious that the thought of smiling at a scene would never occur to us. (If you doubt this, try putting on a grin in front of Adams's *Moonrise, Hernandez*.) Another clue lurks in gender: In the nineteenth century, as the photographer Linda Connor has pointed out, there were many women photographers but virtually no women landscape photographers. The twentieth century offered much the same story until the last twenty-five years. Beahan and McPhee belong to an era in which the tide has been reversed: Besides Connor, their peers include Barbara Bosworth, Lois Conner, Lynn Davis, Terry Evans, Karen Halverson, and Mary Peck, among many others. All approach the landscape as a site of interaction between nature and culture.

Much like Wendell Berry, Barbara Kingsolver, and a host of writers who have lately focused on the complexities of our relationship with nature, Beahan and McPhee do not see the landscape as an idealized site of cultural absence. Instead, they see it as the ground on which the incongruities of modern life are visually inscribed. Their pictures do not aspire to spiritual metaphor, nor do they evidence anger at human depredation; instead, they urge us to consider how poignant, inadequate, and sometimes ridiculous are our efforts to replicate natural beauty. The specter of Las Vegas is never far from these pictures, even in those of Hawaii, which persists in the imagination as a natural paradise but is seen

here as an artificial construct meant to elicit a paradisaical yearning. However, the photographers' allowance for humor and lack of Calvinist zeal should not be mistaken for a laissez-faire sensibility. The frequent presence of fire and its analogues (smoke, lava) marks their work and suggests, in caustic fashion with apocalyptic implications, that in the end nature will reclaim its prominence and at least a semblance of its original, Edenic beauty. At the same time, their photographs imply that such an ending may be too much to hope for.

No Ordinary Land, the ambiguous title that Beahan and McPhee have given this body of work from the last decade of the last century, slyly puts the matter in relief. The landscapes they focus on are exemplary— sometimes hyperbolically so—of how we visually encode the idea of nature in our everyday lives, and as a result they can claim to be extraordinary. Looked at another way, the photographs show us that our penchant for encoding nature has virtually preempted any chance that the natural world might appear as ordinary—that is to say, as itself. Roll over, Ansel Adams.

Andy Grundberg

Marsyas

After the foam-smeared telephone,
still reverberating from far-off lips,
lay down like an offended eavesdropper
the whole refusal began again.

STEFAN HERTMANS

So he stood, grimacing, in front
of the broken mirror, wet his hair
and combed it straight back, put cream on
the blue scar from mouth to ears.

Coat, tie, a short, gray scarf matching
this three-piece suit of soft, woven ice.
And when, looking into that deep cut, he saw
that everything was still there, he began with the overcoat.

He tore it lengthwise first, then across,
and let the strips finger each other in a heap;
bound the coat and the shirt with the tie,
and with the belt his breath and his voice.

He shaved armpits, loins, ears; filled the basin
with his stripped skin. And so he undressed
twice, and stood shivering
in front of the mirror in the neon light.

His resplendent wrapping drifted in flakes
on blood-leavened water; the foam
on his lips made his raw
limbs young, until his inner self

wrung itself trembling and nameless
from the contours of his overflowing body.
Then all the voices came at him, the voices
that expected him at the feast where
he hadn't been.

Translated from the Dutch by Duncan Dobbelmann

CHILDHOOD IN THE DIORAMA
DURS GRÜNBEIN

Strange, already as a child he was drawn to the inert.
In museums he lingered in front of the diorama
With its animals at a standstill, grouped naturally
Before painted expanses, scenes of primeval forests and
 the Himalayas.
Like in the fairy tale, the deer listened, enchanted;
He stepped closer, eyes sparkling in the neon light.
In the skull of the caveman beside him
He saw the hole and forgot the blow of the club
Delivered by the rival, the battle for the fireplace.
The Egyptian mummy stood still for millennia,
Its brain removed. Only with the melting
Of eternal ice did this mammoth come to life.
The most beautiful butterflies, big as a hand,
He found pinned into place. Once it seemed to him
As if their wings still fluttered, like in a memory
Of the fallen trees, the tropical wind.
Or perhaps a draft had passed through the display cases.

One of the great feats of the nineteenth century was the creation of semblance from the spirit of technology. What no single invention or historical-philosophical gospel of transformation could have accomplished resulted quickly and imperceptibly from the will to illusion, which emerged then for the first time in such directness, and with such drive for immediate fulfillment. The race for everything foreign and new and the intensification of the artifactual world produced by commerce and industry, along with scientific systemization and a general passion for collecting, awoke a desire among the people to have the world's treasures presented to them at once, even if only in effigy, so that they might at least gaze upon them. This irrepressible visual curiosity led to the establishment of places for the projection of these wishes. Palaces of collective dreaming opened their doors. Museums, borrowing from the full stock of images provided by natural and art history, drew in awed masses. In exhibition halls much like greenhouses with their vegetative promises, the wonders of the organic and inorganic spheres were amassed in extraordinary collections, separated one from another by mere panes of glass. A market was established within a few decades, whose only product, refined by the latest technology, was the quid pro quo—something that represented something else. However refined or crudely spectacular it was, however exotically improbable or deceptively authentic, semblance became marketable in those years. It was semblance, or appearance as such— its fleshy luster sealed in wax, captured on gelatin paper and later on celluloid, or in naturalist paintings, the molds of live models, and perfected

Hiroshi Sugimoto, *Manatee*, 1994.

specimens—that was offered in all its aspects, in every form technically conceivable, and paid for in hard cash. The effect was that of a massive conversion. From that point on, life without the spiritualism of the world of illusion, a consciousness independent of phantasmagorias, was unthinkable. Historically, this is where the broad acceptance of an *as if* reality begins, the influence of which immediately extended into every area of life, blurring from the outset old boundaries like those between reality and dreams, which were collectivized in the same motion. Walter Benjamin recorded this first act in the age of mechanical reproduction in his notes for *The Arcades Project*:

> There were panoramas, dioramas, cosmoramas, diaphanoramas, navaloramas, pleoramas (*pleo*, 'I sail,' 'I go by water'), fantoscopes, fantasma-parastases, phantasmagorical and fantasmaparastatic *expériences*, picturesque journeys in a room, georamas; optical picturesques, cinéoramas, phanoramas, stereoramas, cycloramas, *panorama dramatique*.

One rather inconspicuous machine of illusion was the animal diorama. Like all phenomena of this sort it now seems dated, its sensational value gone. Although they may never have stopped functioning for some, to the observer spoiled by animal films and zoos they seem like a boring relic from the antiquated chambers of museums. A few dumb-founded animals arranged as if they were still alive— every child notices immediately that they are stuffed. The unbelievable craftsmanship, the exactitude of the reconstruction itself, might generate some respect, but it is unlikely that the theatrical pathos of nature will add to it. Unlike panoramas or picture shows, which have become

quite rare, one still encounters dioramas, often in museums of natural history. They are rarely displayed prominently and are usually on their way to storage, having degenerated to the status of window dressing. With no more than a sentence or two of commentary, they entrust the production entirely to the power of the gaze, inevitably disappointing the modern demand for didacticism. Recent developments in the field of biology can be illustrated by dioramas about as effectively as quantum mechanics by a model of Watt's original steam engine. Mere semblance, this construction of the previous century, is no longer sufficient. Transferred neatly to a lifeless stage, the Darwinian drama of survival of the fittest is not spectacular enough. A renaissance, like that of the dinosaur parks under construction today (the idea is as old as world exhibitions and crystal palaces), is not yet in the picture for the animal diorama. And yet it is easy to imagine that its time will come—namely, when it becomes necessary to document dying species in their typical form of appearance. The extinction of species is the future of the diorama. As a last archive it will attest to disappearing habitat and an animal world displaced by humanity.

There was a time in my childhood when I begged my grandfather every day to take me to the museum. As was the case before the beginning of each school year, I spent the summer with my grandparents in the Thuringian city Gotha. I quickly grew tired of strolls through city parks and the famous baroque orangery, and I took to tramping around on my own. But when supervision was mandatory I was all for a single destination: the Museum of Natural History. I was six years old, in an innocent analph-abetic state, my interests limited to swans and automobiles, trains and dogs, when I first came

Hiroshi Sugimoto, *Oyster Bay*, 1980.

under the spell of a mania of sorts. My grandfather knew what was in store the moment I stormed ahead of him, up the stairs of the broad entrance, and on into the great hall, before he had even counted his change at the entrance. To find me again he needed only to search the row of small rooms on the ground floor. They were separated from a hallway by dark curtains, like boxes in the theater. I stood behind one of the curtains, quiet as a mouse and completely removed from time, for before me was Africa, a savanna landscape shimmering in the heat. Or I would lean forward against the glass, shivering at the sight of ice floes towering against a frozen blue horizon. If my grandfather came in, I just pointed silently to the bamboo thicket, at the tiger stalking its prey. Or I would warn him with a glance about the wild boar

in the undergrowth. Before me, almost within my grasp, stretched an immense expanse, which I had known for some time—from stories, dreams, and vague memories. To my familiarized eye it was just as real as the park outside, or the forests of Thuringen. What was a copy at best for my grandfather, a piece of the jungle imitated with deceptive accuracy, and about as interesting as the window displays of a fur shop, was for me absolutely identical to nature outside. This was exactly how I had imagined the wastelands that were home to the polar bears! Wouldn't one have the same view standing on the deck of an ice-breaker, forging on to the North Pole? And as for this vegetation typical of the Amazon region, wasn't it really the rain forest, where you would lose your way in the undergrowth, caught in a web of lianas,

35

bit by poisonous vipers? Or was it all just fantasy? Every detail had to be accurate. A single slip would have attracted the attention of my childish expertise. And yet I knew next to nothing about tropical plants, and was hearing many of the animal names for the first time, grateful for my grandfather's encyclopedic knowledge. The difference between the two of us was not in attentiveness to details, or in our more or less romantic pleasure. It was in the reception of the whole experience that our minds diverged. What for him remained irreversibly beyond the glass window, a reflection like Dürer's piece of earth, was for me a part of this world, with only a barrier preventing me from walking around inside it. The scenes in the diorama belonged to my world as much as the natural landscapes we had visited or the unseen rooms in a strange house, which I imagined fitted together neatly. Beside the moor were the stalactite caves, and beside the drifting dunes, the wild brooks rushing beneath the pines. For me, geographical knowledge hadn't yet separated places and projected them on maps like the firmament. In my own topography of forests and meadows there were only fluid boundaries, and what I noted impressionistically had already yielded to the dictates of archetypal memory. The armadillo, for example, had made an impression even before I first saw it appear on the familiar terrain of the prairie. With a single glance I registered which vegetation belonged on the Siberian tundra, and which animal species belonged in the Australian outback. The changing scenes behind the glass, those concentrated tableaux of nature from all continents, nicely suited the associative consciousness of a child in the process of conquering the world for himself. The curtain had hardly slipped back into place before I stared, spellbound, at scenes as

Hiroshi Sugimoto, *Neanderthal*, 1994.

exotic as they were familiar. It was the world of picture books and adventure stories, a world I had known for some time. A stretch of the Mexican plateau, a part of Antartica, a dim clearing in the woods with deer, somewhere in Europe . . . I registered every blade of grass, the color of the leaves, the anatomy of the animals in whichever position they had assumed—sniffing, resting, eating—as if I were hypnotized. Were they standing still because they had seen me? Would they still be there when the museum closed? I would have to hold my breath so as not to scare them away. If I studied them for too long a light dizziness set in. The scenes behind branches seemed subject only to my secret observations. This matter ossified in an eternal clearing moved me to the point of ecstasy, and followed me into my dreams, long before I knew what an epiphany was.

Today it seems as if my entire being entered the diorama during those moments. Like the Chinese master who was said to have crossed over into one of his painted landscapes, the imago of the child slipped into that fantastic interstice between

nearness and distance. As if set off by a magic word, everything I encountered there, from the most exotic and foreign to the most domestic and familiar, merged with the fragments of experience of my early years. All the fresh sensations that had been formed by astonishment—the first descent into an outmoded shaft, the foray by lamplight through the woods at night, the view over the edge of chalk cliffs at the sea—were inventoried as archetypal dream-images here in the museum. And it became possible to recall them when the time came. The diorama was the vault waiting to be opened, where memories lay stored as primal geographical motifs.

Seen phenomenologically, the diorama is literally a *feast for the eyes*, in which pictures and nature merge into a whole. In its space of illusion the semblance of the natural becomes a perfect memory of nature. While it is intended here as a means to an end, montage is invisible as a principle, encouraging viewers to speculate on the probable. The naturalistic effect results from the seamless grouping of plastic details. Every centimeter is an imitation, and the whole is *just like real life*. In the diorama, the biotope returns as a genre scene, and real space is sacrificed to the frozen stage, on which animals and plants pause for a moment as if mesmerized. Only after looking at it for a long time do you begin to sense that this moment could last forever. An aggregate condition of mimetic motionlessness is preserved in the installations, a state that would seem to correspond to all that is dead and discarded in nature—a bleached skeleton, a petrified piece of bark, a gnat sealed in amber. Its perception comes as a subtle shock, where the suddenness of the encounter coincides with the knowledge of ossified life. The fact that both the natural scene and the

moment of perception exist only when removed from their respective dimensions places what is observed under suspicion. Preserved in the museum, the evacuated props of flora and fauna make up an artificial void, where indirect lighting is supposed to add a sense of the time of day and the weather. The impression of spatial depth is produced by the light curvature of the rear wall. Optically, the plastic foreground and painted background are miles apart. This spatially manipulative trompe l'oeil painting certainly contributes to the subliminal hypnotic effect that made me dizzy as a child. Perhaps this is one of the reasons for the long-term psychological effect of the diorama?

If the viewer's gaze is first drawn into the depth of the scene, he is lost in the painted horizon, the production itself—this conspiratorial amalgamation of animal specimens and arranged vegetation— will reflect it in the end. The eternal hunting grounds are presented as an interior. The narrowness of a cell furnished with trees and bushes (tomb, camera obscura, cabinet) rids the consciousness of the illusion it seemed to have discovered in the pretense of scenic distance. Observation is referred back to the prominent details, the richness of which calls to mind the phrase "abundance of nature." With a little trick, the sublime forms of natural beauty become the property of the panopticon, before which your held breath betrays a tightness in the chest. The absence of any noise is striking. There is no natural sound to disturb the observation of aestheticized nature. The spell cast suggests the terrifying instant when catastrophe sets in. Something from behind the unsuspecting observer, perhaps the outside world from which the elements of the diorama are taken, reappears as danger. Even the animals within these three walls seem

fixated on something that remains invisible to us. The situation is reminiscent of the Biblical rescue of the animals on Noah's ark, their eyes wide with horror as they escape the flood swelling up all around them. If we weren't so certain that they had, like wax figures, long ago become part of a dusty object world, we might mistake these silent actors in their still lifes for resurrected beings, creatures made of flesh and blood, about to spring back into their long-lost expanses. But it is the very absence of these expanses, which only emerges more clearly in these quotations of wilderness, that produces the melancholy atmosphere of the diorama. The feeling one gets is less that of time-stood-still than of time-long-since-passed. Here, as in the darkest of the romantic fairy tales, the scene is haunted by the specter of lifelessness. In the sparkle of the glass eyes, in this absolute stillness where no leaf is moved by the wind, lies the threat of nature entirely devoid of life, a nature that derides any form of subjective experience.

The diorama encourages the study of what was once living. It glorifies its petrified form just as the cases displaying butterflies bored into place do. What is lost in the process is precisely what is incommensurable—the pyrotechnical nervous systems and enormous range of the animals and the luminous colors of the plants. That they can no longer die or fade away is the precondition for their place in the vitrine. Beyond death their aura seems no different from that of artificial flowers and bronze monuments of animals. And so the fatal image of the *nature morte* illustrates the dream of nature unspoiled. The diorama is the flip side of all the efforts to conquer the world brought about by the industrial age. And in the end isn't it just this incompletion that most haunts these enchanted scenes, the secret of lost utopias?

If we follow Nietzsche in taking the animal as evidence of the eternal present, as a totemic figure leading us out of the nightmare of history, the apotheosis of this belief is represented by the diorama. Precisely because the animal always makes the same impression, whether in front of the child in a zoo or before Herodotus's wandering eyes, it can be removed for a moment from the haze of time. We don't have to move because everything stands still. We listen, motionless, the animals in abeyance, and with them the first day of creation. The eagle waxed firmly to the rock, the pair of antelope grazing eternally, the lion ossified in permanent vigilance—the transhistorical is demonstrated in these figures, as much on the pharaoh's frescoes as in the mind of the child.

For this very reason, the diorama could only come into being after nature itself was recognized as historical. Only when the origin of species had been reduced to the common denominator of evolution by Darwin could natural history move on to the reconstruction of the entire animal world. It is not hard to imagine the extent to which the first dioramas corresponded to common notions of dramatic scenes from the struggle for survival. The step from the first bestiaries and chambers of horrors to a representation of nature more in accordance with the epoch of zoology wasn't much smaller than that from the earliest panoramas and optical phantasmagorias to the exact imaging techniques of photography and film. With improved methods of animal conservation, the attention to detail became as obsessive as in the construction of models. Landscape architecture, anatomical studies, and various naturalist props were among the means utilized to express the greatest possible authenticity. But it was only in the whole

composition that the diorama became a *Gesamtkunstwerk*—as the illusion of an ideally representative wilderness in the smallest possible space.

Perhaps it is only today, with the perspective provided by the enormous devastation of the earth, that the sadness lurking behind the magic of the dioramas becomes truly recognizable. The diorama's still celebration of the moment is the memento mori of nature before the arrival of human beings. Only that which has its own end in sight can one day appear dioramically. The Neanderthal man in his tribe of hunters preceded the modern city dweller into the scenes long ago. The artificial world of the dioramas draws its beauty from a vision of the decline of its real models. This beauty can appear only when history has passed them by, and memory has consigned them, complete, to the panorama.

The melancholy radiance cast over such moments is rarely displayed as majestically as it is in the halls of the American Museum of Natural History in New York City. Extravagant reverence for the abdicated animal families is expressed one final time in its large dioramas. They are collected there with all the trappings, in a splendor that never existed, and deposited in the heart of the metropolis. As if in a pantheon of great nations, they stare from their brightly illuminated burial chambers out into what was once a continental expanse. The museum is their hall of fame, where they reside as monumental mummies. Bison and grizzly bears in the North American hall, hippopotamuses and elephants in the hall of African mammals. The cool air of a mausoleum, the soundless music of a planetary requiem, greet visitors escaping from the streets of New York. For a few hours they become analytical dreamers in front of the exhibits, hallucinating their own past from the archives of the animal world. A lost paradise comes back to them in fragments, a parade of carefully prepared cadavers. As the natural theater begins, scenes of a collective childhood emerge from the endless corridors of artificial flora and panoramas of painted blues, and the viewers find themselves feeling like they did on the first day, a child surrounded by plants and animals.

Could this have been what Baudelaire meant when, after visiting the Salon in Paris, he tired of the many homogenous paintings and noted: "I would rather return to the dioramas, where brutal and enormous magic has the power to impose on me a useful illusion. I would rather go to the theater and feast my eyes on the scenery, in which I find my dearest dreams artistically expressed and tragically concentrated. These things, because they are false, are infinitely closer to the truth."

Translated from the German by Daniel Slager

KIKI SMITH

Musical Clause

MAHMUD DARWISH

He's a poet who now writes a poem,
instead of me,
on the distant willow of the wind.
Why then does the rose in the wall
don new leaves?

He's a boy who now sends a dove on the wing,
instead of us,
high onto the ceiling of the clouds.
When then does the forest shed this snow
around the smile?

He's a bird who now carries a letter,
instead of us,
to the blue from the land of the gazelle.
Why then does the hunter enter the scene
to shoot his arrows?

He's a man who now washes the moon,
instead of us,
and walks on the crystal of the river.
When then does the color fall to the ground?
Why do we disrobe like the trees?

He's a lover who now sweeps away the loved one,
instead of me,
to the mud of the bottomless springs.
Why then does the cypress stand here
guarding the garden's gate?

He's a knight who now halts his horse,
instead of me,
and slumbers under the shade of the oak.
Why then do the dead come to us
out of a wall and a closet?

Translated from the Arabic by Ben Bennani

DANIEL BARENBOIM AND EDWARD W. SAID: A DIALOGUE

MODERATED BY ARA GUZELIMIAN

Ara Guzelimian: I want to begin by asking each of you: Where are you at home? Do you ever feel at home? Do you feel yourself in perpetual motion?

Daniel Barenboim: The used and abused cliché, "I am at home wherever I make music," is true. I say "used and abused" because many of my colleagues and I have used this cliché on occasions when we didn't know exactly how to answer this very question or didn't want to be rude in places that were hospitable to us yet didn't make us feel at home. Wherever I can play the piano—preferably with a reasonably good instrument—or wherever I travel with the orchestras that I lead, the Chicago Symphony Orchestra and the Staatsoper from Berlin, I feel at home.

I feel at home in a certain way in Jerusalem, but I think this is a little bit unreal, a poetic idea with which I grew up. We moved to Israel when I was ten years old and lived in Tel Aviv, which is a city without any history to speak of, a very modern city, not particularly interesting, but bustling and bubbling with life, whereas Jerusalem, of course, means everything to so many different people, and that is why its politics have always been so problematic. In the 1950s, Tel Avivians looked to Jerusalem for everything that they couldn't find in their own city:

spirituality, intellectual and cultural curiosity. Unfortunately, all those things seem to be disappearing now due to the lack of tolerance shown by some of the extreme populations in Jerusalem.

So what I mean to say is that I feel at home in the *idea* of Jerusalem. Otherwise, I feel at home in the company of a very few close friends. And, I must say, Edward to me has become a soul mate, the one friend with whom I can share so many things. And so I feel at home whenever I am with him.

I am not a person who cares very much for possessions. I don't care much about furniture. I don't care much for reminiscences of the past. I don't collect memorabilia, so my feeling of being at home somewhere is a feeling of transition, as everything is in life. Music is transition, too. I am happiest when I can be at peace with the idea of fluidity. And I'm unhappy when I cannot really let myself go and give myself over completely to the idea that things change and evolve, and not necessarily for the best.

Edward W. Said: One of my earliest memories is of homesickness, of wishing that I were somewhere else. But over time, I've come to view the idea of home as being overrated. There's a lot of

sentimentality about homelands that I don't really care for. Wandering around is really what I like to do most. But the reason I find myself happy in New York is that it is a chameleon city. You can be anywhere *in* it and still not be *of* it. In some way I appreciate that.

When I return to where I grew up in the Middle East, I find myself thinking about all the resistance I feel to going back. Returning to Jerusalem, for example, where I hadn't been for nearly forty-five years: When I went back in 1992 with my family I found it a completely different place. It just wasn't the same place I recalled. And my Palestine—the Palestine where I grew up—has become Israel. I didn't grow up in the West Bank, so places like Birzeit University—a wonderful location, where Daniel played a recital a year or so ago —are really not home to me. I feel very much at home in Cairo, where I spent much of my youth. Cairo has something of the eternal about it. It's a fantastically complicated and sophisticated city, and its particular dialect is what gets me in the end.

I think one of the things that Daniel and I have in common is a fixation on the ear rather than on the eye. There's a *specular* capacity that I don't have. And so, like Daniel, I'm not attached to physical objects as such, except that I collect certain things. I collect exceptional fountain pens for reasons that have to do with my father's profession. As a follower of Kant, I hate computers. I collect pipes and clothes, but that's about it. Possessions don't inspire the same feelings in me that they would in a collector of art or houses or cars. I've read about people who have fifty cars. That's incomprehensible to me.

Daniel mentioned—and I ended my memoir *Out of Place* with a similar thought—the sense that

identity is a set of flowing currents rather than a fixed place or a stable set of objects. I think that's quite an important thought.

Daniel Barenboim: This idea of "currents" must be related to the way you've lived your life. You were born in Jerusalem, which was British at the time. You grew up in Cairo, which was still under the British. Even though you came to America, a very high percentage of your interests are European. The things that matter to you the most—what you think, what you teach, what you know, not only in literature, philosophy, and history, but also in music —are European in origin.

If you are active in a profession that is more than a profession—that is a way of life—then geographical location is less important. I'm sure that when you read Goethe, you feel, in a funny way, German, as I do when conducting Beethoven or Bruckner. This was one of the lessons of our workshop in Weimar—precisely, that not only is it possible to have multiple identities, but also, I would say, it's something to aspire toward. The sense of belonging to different cultures can only be enriching.

Edward W. Said: One of the striking things about the kind of work you do is that you act as an interpreter, as an artist concerned not so much with the articulation of the self as with the articulation of other selves. That's a challenge. The interesting thing about Goethe—and also about our experience in Weimar—is that art, for Goethe especially, was all about a voyage to the other and not a concentration on oneself, which is very much a minority view today. There is more of a concentration today on the affirmation of identity, the need for

roots, the values of one's culture and one's sense of belonging. It's become quite rare to project one's self outward.

In your work as a performer, Daniel, and in my work as an interpreter of literature and literary criticism, one has to accept the idea that one is putting one's own identity to the side in order to explore the other.

Daniel Barenboim: I feel very much today—especially in the world of music—that the choices are incorrect as presented. Let's go to the nerve of the question: the sound of the orchestra. Often you hear it mentioned, "Well, it's a pity that French orchestras have lost the nasal sound of the French bassoons." It's because they now play German bassoons. American orchestras sometimes play German trumpets or trombones. The Czech Philharmonic sounds very similar to the Sydney Symphony in sound, et cetera. What a terrible thing globalization is, people say, as if you have to be *French* to produce a nasal sound or *German* to produce a German sound.

This is the beginning of a lack of cultural tolerance. Yes, there is a difference between a feeling for national heritage and fascistic ideas about a nation-state. There was nothing wrong with the Germans in 1920 feeling that there was something culturally *German* about Beethoven and Brahms. I have absolutely no problem with that. But I do have a problem when they claim that only Aryans can appreciate Beethoven, and I think that this is where we're heading again.

The United States has proven the opposite, because the best American musicians don't relate to music on the level of culture. In other words, the great German musician will always have more than a rational reaction to the Beethoven and Brahms with which he or she grew up, something almost atavistic—which *La Mer* by Debussy would not elicit even if the musician plays it marvelously—whereas for the American musician, Beethoven and Debussy are equally distant or near, according to his or her talent and knowledge.

Edward W. Said: Unfortunately, there is a sort of amnesia going around in this country about the fact that the United States is an immigrant society and always has been. The attempts made recently to declare that America is one thing and not another and the quarrels over what is the American tradition, and what is the canon, and what are the unifying aspects of America make me deeply uncomfortable; these assertions can turn into a kind of imported sense of nationalism (what is "German," what is "English") that has very little to do with the quite volatile and turbulent and finally, to me, deeply attractive aspects of America, which are that it's a society continually in a state of flux, continually in a state of unsettlement, rather than something that is given and formed once and for all. It seems to me, therefore, that places like the university and the orchestra—those places in the arts and sciences where one's life is given over to an ideal—should be places of exploration rather than of simple affirmation and consolidation, which are really not at all, in my opinion, in conformity with the history of this society and this country.

Daniel Barenboim: This is very much in your area, Edward. How do you explain that, on the one hand, market globalization makes everything the same: You can eat—

Edward W. Said: A Big Mac on the Champs Élysées and in Cairo.

Daniel Barenboim: And you don't have to go to Japan to eat sushi. Yet political conflicts and national conflicts are deeper and between smaller units than ever before. Why is that?

Edward W. Said: Well, there are two reasons. The first is the reaction *against* global homogenization. One way to defend yourself against the sense of an all-encompassing global atmosphere—represented by America to most people—is to return to comfortable symbols of the past. In the Islamic world, for example, more people are wearing traditional dress, not necessarily as a form of piety, but as a way of affirming an identity that resists this global wave.

Second is the legacy of empires. In the case of the British, whenever they were forced to leave a place, they divided it up. It happened in India. It happened in Palestine. It happened in Cyprus. It happened in Ireland. The idea of *partition* as a quick way of solving the problem of multiple nationalities. It's like someone telling you, "OK, the way to learn a musical piece is to divide it into tinier and tinier units, and then suddenly you can put it all together." It doesn't work that way. When you divide something up, it's not so easy to put it all back together.

Both of these factors have produced xenophobia and identity conflicts that are endemic to this period and very dangerous.

Ara Guzelimian: I want to turn the subject to a musical figure who was formative and central to both of you—Wilhelm Furtwängler. This may seem like a radical right turn from where we just were,

but it's related to the discussion of cultural influences. Growing up in Buenos Aires, Daniel, you saw a veritable parade of the greatest imaginable European musicians. It was the same in Cairo for you, Edward, during the 1940s, '50s, and a year or two in the '60s. A thriving colonial European culture in Egypt dates much further back, to the establishment of the Cairo Opera House and the premiere of Verdi's *Aida*. It was quite possible to see Beniamino Gigli, Gino Becchi, and Maria Caniglia perform in Cairo in the 1940s. There were regular visits of out-of-season Italian and French opera troupes—

Edward W. Said: Out of shape, too!

Ara Guzelimian: Yes. Wilhelm Furtwängler and the Berlin Philharmonic came to Cairo in 1951. My parents were at those concerts, and so were you as a teenager, Edward. The broadcasts of a couple of Furtwängler's performances on Radio Cairo have survived—Tchaikovsky's Sixth Symphony and Bruckner's Seventh Symphony.

Edward W. Said: You mentioned the cultural life of Cairo in the 1940s and '50s—I grew up hearing stories of Cairo in the '30s as well, when it was a great venue for concerts and many wonderful musicians passed through. A teacher of mine in Cairo named Ignace Tiegerman used to tell the story of Artur Rubinstein giving a concert and enjoying it so much that he wanted to give another one in order to stay in Cairo a little longer. But they couldn't fit him in the concert calendar—it was so crowded that there was simply no place for him to play. So that was the sense of bustle one had in those days. And I recall that when Furtwängler appeared,

it was the first time I had ever seen a great foreign orchestra. There were local groups that played and I would occasionally go to hear them—

Daniel Barenboim: Did you ever hear the Palestine Philharmonic?

Edward W. Said: Never. My parents heard them with Toscanini in Cairo. But I was considered too young for a concert when Toscanini visited in the '40s.

Furtwängler's appearance in Cairo had been preceded the year before by the Vienna Philharmonic with Clemens Krauss, who came and played in the same theater. And that was, for me, a wonderful experience, because although I'd been to the opera in Cairo and had experienced those out-of-shape singers—who were, in their own day, very great singers—going through the Italian repertory, the appearance of Krauss was extraordinary.

But that experience was completely trumped by the appearance of Furtwängler and the Berlin Philharmonic. I had never in my life seen such concentration as was present on that stage. Furtwängler played a very conventional program, which replicated to a certain degree some of the records we had at home, including Beethoven's Fifth, but to hear the record replicated in real life, as it were, was for me a tremendous thing. And this rather gaunt and unprepossessing figure on the podium was very different from Clemens Krauss, who was almost like a businessman, just conducting away. Furtwängler transfixed me with his waving arms and his tall, angular frame. And what I remember, in particular, was his feeling for time. It was a new concept of time, because for me time had always been connected to duty and chores and the various obligations I was supposed to honor.

Wilhelm Furtwängler, Alexandria, 1951.

Here, all of a sudden, time was transformed into possibility and a beautiful plasticity, which I'd never experienced before in quite that way and with such a large number of people all at once.

Later, of course, I discovered Furtwängler again through his writings and recordings, but in the Egyptian culture of that time, there wasn't really a place where I could look for anything about him. It was as if he were an *emanation*. Furtwängler existed in the European context. Here was a great figure from another culture transplanted into Cairo—a culture in transition—making this tremendous impression on individuals, and perhaps collectively on an audience, but there was no resonance beyond that. I remember feeling deprived because his performance had been a one-time experience. Perhaps it's given me a taste for the actuality of performance. When you perform,

Daniel Barenboim and his parents with Wilhelm Furtwängler, Salzburg, 1954.

there's something rare about it. It happens and it's over, and then you have to carry it around in your mind.

Daniel Barenboim: I understand what you mean about performance from the other side: playing in surroundings where there's no follow-up. I remember playing once in Calcutta with the Calcutta Symphony Orchestra. First of all, it was terribly hot. Rehearsals started at seven o'clock in the morning—and I'm not a morning person. When I was told exactly when I had to wake up for rehearsal, I thought, "It must be because of the heat." But actually it wasn't the heat. It was simply that most of the musicians were amateurs, and they worked in shops and other places and had to go to work at ten o'clock. In instances like that, one remembers the feeling of giving a performance.

Ara Guzelimian: There's a photograph reproduced in your book, *A Life in Music*, Daniel, which shows you with your back to the camera, wearing white shorts, framed by your parents, talking to Wilhelm Furtwängler. This was in Salzburg in 1954, when you were eleven or twelve years old. Furtwängler was so taken by your talent that he invited you to Berlin to perform with him and the Berlin Philharmonic. Your family, for reasons that maybe you will explain, declined. And, sadly, several months later, Furtwängler was dead.

Daniel Barenboim: What Furtwängler represented was fraught with several difficulties. My musical education had come mostly from my father, which I consider to be extremely beneficial in that I don't think I've really changed anything I learned from him. I didn't have the problem of different teachers. I didn't have to adapt to different methods. But I was not taught the kind of music-making that I heard with Furtwängler.

In the summer of 1952, when I was nine years old, I was invited to Salzburg by Igor Markevitch, who was giving a conductor's class. It was there that I played my first concert in Europe. At the end of the class, I played as a piano soloist with the orchestra. I remember quite well that I didn't admire Markevitch in the same way I admired Furtwängler. He was much more interested in so-called clarity, in other repertory, and in other ways of making music.

It was Edwin Fischer, the remarkable Swiss pianist and conductor, who said, "You must go and play for Furtwängler." So I was summoned to the old Festspielhaus to play an audition.

Edward W. Said: What did you play?

Daniel Barenboim: I remember playing the Bach Italian Concerto. I remember playing the second movement of a Beethoven sonata. I remember playing Prokofiev's Second Sonata and a couple of Chopin Etudes. And I was eleven years old.

Edward W. Said: No one's perfect.

Daniel Barenboim: On the contrary, the imperfections have been growing ever since. Obviously, being fifty-eight years old now, I imagine that if an eleven-year-old child came and played all those things, I would be impressed. It would be ridiculous to show false modesty and say, "No, no." Somehow, I think Furtwängler really was quite taken. And then he asked me to improvise, which I did, and he tested my hearing. At the risk of sounding terribly cynical, I thought it was extraordinary to be tested by somebody who had great difficulties in hearing himself.

Edward W. Said: You mean he wore a hearing aid?

Daniel Barenboim: Yes, because he was going deaf. Many of the old musicians from the Berlin Philharmonic have told me that in a certain sense it was a benediction. Not that he died, but that he was unable to deal with this affliction and was forced to stop conducting. Hearing aids in those days were obviously not as developed as they are today, and he threw his away because they made him hear everything in one color.

Anyway, Furtwängler tested my ear by playing some chords and, with my back to the piano, I had to tell him the notes. And he was very impressed and asked me to play with the Berlin Philharmonic. I was eleven, I hardly spoke any German, and his English was rather poor. My father told him that it was the greatest honor that he could have bestowed upon me, but we were a Jewish family living in Israel—this was just nine years after the Holocaust and the end of the war—and he didn't feel it was the right time. He hoped that Furtwängler would understand.

Not only did Furtwängler understand but, without anybody asking, he wrote a letter that opened innumerable doors in my professional life. It was Furtwängler who sent me to play for George Szell and Karl Böhm, who were conducting in Salzburg. This has all become folkloric. Furtwängler then allowed me to sit in at the rehearsals of *Don Giovanni*, the same production that was the basis of the 1954 film.

I really got to know everything about Furtwängler and his philosophy of music through his writings and his recordings and, of course, through people I've met who knew him and worked with him— musicians from both the Vienna and Berlin Philharmonic Orchestras. And I came to realize that Furtwängler had been unfairly criticized in the United States for political reasons and for some facts that were totally out of contact with reality.

As you may know, he was supposed to have been appointed music director of the Chicago Symphony Orchestra 1948, but a whole list of Jewish artists—practically a Who's Who of musicians in America—signed a letter saying that they would no

longer play with the Chicago Symphony Orchestra if he was engaged there. I think they all signed it, with the exception of Yehudi Menuhin. Obviously Furtwängler didn't come.

Furtwängler was also criticized for his music. Every great artist, of course, has a personal way of making music. But Furtwängler had his own *philosophy* of music based on paradoxes and extremes being necessary to reach an equilibrium—extremes being essential to achieve a musical equivalent of the Greek word "catharsis." Extremes as a necessity in starting on the path from chaos to order. Extremes as an absolute necessity in achieving unity in music. All of this was not only out of fashion, in the same way that it's out of fashion today—in that respect, nothing has changed—but also his method was much too deep and much too complicated, conceptually, for many people to understand.

And the outward manifestations of Furtwängler's kind of music-making were, shall we say, more disturbing than the outward manifestations of more orderly musicians. In other words, it was obvious that in Furtwängler's Beethoven and Brahms there was a certain fluctuation in tempo. In Wagner it was tolerated, but in Beethoven and Brahms? If you don't understand the reason for this fluctuation and for the extremes, you only notice the outward manifestations—extreme dynamics, extreme tempos, and fluctuations of tempo. And that's very disturbing to some listeners.

Furtwängler was criticized in the same way that Wagner had been criticized for his conducting and Liszt for his playing. This kind of criticism has existed throughout the history of music. After Furtwängler came Sergiu Celibidache. The same criticism was leveled at Claudio Arrau. And, I must say, in my small and modest way, I am very proud to belong to that elite group which has been criticized for these qualities.

Furtwängler understood music philosophically. He understood that music is not about statements or about being. It's not the statement of a phrase that is really important, but how you get there and how you leave it and how you make the transition to the next phrase.

Edward W. Said: Don't you think that what you're saying about Furtwängler relies on a deeper level of awareness and reception than what is being put forward in the music itself? There doesn't seem to be a prearranged method when you listen to Furtwängler. The impression his music gives me is that it's being worked out in the performance itself, and these extremes, as you call them, are really part of an ongoing process that takes you through the piece from the opening silence to the final silence, in a way that you can't abstract from the performance and say, "This is the formula. It's clear and it can be repeated in the same way."

You and I have disagreed about Glenn Gould in the past. In a certain way, Glenn Gould is predictable. You know how much I admire him. But there is a Glenn Gould *manner* that can be reproduced— not by others, but by him. What has always impressed me tremendously about Furtwängler—and I even recall it dimly from fifty years ago—is a sense of a highly plastic process, or what you call *transition*, which seems to be working itself out right then and there. There's no prior statement. There's no program. It's all contained in the actual performance, which is, I think, very difficult for some audiences to accept.

Daniel Barenboim: Furtwängler was not only spontaneous and flexible, you know.

Edward W. Said: No, it's not about spontaneity. I didn't mean that.

Daniel Barenboim: Furtwängler rehearsed sometimes painstakingly and thoroughly, but he rehearsed in a different way. This is very well defined by Celibidache. He says that Furtwängler rehearsed two hundred ways of saying "No" in the hope that on the evening of the concert you can say "Yes" once. In other words, you rehearse to make sure that certain things don't happen: that the music doesn't sound hollow here, or drag there, that there's no accent in another place, whereas most people rehearse so that they can put it together in the morning and then repeat it in the evening. But the most extraordinary thing about music is its unrepeatability, if one can use that word.

Edward W. Said: That quality I mentioned earlier: It's something very rare.

Daniel Barenboim: Sound is ephemeral. It goes by. One of the reasons sound is so expressive is that it's not here at your beck and call. You can't draw the curtain and see it again like a painting or open it like a book. This quality is what Furtwängler understood and articulated. Some of his writings are very much tied to the zeitgeist of his time, and some of his contentions about atonal music are naive. But his understanding of the nature of music is, to my mind, unique.

Ara Guzelimian: Isn't this part of the perpetual Apollonian/Dionysian battle that has gone on for centuries in the arts? The quantifiable and ordered versus the irrational?

Edward W. Said: It's a common misunderstanding to pose this battle as an either-or—either you're Dionysian or you're Apollonian—whereas Nietzsche argues that one requires the other. That's the challenge: The two are synthesized in special and privileged moments—tragedy, for example—which, paradoxically, are painstakingly rehearsed and do *not* happen in spontaneous or miraculous ways. There is a certain science to it, you could say. It's generally true in the arts that what seems like a finished performance, whether it's a painting or a poem, is really anticipated by a great many processes, moments, and choices that go on before the finished product is put before you. In literature, which is what I've spent most of my life working with, the words are shared by everyone. Everybody uses language. Although the words you see in a poem, play, or novel are arranged in different ways and have a highly artistic finish to them, they are the words of everyday life. I find music fascinating partly because it encompasses silence, even though it is, of course, made of sound. Music doesn't explain itself in the same way that a word does in relation to other words.

This is one of the reasons why music today, at least in the West, is separate from the other arts. Music requires a particular type of education that is simply not given to most people. And, as a result, it's set further apart. It has a special place. People who are familiar with painting, photography, drama, and dance cannot talk so easily about music. And yet, as Nietzsche writes in *The Birth of Tragedy*, music is potentially the most accessible art form because, with the Apollonian and the Dionysian coming together, it makes such a powerful impression. The paradox is that while music is accessible, it can't ever be totally understood in discursive terms.

Daniel Barenboim: The other challenging notion about music is that it can serve two totally opposed purposes. If you want to forget everything and run away from your problems and difficulties—from sheer existence—music is the perfect means, because it's highly emotional. Music can lead to states of frenzy, as Wagner expected his *Tristan* to produce, or lead to extreme feelings of savagery, as in Stravinsky's *The Rite of Spring*.

The study of music is one of the best ways to learn about human nature. This is why I am so sad that music education is practically nonexistent today in schools. Education means preparing children for adult life, teaching them how to behave, and exploring with them what kinds of human beings they want to be. Everything else is information and can be learned in a very simple way. To play music well you need to strike a balance between your head, your heart, and your stomach. And if one of the three is not there or is there in too strong a dose, you cannot achieve it. What better way than with music to show a child how to be human?

If one observes the great works of music, or even lesser works of music, one can learn to understand many things. Beethoven's Fourth Symphony is not only a means of escaping from the world. There is the sense of a total abyss when it starts, with one sustained note, a B-flat, one flute, the bassoons, the horns and the pizzicato, the strings . . . and then nothing happens. There's this feeling of emptiness, only one note standing there alone, and then the strings come in with another note, a G-flat, and at that moment, the listener is displaced.

I would argue that this sense of displacement is unique. When you hear the first note, you think, "Well, maybe this is going to be in B-flat." In the end it really *is* in B-flat, but by the second note you don't know where you are anymore because it's G-flat. From that moment alone you can understand so many things about human nature. You understand that things are not necessarily what they seem at first sight. B-flat is perhaps the key, but the G-flat introduces other possibilities. There's a static, immovable, claustrophobic feeling. Why? Because of the long, sustained notes, followed by notes that are as long as the silences between them. The music reaches a low point from which Beethoven builds up the music all over again and finally affirms the key.

You might call this the road from chaos to order, or from desolation to happiness. I'm not going to linger on these poetic descriptions, because music means different things to different people. But one thing is clear. If you have a sense of belonging—this feeling of home, harmonically speaking—and if you're able to establish this as a composer, and as a musician, then you will always get this feeling of being in no-man's-land, of being displaced, yet always finding a way home. Music provides the possibility, on the one hand, to escape from life and, on the other hand, to understand it much better than in many other disciplines. Music says, "Excuse me, this is human life."

Ara Guzelimian: In 1999, the two of you collaborated on a project in Weimar, Germany, which had been named the culture capital of Europe, a rotating honor given to different cities. Weimar is a city closely associated with Goethe, and it was on the 250th anniversary of his birth that you brought together an orchestra of young Arab and Israeli musicians, as well as a smaller group of German musicians, to explore possibilities.

Edward W. Said: In a way it was a quite daring experiment. There have been other attempts in the past—I know in this country they've brought musicians from the Arab countries and Israel to play together in music camps and give concerts— but the novelty of Weimar was, first of all, the level of participation at the top: It included Daniel and Yo-Yo Ma. You can't find any better musicians to lead a group like this. Most of the participants were between the ages of eighteen and twenty-five, although I do remember that there was a cellist who was fourteen or fifteen, a Kurdish boy from Syria.

It took a long time to prepare for the event. Of course it required auditions. And surprisingly, at least in some Arab countries, there was a question of whether the governments would allow the students to attend. They did come in the end, including a group from Syria, another from Jordan, one from the Palestinian territories, and others from Israel, Egypt, Lebanon, and maybe one or two other countries.

There was an assumption that this program might be an alternative way of making peace. But I don't think saving the peace process was our main intention. From my point of view, the idea was to see what would happen if we brought these people together to play in an orchestra in Weimar, in the spirit of Goethe, who wrote an extraordinary collection of poems based on his enthusiasm for Islam. Goethe discovered Islam through Arabic and Persian sources—a German soldier who had been fighting in one of the Spanish campaigns in the early part of the nineteenth century brought back a page of the Koran for him. Goethe was transfixed. He started to learn Arabic, although he didn't get very far. Then he discovered Persian poetry and produced the set of poems about the "other" really,

West-Östlicher Divan (West-Eastern Divan), which I think is unique in the history of European culture.

That was the idea behind the experiment. And then, under that aegis, to bring the musicians together at Weimar, which is very close to Buchenwald, the former Nazi death camp. In fact, Buchenwald was *designed* to be near Weimar, which had been romanticized as the city at the very pinnacle of German culture: the city of Goethe, Schiller, Wagner, Liszt, and Bach. So there was a quite daunting, and, I think, impossible, cultural and historical mix. Nobody could fully comprehend it.

An orchestra rehearsal took place every day, in the morning and in the afternoon, led by Daniel. There were chamber music groups and master classes—all of them occurring simultaneously. Here were all these students who had never seen each other before, and at night, several times a week, we had discussions.

I remember the first discussion in particular because it immediately crystallized all the tensions that were in everybody's heart and mind. The conversation started by someone asking the group, "What do people feel about this whole matter?" One kid put up his hand and said, "I feel that I'm being discriminated against because I tried to join a group of improvisers and they wouldn't let me." So I asked, "What exactly happened?" A Lebanese violinist explained, "The problem is that after the program is over at night, usually around eleven o'clock, a group of us get together and improvise Arabic music." I turned to the first kid and asked him to explain the problem. He told me, "I'm an Albanian. I'm from Israel, but I'm originally from Albania and I'm Jewish, and they said to me 'You can't play Arabic music. Only Arabs can play Arabic music.'" It was quite an amazing moment. And then

there was this whole discussion about who could play Arabic music and who couldn't.

So that was one problem. And of course, the next question was, "Well, what gives you the right to play Beethoven? You're not German." That discussion went nowhere. There was an Israeli cellist in the audience who was also a soldier, and he was having trouble speaking in English, so Daniel asked him to speak in Hebrew. He said, "I'm here to play music. I'm really not interested in all the other stuff that you guys are trying to push on us, and I feel very uncomfortable when we get into these discussions, because, who knows, I might be sent to Lebanon and I'll have to fight some of these people." Daniel told him, "If you feel so uncomfortable, why don't you leave? Nobody's forcing you to stay." And he ended up staying.

So there was a very tentative atmosphere in the beginning. However, ten days later, the same kid who had claimed that only Arabs can play Arabic music was teaching Yo-Yo Ma how to tune his cello to the Arabic scale. So obviously he thought Chinese people could play Arabic music. Gradually the circle extended and they were all playing Beethoven's Seventh. It was an extraordinary event.

It was also extraordinary to watch Daniel drill this basically resistant group into shape. It wasn't only the Israelis and the Arabs who didn't care for each other. There were some Arabs who didn't care for other Arabs. And it was remarkable to witness the group, despite the tensions of the first week or ten days, turn itself into a real orchestra. In my opinion, what evolved had no political overtones at all. One set of identities was superseded by another set. There was an Israeli group, a Russian group, a Syrian group, a Lebanese group, a Palestinian group, and a group of Palestinian-Israelis. All of them suddenly became cellists and violinists. I'll never forget the look of amazement on the part of the Israeli musicians during the first movement of Beethoven's Seventh when the oboist plays an A-major scale. They all turned around to watch the perfect performance that Daniel had elicited from an Egyptian student. The transformation of these kids from one state to another was basically unstoppable.

Daniel Barenboim: What seemed extraordinary to me was how much ignorance there was about the "other." The Israeli kids couldn't imagine that there are people in Damascus and Amman and Cairo who can actually play violin and viola. I think the Arab musicians knew that there is a musical life in Israel, but they didn't know very much about it. One of the Syrian kids told me that he'd never met an Israeli before and, for him, an Israeli was somebody who represented a negative example of what could happen to his country and what could happen to the Arab world.

This same boy found himself sharing a music stand with an Israeli cellist. They were trying to play the same note, with the same dynamic, with the same stroke of the bow, with the same sound, with the same expression. They were trying to do something together, something about which they both cared, about which they were both passionate. It was as simple as that. Having achieved that one note, they already couldn't look at each other the same way, because they had shared a common experience. That was really the important thing about the encounter for me.

In the political world today, especially in Europe—I don't want to say anything about American politics because I don't know enough about it—the leaders still behave as if they control

the world, whereas in fact they hardly control anything. The world is controlled by big business and money. It seems to me that politicians display the kind of self-assurance that an impotent person shows in public. Obviously, money can buy a lot of things and, on occasion, at least for a short period, some goodwill. But the fact remains that if conflicts are to be resolved, they are only going to be resolved by contact between the warring parties.

The area that we're talking about—the Middle East—is very small. Contact is inevitable. It's not only dollars and political solutions about borders that are going to be the real test of whether a peaceful settlement will work. The real test is how productive the contact will be in the long run.

I believe that in cultural matters—with literature and, even more, with music, because it doesn't have to do with explicit ideas—if we foster this kind of contact, it can only help people feel closer to each other.

Edward W. Said: One area in which Daniel and I disagree is that we have different views of the history of the part of the world from which both of us come. That is to say, Daniel sees history from a point of view which is obviously different from that of a Palestinian. And in fact there is some value in keeping distinct different views of history without collapsing them into one another, and I think this tension can be healthy rather than unhealthy.

One of my criticisms of the peace process as it's currently being enacted on television screens and at negotiating tables is that, in a way, it's ahistorical. The process doesn't do enough to recognize the histories of the Palestinians and what they went through, and it's sort of amnesiac about the need to understand history in its complexity and detail in order for people to be able to live with that history. To pretend that history isn't important, and that we have to start somehow from the reality on the ground, is a pragmatic political notion with which I simply can't agree as a humanist and as somebody who believes that peoples' histories are complex matters involving ideas of justice and injury and oppression.

I don't think it's necessary that everyone should agree, as long as there's a mutual acknowledgment that a different view exists. That's the important thing. We must have respect for each other's views and tolerate each other's histories, especially because, as Daniel said, we're talking about such a small part of the world. The idea of separating people simply cannot work—it hasn't worked. The moment you start boxing people in, you give them a sense of insecurity and produce more paranoia. In my opinion, you produce more distortions.

It's the same everywhere. You know the story of the Lebanese civil war, which began as a conflict over large areas of territory and, in the end, turned into a fight over individual streets and sidewalks. Where did it lead? Nowhere. So the idea of different but intertwined histories is crucial to a discussion, without necessarily resolving them into each other.

My Grandmother's Suitcase

KARL KIRCHWEY

I threw my grandmother's suitcase on the dump
 with something like anger, finally shut
of its calfskin, freckled with mold, its blush and imp
 of mildew. Now the sky could work on it:

that lens of blue, pale as my grandmother's eye,
 above a half-starved covert of trash saplings
regarded the flayed carcass where it lay
 amid a broached convolvulus of bedsprings,

a smashed tear-stained cheek of vitreous china,
 and two nude headless dolls to gossip over
her half-century's grief for the pilot son
 lost at twenty-two off the carrier.

Letters, medals, newspaper clippings, dust:
 I emptied it all out. "Why seek ye the living
among the dead?" Now decently at last
 that scorched trapezium of remembering

might fill with autumn rains and lustral snow
 and so recede to earth and its few salts
after an interval. Tooled fawn askew,
 gaping like a jaw, it seemed to cock at

the gentle slope of self-heal and wild asters
 where we made love when she was eight months gone.
I stared into its blank, flesh-eating face
 and knew that nothing would be forgotten.

The Lake, Part III

The sun strikes wet tobacco leaves,
Names fade to yellow, mulberries
Fall to the cracks of time,

LEVENT YILMAZ

Judas trees shed blossoms, the brute
Cold, dragged by ruthless breezes, brings
Its lifelessness to life, before the storm dusts it;

Punishment for ignorance of time is death.
The house of stone has become a hive to bees,
Hope and bruised cherries have filled its well.

Why are the eyes of the child inside wet?
Crouched in a damp corner, he sighs,
Has he forgotten his name, can't he hear the voices?

A stone is tossed onto the roof, the bees swarm,
Running toward the lake, water hides the fear,
Don't get caught, escape the "you" chasing you.

The sun alone proves there's no rationale,
Being deceived is scalding: *I'd found you once, where are you now?*
I've taken to the roads where you lost yourself.

How could we be reunited? I stitched question to question
Then shredded the cloth and the cover, too. I hoped:
Would the essence buried deep reveal itself one day?

How I slaked my thirst with my fill of water, how
I'd staggered and fallen . . . Now I'm watching
The world from a corner, I remember those words,

That I didn't hold, didn't imagine I could hold,
Those bent, misshapen, contorted, forked words which
Sent me north, wore me out, and made me seek love in a stone.

They were a digression. I spent an entire day staring at a tree,
As the light changed it into another tree with each passing minute,
It was a different tree forming in stone, one I'd never seen.

Everything was beautiful as it transpired, and love was alive,
Then it became a rose, then moonlight, and as
We lost ourselves in blue waters, a dead star.

Smirk at those who seek "you" in you; look:
If the moths drawn to the branch where the lantern hangs burn,
You think we're immune? As a child, hopping toward death,

As the tree ingrained in your mind faded, your eyes teary,
As your heart singed, the well water was yet cool,
Drink up, it was poisoned long ago, but we're happy now . . .

Will winter forever stay winter, as snow filters the light,
Will our eyes glint; if the forgotten world is
The forgotten country, where will the words leaving our tongues go?

If the word is resurrected again, if joy is again
Engraved on stone, let it be made law that apprehension
Belongs only to the night, let the rocks fall quiet

Let the heart speak, with words beyond language,
With words distilled from voices, if another tone
Rises, a cry, let all fall silent, let love be mute.

Approach the shore, walk across the sand, see the sunset:
Your trace will be washed away, the waves will carry
Away the "you" you once were, and absorb it. There,

At that time, you'll be overtaken by a great language, and fall silent,
And be swayed, you'll do what you have to do,
You'll walk without turning to look back.

They've presented you with such a world that you won't think
The one you've lost was "you," in a garden where acacias
Shade time, on a stone warmed by the sun, there,

See how the cat naps and dreams an amber dream,
Sees a scene in agate; but its own fate has already been set,
The animal will always be itself on this path, strong.

Would you know or recognize the hard breathing of one
Climbing a mountain? At the summit, would you know the sound of the pressure
One experiences, the way it tears at the ears and constricts the chest?

Before the climb, you remembered the conquerors of old,
They were the masters of worlds you know:
Two worlds? Both love and stone? How could one master them?

You thought you were climbing, you were descending,
The real mountain is the inclination of the heart,
Is what lies below even real? Is the world a vista or a picture?

After you catch your breath, and see that the stone house in whose corner
You cried is destroyed, realize that the cherries and mulberries
Filling the well in your inner world were each a letter, a tone, a voice . . .

The bird flies to the vines, to the burning knowledge,
The grapes are being pecked; what remains of the fear hiding
At the lakeshore, which can be seen through the holes in the cloth: Nothing, nothing . . .

When you read, they said, think about the self not existing,
I was the reflection, and I was the scared, thin ghost at the summit
Of the distant mountain; now, let's turn back . . .

With burning roses, to the lakeshore, to love . . .

Translated from the Turkish by Haydar Dilaçar

FUJIKO NAKAYA

ABOVE:

Fog Tree, detail from *Fog Sculpture #94768*
(*Earth Talk*), Sydney Biennale, 1976.

LEFT:

Cloud Installation #72503 (Opal Loop)
(collaboration with Trisha Brown),
Brooklyn Academy of Music, New York, 1981.

ABOVE:

Cloud Installation #72405 (Cloud Lake),
11th National Sculpture Conference,
Washington, D.C., 1980.

LEFT:

Fog Environment #47660 (Foggy Forest),
Showa Memorial Park, Tokyo, 1985–92.

Fog Sculpture #08025 (F.O.G.) (with Yves Klein fire fountains in foreground), Guggenheim Museum Bilbao, Spain, 1998.

I originally called this work *Fog Sculpture #08025*. Zero-eight-zero-two-five is the international code for the Bilbao weather station. My fog sculptures usually have titles that are more descriptive, like "Earth Talk" or "Foggy Forest," but I knew so little about Bilbao that I just couldn't make any special name for this one. Then, one evening, Bob Rauschenberg asked me, "Fujiko, do you know what Frank Gehry's middle initial is?" And I did know, because Americans say Frank Gehry, but in all the Japanese architectural books his name is written Frank O. Gehry. I said, "O," but I didn't make the connection. Bob said, "F-O-G." I still didn't catch on. "FOG!" So it's nicknamed *F.O.G.*

F.N.

Fujiko Nakaya

Conversations with the Wind

Fujiko Nakaya was interviewed by author Julie Martin on November 21, 1998, in Bilbao, Spain, where Nakaya had recently completed a fog installation for the opening of Robert Rauschenberg's retrospective at the Guggenheim Museum Bilbao.

I made my first fog sculpture in 1970. Sometimes I call them cloud sculptures, but more often I call them fog sculptures. Fog has a bad image, like smog. You can't drive; airplanes can't land. In fact, the Bilbao airport was fogged in when I arrived— we couldn't land, and I thought, "Somebody up there is very jealous." It was also a good sign for me, because if natural fog forms, then there's enough humidity for a fog sculpture. Anyway, fog is always interfering with our lives; a lot of scientific research is done on ways to disperse it. We're always doing that with our environment—trying to conquer it. Clouds have a nice image, so calling something a cloud sculpture isn't such a challenge to people's ideas. I want to change the image of fog. Instead of thinking, "I can't see the beautiful scenery because of the fog," maybe someone will think, "The fog is so beautiful on the mountain."

Three weeks before the opening I was having dinner with Bob Rauschenberg, and I showed him postcards of my recent work. He said, "The next time you find a good place for a fog sculpture, just tell me and I will commission the work." After a moment he asked, "What about Bilbao?" He told me about his retrospective exhibition and said that a fog installation might be a good event for the opening. Then he asked, "Could you do it in three weeks?"

I usually take about six months to prepare—to study the wind. Fog sculptures are always threatened by wind, but I'm interested less in how to control the wind than in how to negotiate with it. My role is to design a landscape that interacts with the wind, to create a stage where the fog can perform.

In fog, visible things become invisible and invisible things—like wind—become visible. Air looks as if it is empty, but there is so much going on in it. Often I try to design a microenvironment for the fog to behave at its best—to dance with the wind. So I study the area carefully, and if the wind is always blowing in one direction, then I add some obstacles like trees, or shape the land surface so it will create turbulence when the wind hits it. If the sun shines on a stone, heat from the stone will create an updraft, and the air currents will become more complicated and interesting. By placing a stone surface in the middle of a grassy area, you can create a fog fall or a fog lift. It's a way to have a dialogue with nature. We've been using nature too much, and now it's time for nature to speak up.

It is very Japanese to copy nature. My father, Ukichiro Nakaya, made the first artificial snow crystal. He used to say, "You must listen to ice if you want to learn about ice." He always said that you have to be humble, surrender to nature in order for nature to speak. Observation is very important. And being truthful.

Before coming to Bilbao, I didn't know where I would put the sculpture. I collected all the photographs of the museum that I could find in Japan and studied them. I was rather overwhelmed by Frank Gehry's building—it was so impressive! I knew I couldn't make a fog sculpture in relation to that architecture;

it's so strong that whatever I did would look tacky. I already had the idea that the nearby lagoon would be a better site; there is more humidity for fog where there's water. Then, when I arrived, I saw that beautiful arched footbridge over the lagoon. It was perfect—it might have been made for a fog sculpture.

I still had to think about the number of nozzles I needed to install, and where to place them. I use high-pressure pumps and jet-spray nozzles. Pressurized water comes out of a tiny hole in the nozzle and hits a needle positioned above the hole. The water breaks into small droplets twenty or thirty microns in diameter, which is the same size as those in natural fog. I have to think about the direction the nozzles face as well, because the pressurized water creates quite a bit of wind.

I usually build a model of the area and do wind-tunnel tests; in Bilbao, there wasn't enough time for such a test, so there were some surprises. When the air was still, the wind created by the nozzles brought the fog forward over the lagoon until it achieved a balance with the outside air. Then it stopped and seemed to hesitate over whether to go ahead. Usually, at this point, evaporation took place and ate up some of the fog's mass. You could see the fog's shape change as its humidity interacted with the outer air. If the fog mass reached the museum building, it would bounce back and start to build up. I had already established the fog's route, so the more I fed it the higher it built. When it reached a certain height, it lost its balance or was blown by the wind, and then it really changed shape. It was much more of a performance than I had expected.

At another point, the wind was blowing and pushing the fog in the opposite direction. I had been thinking of blocking off the opening between the river and the lagoon, so as not to lose the fog. But nature does it better, and what happened was very nice—the river filled up with clouds. I realized then that I shouldn't worry so much, that I should let the wind speak louder.

F.N.

Fog Sculpture, Pepsi Pavilion, Expo '70, Osaka, Japan.

Peaches

KYOKO UCHIDA

Afterward, you fed me peaches
cut into cold quarter moons and
tart, not yet ripe. You were late
for my appointment because you'd
stopped for them on the way, three
small peaches, the first of the season.
Later you wondered why I was
bruised like bad fruit, my arms
raw, stained wine and violet where
the needles had gone in, hip bone and thigh
where they had not. You who loved
the story of the boy who leapt in full armor
out of a peach, came floating down the stream
to an old woman washing clothes.
(Japanese were always finding children
in peaches and bamboo, but they all left,
crossing the ocean or riding to the moon.)

You peeled quick crescents and fed me
by hand, the sharp scent of what is
not yet there. I opened my mouth
in penance. You'd chosen them for me,
touched each one in its turn, weighed them
against your wrist, considered their
blush and curve. In your palm they'd
smelled easy, warm as a kept promise.
You'd held them as you'd held me,
swollen, each one a late moon turned
sour, too early to tell; as you would later,
when I'd grown thin from staring.
Now you cut them open one by one,
with a knife, out of love.
But no child appears, only
blood and the hard, bitter pit of it in
my mouth, which you are careful to remove.

Motion

They were wound on a wooden spindle, which couldn't be seen because
of all the laces. Then we would slowly turn it and watch the designs unroll,
and we were a little frightened every time one of them came to an end.
They stopped so suddenly.
 —Rainer Maria Rilke, from *The Notebooks of Malte Laurids Brigge*

You are surprised at how easy it is, this
breaking away as you must think of it, nearly sorry for being
in motion so soon past our own departures, our ends.
Perhaps you'd imagined a heart's
old gravity, its wound ribbon white, unraveling
only at the speed of grief: small turnings
evenly arcing. You forget that bodies in motion tend to
stay in motion, repeat themselves like the fine, patient
weave of lace until they lose themselves. For years
together we'd been traveling here in circles,
unknotting ourselves from each other.
We'd been gaining momentum the way we'd gathered
place names on maps, long hours of highway or of
wine or getting dressed, matchbooks, used books, recipes,
lies, and each other's hair in our fists as we slept.
Even the earliest slow morning loops back, spirals
away from a center, opening and opening again its pale-
butter light, fast toward the next time we touch or cannot:
for we must always leave ourselves behind.
Now you find yourself arriving where you'd been
headed all these years, the new white lace, the ribbons
gathered thick and spinning in your open hands, and
at the end of it, someone else.

Taking Your Shoes Off

In Japan, when jumping
off a bridge or tall building, not expecting
to return, it is customary to take off
one's shoes, as when entering any other
private dwelling, a school or shrine, so as
not to track in the dirt you've collected,
carried so far, only no one will bring you
slippers this time. Always point your shoes
in the direction you'll be headed in
when you put them on again, toward
the door but only if you are leaving.
There is no need otherwise
for ghosts here have no feet.
On a sharp cliff off the Pacific known as
the Cape of Grief or Writhing Feet
pairs of shoes are found each spring
like misshapen crocuses unable to survive
through April. Every time I see
a single worn sneaker limp by the curb or
workboots unclaimed against a lamppost
down Sixth Avenue, I hear doors opening ahead of me
on the sidewalk, on every unlit street and fire escape,
each one an exit accidental or not,
these hundreds of exits opening onto nothing but air.

OPHELIA
TERÉZIA MORA

I SWIM FIFTY WIDTHS. That's nothing, shouts the woman who cleans the pool. Last year there was a girl here who swam fifty lengths. The cleaning woman is fat as a Buddha.

The pool is twenty-five meters long, twelve across. The lengths are too long for me. I just started swimming this summer. After swimming fifty widths I take a rest. I float in the water, spreading my arms. That's nothing, shouts the cleaning woman, but I don't listen to her.

The master named me Ophelia. I had to call him master. Ophelia, said the master, what are you doing? Is that all you can do?

The pictures I see are always changing. Facing up they are orange, yellow, and then green and lilac, like the sun, like fiery ovens and flecks of flame. Face down they are everything I want them to be. Silver letters on a black surface. Buildings, streets, and animals that don't even exist. I lie face down in the water. I hold my breath: one Mississippi, two Mississippi, three Mississippi, four . . . I float. Still. The water seeps into my ears, pushing and holding me away from the sides. My arms and legs are like aquatic plants. I watch my heart beat beneath my bathing suit. I hear the bubbles of air ascend from my mouth to the surface, where they burst in tiny circles. Their waves scratch lightly at the side of the pool. The wind touches them and they descend into the drain, back into the pipes, gurgling down into the passages and pipelines of the underworld. I see them: silver traces on a black surface. They leave me behind. The floating sensation contracts, flowing out of my fingertips and back into my chest. The last air bubble ascends from my

Adam Fuss, Ark, 1989.

75

mouth. I turn to watch it climb to the surface. Behind closed eyelids the sky is red. Cool. I breathe out. It hurts a bit. Ophelia, calls out the master, but I don't hear him.

A tavern, a steeple, a sugar factory. A swimming pool. A village.

Low, two-eyed houses, green doors, and behind every door a mutt on a chain. The chains are of different lengths. Steady rain for ten months, wind and the smell of molasses, soot from the factory falling on laundry. The rest of the year is white summer, powdered sugar winds, and molten asphalt. Early in the morning, on the way to the swimming pool, I walk across it barefoot. At the end of the road a quick look around and then under the crossing arm, taking the shortcut across the railroad tracks, passing the train station with its green-white-red geraniums, lifting my knees high as I step across the oily gravel. Slender in the early morning light, my shadow bounds spryly over the rails. A stick man with knobby knees. The tracks fork before and after the village, but there is just a single pair of rails here, and only two trains a day as well. The wires beside the rails hum. I think of the current and lift my knees high. Shadows of my hair float like wings around me.

Pebbles in your pockets, the master always says to me. Otherwise the wind will blow you away. He could wrap two fingers around my ankle. You should learn how to fly, Ophelia, not swim.

She is too weak, said the nurse when we moved here. She touched my cheeks, eyelids, calves, and chest. Some exercise would do her good.

A tavern, a steeple. I forgot the soccer field. Square beside the pools, surrounded by a perfectly square row of poplars and a wall. One has two soccer goals and one has two pools—one warm, one cold—in perfect squares of grass. Over there the boys go from goal to goal, and here I go from wall to wall. Widths. Early in the morning I'm alone with the master.

A village. A swimming pool. It surprised me a bit at the time.

They dig for something more valuable and find water. It comes up yellow from beneath the moor, smelling of sulfur, chlorine, salt, and carbonic acid. Hydrogen. Temperature—105 degrees. It heats the pool and flows through the pipes below us, then through the greenhouse next to the pool. Fleshy green

leaves press thickly against the low windows. When the pool is cleared for a break the villagers press their faces to the glass. Strange blossoms breathe from within, leaving the glass wet with moisture.

Sulfur, chlorine, salt, carbonic acid. I never go in the warm pool. The master has always said it isn't for people like us. They say he's a drunk, but so far he has managed to teach all of them how to swim. In the second pool is tap water. Temperature—fifty-eight degrees. That's where I swim my fifty widths. Early in the morning the air is cold. My body feels tepid, then hot. No pain, no gain, Ophelia, says the red-faced master beside me. He sits, his beer bottle resting on the side of the pool. Best beer on the continent. Brewed with our water. Now I know why it's so yellow. You don't know anything, Ophelia. Be careful not to swim under me. You'd be better off keeping your trap shut in the pool. Fifty widths, but fast. His feet hang in the water, I touch the wall beside them. The last drops from the bottle fall onto his tongue and he draws them into his mouth. Take a little break now, he says, I'll get another beer. He goes.

I float with my red eyes facing first to the sky, then to the bottom. I am light and hot. The water carries me. Cool.

Shit floats. That's what the nurse's son said to me. He is tall and as white as she is. He climbs over the wall with the boys. He is my enemy.

Like that, he says, pressing his thumb and index finger together. I could crush you like that. Bits of apple ooze from between his fingers, a pulped mash. He sucks up a piece with his lips and chews. Like that, he says. You know why? Because you are fascists. That's why, he says, pointing his finger at me.

In history class everyone turns around and stares at me. The teacher explained it quite simply: Anyone who speaks the way we speak in my family is a fascist. Anyone who is tutored by my mother is learning the language of the enemy. She would know, says my mother. And: Think nothing of it. We're the only foreign family in the village, if you can even call us a family. Three generations of women, they say, and all divorced to boot. They're probably communists, or not Christians in any case. They talk funny and don't pray. They turn to look at us, completely silent.

It's quiet here, said my mother when we came. We need that. A tavern, a steeple. And a swimming pool for the exercise.

I walk barefoot. The asphalt is soft, little pieces cling to my feet. Priests, teachers, and the women who work in the post office are always to be greeted first. That's what my grandmother said.

By mistake I say hello to the priest in our language. He understands it anyway and stands over me. He asks me why I don't praise him, instead of just saying hello. I stand before him, my bathing suit foreign and lilac, his frock heavy and black. Can he swim? His white body with black hairy arms and thin calves in the water. Topped with a bald head like a buoy. The asphalt cooks under my feet, the sun above me all white. It replaces the priest's head on his neck, and his neck is no neck but a collar, a collar on a frock. And for that I'm supposed to praise him. He presses the matter.

I don't understand, I say in our language. Hello.

The sound when my feet tear away from the molten asphalt. And then a bit less with each step. Faster, Ophelia, yells the master. My blackened feet hit the water. He grins. Well done.

My bathing suit is foreign and lilac. I'm alone with it in the cold pool. The master taught them all swimming in vain. The village prefers the sulfur bath.

They come with the whistle, in a haze of powdered sugar, running out of the factory and across the railroad tracks, their short evening shadows trailing. A quick hour in the brew, before the pool closes. And then Sundays after Mass, perfectly quiet. The pool is cleaned on Tuesdays and Thursdays. By the time they arrive I have fifty widths behind me. Without uttering a prayer. You will all go to hell, says the nurse's son, and tests me with the matches to prove it. Only God-fearing people can light red-tipped wood matches on black surfaces. To make it more difficult the boy dipped them in the water.

In sulfur, salt, chlorine, carbonic acid, and hydrogen.

They all sit in it. The water is good, like chicken soup. It has the same color and taste. The smell wafts over from the factory cafeteria. Thin, light soup. Around here, people drink it like holy water.

After Mass on Sundays, they picnic by the side of the pool. Fried chicken, dill pickles, quince compote. The men shake hands lightly, touching each other on the fingertips. They won't get out of the water for anything. One big happy family in a family tub. All of them in the factory, all of them at Mass. In the evening the children go shopping with net bags. Beer bottles poke through the net. Why not yours? asks the boy, my enemy. Why do you have to be different, not going to church, no beer, never in the tub, fifty widths. Always working, always better.

Breathe, Ophelia. That's what the master always says to me. You have to breathe, otherwise you'll poop out. Can't you see how I do it? Gulps of air from the sky, exhale below. As deep as possible. Go now, fifty widths.

The water in the swimming pool is azure. It's azure because they painted the bottom and walls azure. Every day more paint peels off and sinks to the bottom. The pool sheds its skin, the jagged edges of its abscesses pierce the soles of my feet and the tips of my fingers. But I still swim from wall to wall as if it were a race. Careful, I'm watching everything you do, Ophelia, not a foot short, hands and feet touching the razor sharp edges diligently and then back again. And afterward running on my heels, bloody toes up in the air, my blue fingers hanging beside me. The boy, my enemy, is waiting with the matches.

You're an idiot, I say to him.

I know from mother that the nurse's son has no ear. He can't learn languages. The words get all garbled in his mouth. We laugh about it. Conceited, says the nurse, her face contorted as she measures my breath by the liter. Pathetic, she says. Really pathetic. It's no wonder these women are alone.

If that's it just tell me, says the master. I'll marry your mother. She doesn't care for men, I say. Then I'll marry your grandmother, he says, she's better for me anyway. Same problem, I say. That's why we're here. Five hundred souls, a village. Where there's no choice there's no disappointment. Then you, Ophelia, says the master with a laugh. Join the crowd, I say.

My bathing suit is foreign and lilac, my feet are covered with blisters and tar. A man gives me a ride on the crossbar of his bicycle. I hear you're a champion swimmer. Somehow he manages to brush my arms and thigh with his knees as we ride. He goes slowly and is careful not to let me fall. When I get off he wants a kiss.

That old queer, says the master. And as for you, he says to me, you're an idiot, Ophelia. Let's go. Swim. Extend your legs.

Before he pushes me off, with one hand beneath me, he presses his thumb between the cheeks of my ass, long and deep. One more time, he says. Again. Remember, extend your legs. Slow and deep.

You drunk old goat, screams the woman who cleans the pool. She has the girth of a Buddha. She sits, her body sits, in an apron covered with flowers, under an awning in the sweltering heat. The overripe apricots she sells are rotting in front of her on the grass. She screams at me. Her voice cuts right through, I don't think she likes me. And yet somehow she belongs there. She is so big and loud that you can't overlook or forget her, you just have to stare at her, at the plump body that constantly emits heat and the smell of sweat, nylons, and apricots. And her elbows, these two chapped spheres in the middle of her arms, black like the tar on my feet. It was from this woman that I heard the word *bodymilk* for the first time. Come here, she screams. What do you people speak? Croatian? I tell her it is German, and she shouts: At least that's a decent language. Unlike the language my children have to learn. Russian—the language of the enemy. For me, *Mir—eta nadezhda narodov:* Peace is the hope of all peoples, I think. Then Buddha with the girth of a cleaning woman assures me that she doesn't have anything against foreigners like us. Thanks, I say, but I'm not one. Oh well, says Buddha, and laughs.

Maybe we should do it, says grandmother. Like the others. The badge under the collar. And above all speak the language of the enemy. The sugar-beet silo is light blue, the steeple canary yellow.

The priest stands in the middle, two large wings glued to his shoulders. The wings are gold and white. Seven altar boys in robes. They sing like angels, from throats like ovens, loud as molten iron. It emanates from them, resounding

ore, and then blows away, across the heads of the old women cloaked in black as they seek to step in the river of angelic breath, to be carried away, perhaps to heaven.

I float.

Grandmother still remembered a lot. Like how important people in the village are to be greeted, which she learned as a child. But the words get garbled in our mouths, we don't know the prayers. Beneath the canary-yellow steeple they all turn and stare at us.

To hell, says the priest, you will all go to hell. In front of him and his wings there are two golden angels. They're made of copper, with wood rods rammed in their backs to hold them up.

The sacrament of heaven, says the master softly. Why do you go when you don't have to? You should be happy to be a communist. But I'm not one, I say. It doesn't matter, he says, it's all the same.

Mother says no. We tried, what more can we do. There may not be freedom of assembly here, but there certainly is freedom of religion. And freedom from religion as well.

The priest gave the tallest altar boy on his right, the one with the angelic blond curls, a red bathing suit. So they say.

Hhhh, on-n-n-e, two-o-o-o, hhhh, on-n-n-e, two-o-o-o, hhhh, one, two. And take in air like the master. His big red mouth. He grimaces as he gets out of the water. Gulp air out of the sky. That's what I do too. Gulp it in from above and breathe out below. From heaven to hell.

The smell of rails, oil, and sugar beets wafts in through the poplars. The factory is only two steps beyond the tracks. A cloud of sulfurous steam hovers over the warm pool. Just twenty minutes to anesthetize the heart. Here they sit in it for days. They won't leave the water for anything. Beyond the wall, the voices of boys; from the houses, the hoarse howling of dogs. When the boys aren't playing football they torture the mutts. They pester them until they strangle themselves on their chains. There's a new one every month. Sometimes it goes quickly, other times it lasts for weeks. The chains are of different lengths.

The water seeps into my ears, I don't even hear what happens in the village. I listen to my breath. Its length varies from wall to wall. My arms rise again and again, strong. The sky creeps along with me. For the last ten lengths I finally turn from my back to my stomach and crawl. Just ten more, then nine.

Breathe, Ophelia, the master says to me.

One Mississippi, two Mississippi, three Mississippi . . . four. Hold a breath. The tap water is fifty-eight degrees, but it warms up quickly. The water level in the swimming pool is not consistent. On the sides, the water sloshes through slits the width of a child's arm, down into the extensive labyrinth of pipes, covered by the same blackish yellow, sulfate-encrusted stone that covers the sides of the pool. Yellow like piss, says the master with a wink—that's not for people like us. When I float I can hear the water moving in the pipes. I know where they are beneath the pool, their ducts and conduits pushing up through the slits. Facing down I see them clearly, a yellow network on the black surface. I flatten my body until I'm like a figure in a comic book. Inconsistent water level. I slip through the cracks with it.

Buddha is screaming at me. Finally, she screams. I thought you would never come. She is standing in her apron beside the pool. I kick past her, the round cover of the drainage pipe above me. Oh, I say, how do I get out of here. Like this, says Buddha, pointing with her mop to the drain. Suddenly I'm standing next to her. I cling to the edge with my blistered toes so as not to fall in. The group of boys comes by. They swim on their backs in the yellow water, waving to us. Buddha laughs and waves back. So, she says. The boy, my enemy, is there too. He waves to me, laughs, and turns his face down, as if into a pillow, in the water. Air bubbles ascend for a moment, then no movement. The boys come through under the wall. What is out there? I ask the woman, fat as a Buddha, beside me. You know what's out there, she says. Rewards. Life. But they drown, I say. Yes, she says. Here they drown and outside they live. Now jump. My knobby knees shake on the side of the pool. Below the boys flow away. Motionless, under the wall. That can't be water, I think. It must be poison. You don't have much time left, says the Buddha beside me. I can't jump, I say. I never could. The master is disappointed with me. I can't compete because I can't dive. Oh well, says Buddha, and begins to mop up. There's no law that

says headfirst. My toes wrap around the edge. I watch the last of them leave and whatever it was down there—water or poison—slowly dry up. That's how cowards break their necks, says Buddha. She walks away and leaves me standing there, alone on the side of the pool. I want so badly to drown like the others, but I can't.

You're a weakling, Ophelia, says the master. I wouldn't have expected it of you. I taught you, after all. Now get me a beer.

Ninety-eight, ninety-nine, one hundred Mississippi. Holding your breath is important. Suffocation is the worst way to die. I open my eyes: chlorine red.

Like that, said the nurse's son, as he held the mouse's head under water. Its front feet thrashed the water, back feet, the air. Only its head was submerged. A puddle of water is enough for a rat, said my enemy. When it was dead he dropped it. It floated toward me in the middle of the pool.

Nights in the village are louder than days, and almost as bright. Light from the sugar factory filters through the acacia leaves and into my bedroom, making shadows on the bedcovers. The dogs bark into the morning. The boys thought up something new for the mutts—a pipe that sounds like howling wolves when they blow into it. It drives the dogs crazy, they gnaw at their chains. But recently there has been a stop to that. They're more cautious after what happened to the master.

No time for you, Ophelia, he said. He hobbled along with a case of beer. I have an important guest. The master's guest is said to have been a famous platform diver, and the master dove himself—from the starting block into the cold, azure pool. The sugar factory is just two steps beyond the railroad tracks, its lights behind the poplars cast wavy shadows on the sides of the pool. Excuses, excuses, said Buddha to me afterward. The old goat was drunk, he had no idea where he was. It was Tuesday night, when the pool is cleaned. There was a foot or so of water on the bottom when the master dove in headfirst. He had simply forgotten that it was Tuesday, just as he had often forgotten me. So I swam alone. They say the platform diver survived it. They also say he won't be back. The drunk old goat, says the cleaning woman. I wouldn't take him back either.

I take myself back. I float. Flat like a figure in a comic book.

The first night the boys make the wolves howl I go to the swimming pool. The knees lifted high over singing rails. The shadow of my hair jumps lightly over them in the moonlight. I climb over the wall.

 The square of poplars, the grass border, the sharp rim of the pool. Dangerous, blind. I put my finger in. It feels too light, too silky to the touch. A blanket slipping from feverish fingers. I pull my hand back, not daring to go in. The wind rushes over the mercury, poplars, and grass. I smell it again: powdered sugar and cold chicken grease. It comes from the village, where—I can hear it—they're hunting the dogs, the wolves, the boys. I put my foot in the brown ripples of the warm pool. The water like a thorny ring around my ankle. My skin burns. Little pieces can be seen swimming in the moonlight. Salvation. Holy water. I pull my foot out again.

You are fascists. And communists. I will kill you, says my enemy.

 Your mother has something going with the priest, I say. I heard it from Buddha.

 He grimaces. I promise, he says. If you ever set foot in the swimming pool again.

A tavern, a steeple, a pool. Where there's little choice there's little disappointment. The water is good, like chicken soup. Sulfur, chlorine, salt, carbonic acid—they all sit in it Sundays after Mass. Twenty minutes to anesthetize the heart. The sulfur crowns their heads with steam. Their limbs are slippery and white, the deposits covering them yellow. They sit close together and touch each other underwater. The spring belches from the pipes. They stand beneath the stream, feeling the lashes and screaming with happiness. The priest isn't there. He has his own tub. I am alone in the cold pool. I turn onto my back and listen: The waves scratch lightly at the side of the pool and fall back into the pipes. I hear them. I hear my heart beat, locked into my head. I breathe out into the sky. Beneath my eyelids: red.

And then the water covers my face, cold and black. I warned you, says the nurse's son. My tarred feet beat the water, I writhe on the surface. There can't

be more than a foot of water above me, but it will do for a rat. Air bubbles rise from me and are crushed by the boys. Water seeps into my ears. I hear the waves squeal at the drain. Why am I not sinking majestically into the sea, as in my dreams? I kick the slippery bodies. Strength fades, drawing back into my chest, into my heart. My arms and legs fly away from me.

There is one dream I did not tell the champion before his leap. I was lying on the bottom of a lake looking up. From below the water was fresh and clear, and I could see them from inside out. They stood over me looking down, but they saw only themselves. She's dead, they said, and left. I went on lying there, on the marmalade-soft bottom, breathing. But it was only a dream.

The water keeps me far from the village, from the noise. The boys gone, the sounds slipped up and away. It is black and still. Silver signs on the black surface. Houses and animals that don't exist. I'm alone. Early in the morning, late in the evening. The water envelops my body. I sink, I float. Ophelia.

Here you drown, outside you live, says Buddha. Headfirst. With a tentative knock you land on the sky-blue bottom. First the skull, then the knees. And then the ankles. No law, but the freedom of instinct. I push off. I break through. The air sharp, painful as first breath. Snatched from the sky.

I'm dripping at the feet of my enemy. With pain in my chest I say to him: You're too stupid to pull that off.

He watches me go barefoot across the molten street. Perfumed with powdered sugar. Weak and thin in the white sunlight. Soon I'm just a faint figure in his eyes, hovering above the asphalt surface.

And mother says: You shouldn't have frightened him so.

Translated from the German by Daniel Slager

The Devils
(after Dante)

We gawped into another crevice and overheard
In the astounding blackness futile lamentations:
As when in a shipyard they boil the sticky pitch
For caulking leaky boats in wintertime, some
Building new boats, others repairing wear and tear,
At prow and stern hammering away, carving oars,
Twisting ropes, patching tattered jib and mainsail—
So in the sheugh beneath us the adhesive tar
(Ignited by God and not by ordinary fire)
Bubbled up and plastered the banks on every side.

While I was watching the bubbles puff and peter out,
Virgil yanked me to his side—"Look out!"—and I,
Like one anxious to see what he's escaping from,
Scared stiff and glancing backward and sprinting faster,
Saw hotfooting it behind us along the ridge
A black devil, bloodcurdling his face and movements,
His wings and feet bloodcurdling. Across pointy shoulders
He lugged a sinner by the thighs, hooking his claws
Through the heel-tendons of a councillor from Lucca,
An elder. The devil gave orders from the bridge:

"Scrotum Hook! Push him in while I go back for more
Of the same to Lucca, capital of racketeers
(Except for Councillor Borturo, of course) where
Backhanders turn a 'yes' vote into 'no.'" Before
Launching himself from the rocky ridge (no watchdog
After a burglar could move faster) he flung him in
And the sinner sank, then bobbed up like a crucifix
Making the devils under the bridge make fun of him:
"No Holy Face here to help you! Here it's different
From swimming in a river like the Serchio! So,

MICHAEL LONGLEY

"Unless you want to feel our grappling hooks, don't show
Your face above the surface, don't come up for air!"
They punctured him with a hundred pitchforks, screeching:
"Dance your shady dance in darkness, out of sight,
Picking pockets and pilfering in the underworld!"
They were like cooks showing their scullions how to poke
Down meat in a stew to stop it floating on the top.
Virgil instructed me to hide behind a boulder.
"And don't be put off if they have a go at me.
I've been here before. Trust in my experience."

He crossed the bridgehead to the sixth embankment
And put on a brave face. With the hullabaloo
Of a pack of dogs attacking a down-and-out
The moment he starts to beg, from under the bridge
They swarmed and swung their grappling hooks at him.
"Behave yourselves! Before you start goring me with gaffs,
Would one of you step forward to hear my case, then
You can have a fair debate about impaling me."
"Go on, Rancid Arse," they screamed, standing their ground,
Muttering to themselves: "What good will this do him?"

"Do you think I could have got through your defenses
Without God's intervention? It's destined that I
Accompany someone else down this godforsaken path.
So let us through!" The devil despite his bluster
Crumpled and dropped his pitchfork with a clatter.
"No one lay a hand on him," he told his colleagues.
Virgil shouted at me squatting behind the boulder
That it was safe to join him. I made a dash for it
But the devils darted forward to threaten us.
I was terrified they'd go back on their promise

(I once saw soldiers at Caprona during a truce
As scared to be passing among the enemy)—
I snuggled up to Virgil and kept my eyes glued
On those malevolent faces and prodding pitchforks.
"Shall I jab him in the arse?" "Yes, stick it up him!"
As one broke rank, so the others egged him on
But the devil who was parleying with Virgil
Spun around and shouted: "Easy there, Stubble Skull!"
Then to us he said: "You can go no further here, for
Far below us the sixth arch lies in smithereens.

"If you must keep going, then walk along that cliff
And you'll come to a bridge you can get across. (Five
Hours later than this time yesterday, one thousand
Two hundred and sixty-six years ago Christ's death
Pulverized this path.) I'm sending a squad that way
To make sure no sinner's bobbing up for air. Buttock
Head, Dog Itch, Dragon Spit, Winkle Nose, Earwig
Bite, Moldy Belch, go and check the boiling pitch—
And chaperon these two poets to the next bridge
That stretches unbroken out over the abyss."

"Let's go without an escort, if you know the way,"
I begged. "If you're as eagle-eyed as you usually are,
You'll have noticed them grinding their teeth and how
Their eyebrows threaten us with torture." "Don't panic!
Let them grind their teeth if they like," Virgil assured me.
"They're doing it to scare the wretches down below."
But wheeling to the left along the ridge, the devils
Went on grinding their teeth, sticking out their tongues,
A signal to their leader who farted a fanfare
By making his arse-hole a trumpet (or trombone).

The Pheasants

As though from a catastrophic wedding reception
The cock pheasant in his elaborate waistcoat
Exploded over cultivated ground to where
A car in front of our car had crushed his bride.

I got the picture in no time in my wing-mirror
As in a woodcut by Hokusai who highlighted
The head for me, the white neck-ring and red wattles,
The long coppery tail, the elegance and pain.

The Painters

John Lavery rescued self-heal from waste ground
At Sailly-Saillisel in nineteen-seventeen, and framed
One oblong flower-head packed with purple flowers
Shaped like hooks, a survivor from the battlefield.

When I shouldered my father's coffin his body
Shifted slyly and farted and joined up again
With rotting corpses, old pals from the trenches.
William Orpen said you couldn't paint the smell.

THE DEAD WON'T LET US GO

LINDA LÊ

THE DEAD WON'T LET US GO, I tell my friend Sirius, as I put my father's letters away in a drawer. I'm enduring the torture of Mezentius, chained to a corpse, hand to hand, mouth to mouth, in a sad embrace. The letters have stopped coming from the country of my childhood. The man who wrote them has died a lonely death and is buried on the bank of a stream. But he is still here: His skin touches my skin, my breath gives life to his lips. He is here, I tell Sirius, when I speak to you, when I eat, when I sleep, when I go for a walk. It's as if I have died, while my father, this cadaver who won't leave me in peace, is overflowing with life. He possesses me, sucks my blood, gnaws at my bones, feeds on my thoughts. I read his letters over and over, and again I see myself in the house of my childhood: I am thousands of miles away, an old man sitting with a sad cup of tea, waiting for my daughter to visit me; I am a tired man whom nothing can comfort; I am a man alone, thinking of an absent woman; I am a dying man who writes letters as if bleeding blue ink. If I look at the sea, his eyes see the sparkle of the water, his ears hear the rumble of the waves. If I walk down the street, I feel his body moving. If I eat a piece of fruit, his teeth bite into the apple. If I talk, my mouth recites his sentences. The dummy inhabits the ventriloquist, and at night I dream his dreams. From this hand-to-hand combat with a ghost, I emerge exhausted. I am bearing my father's corpse on my back, my shoulders bend under the burden. I am like the son who carries his ailing mother to the top of a mountain, leaves her there to die, and returns alone, but then feels his dead mother's weight on his back wherever he goes, his dead mother's breath on his neck, his dead mother's hands on his arms. Do you think, I ask Sirius, that the dead can take revenge? I left my father to die alone. He was a quiet

man, and now he speaks through me. He speaks of his sadness, his rancor.
I read his letters, reread them, put them away, take them back out. Perhaps I
should burn them and burn his ghost with the same flame. But the dead
don't die. They live a life that is sometimes silent, as light as the footsteps of
a dove, sometimes as threatening as a cloudburst. That storm breaks over my
head. The dead man takes hold of me. Death comes to me. I wander through
a dark labyrinth where the words of the dead man echo. I look for him. I find
him. I lose him. He is playing with me. His voice says, *Warm, warm, cold, very
cold, burning hot.* I continue through the labyrinth, a candle in my hand. But
halfway through someone blows the candle out. The light is gone. I am in
darkness. I grope for the way. The ghost circles me. I can hear him murmur.
I see him as he is in photos, sitting on a park bench with a hat on his head or
standing by the sea. His eyes examine me, his hands reach for my hand. Then
I see only a skeleton, dancing around me; I see only a specter, wrapped in its
shroud, sitting on its tomb on the bank of a stream. Do you know, I ask Sirius,
that the dead leave their image on our retinas and that through this veil we
can no longer see the world as we did before? Do you know, I ask Sirius, that
since the death of my father I view life as if from a cellar? I am locked in a
dark, damp place, the bright light of day hurts my eyes, the tumult of the world
hurts my ears. I scratch the earth, looking for traces left by the dead man. The
blue of the sky tells me only that his sad eyes can no longer feast on colors.
The steps of passersby tell me that his ears, which longed to hear the clack
of my footsteps leading to my childhood home, can no longer capture any
sound. What color does a man see as his life is leaving him? The white of
hospital sheets? The red of his blood in revolt, flowing without any daughter
to staunch it? The black of the night that falls over his eyes? Or the green of
the trees that continue to bloom while he withers and waters his pale cheeks
with bitter tears? What sound does a dying man hear? The murmur of death
knocking gently at the door? The cry of a child who is entering the world?
Or the sobs of his heart that is leaving it alone? Was his hand damp? Were
his cheeks hollow? Did he speak, fight, cry, call out? Or did he go without a
word? Did he ask what time it was? Did he sense the void approaching as the
day broke? If I had been with my father, I tell Sirius, I would have an image
to feed my memory. I would be able to remember the expression in his eyes
as he watched his last hour arrive; I would have received his last good-bye;

I would remember his silent face, or the pressure of his hand. But I left him to die alone. And now he enters me like an empty house, his silence weighs on me like a gravestone, the words he didn't say blow like a glacial wind and lay waste to my soul. *The last hour, the last instant* are terrifying phrases, I tell Sirius. We use them to mask our terror, that shiver of fear that takes hold of us, the survivors, at the thought that time is continuing to pass, while for the man who is lying there time no longer means anything. He has already entered eternity, he has one foot in nothing, his whole life seems only dust to him now, only smoke, only vapor. As he was leaving, my father said that he loved the rain. These are the only words that have been reported to me. It was pouring the day my father died. I remember that he loved warm rain showers. As a child, I saw him, on rainy days, standing by the window, listening to the drumming on the roof; I saw him go out bareheaded, hoping for the rain to refresh him; I saw him strain to hear the thunder and to see the lightning as it streaked across the gray screen of the sky. My father, I told Sirius, loved simple things. The pearls of rain on a banana leaf, the ebb and flow of the tide, the quivering of wind in the trees, the evening silence, the contour of a flower, the smell of tobacco. I try to gather the images of the dead man who released me only to trap me. Stone after stone, I rebuild the house of my childhood. Piece by piece, I resew the cloak of my memory. When a man dies, we tell ourselves that he loved these things, that he believed this or that, and the things he loved are buried with him, the things he loved take on a particular tint, the color of museum objects: They become fixed. We gather the rain in a little box, seawater in another box, the evening silence in a third box, and in a last box the smell of tobacco. All these little boxes form an altar, and we reassure ourselves by repeating that he loved this or that, without ever being wholly sure that he hadn't changed his mind one day, that he hadn't suddenly begun to hate rain or silence or tobacco. His words resurface in our deformed memories; we recite them like prayers, like invocations to the dead man. He used to say this, we announce. He was like this, we tell ourselves. We long to hear the dead man's voice, but all we do with our words is pin him up like a dried-out butterfly whose immobile wings we are studying. From now on, he is dead, he belongs to us. We have appropriated his words, the things he loved, and we have the power to make him live from time to time by reciting a word he once said, by lifting the lid of a little box to listen to the

rain he loved, the silence he loved, the sea he loved. My father, I tell Sirius, was miserly with words, even in his letters. Until his death, I paid no attention to his words. I read his letters, but the words slipped past me without leaving any traces. Yet now, when I take the letters out of my drawer to read them again, the smallest word tears me apart, the smallest fragment of a sentence sends a flash of pain through my body. These words that speak to me from beyond the grave are like poison. They burn my entrails. I swallow them, I devour them. Their acid climbs to my throat. But I love this. All of my childhood is contained in these letters, written during twenty years of separation. These letters have the peppery scent of the flowers my father grew, the bitter odor of the tobacco he smoked in the early morning, the sweet smell of the candy he bought at the corner of our street. I see the house of my childhood, its shady courtyard, its empty rooms. I see my father leading me through the maze of streets as we go for a walk. I read and reread the words that now belong to a dead man. Wasn't it you, I ask Sirius, who said that when we search for our childhood we find only a gaping void? The hole I'm looking into is my father's grave, from which emerges the voice of my past. My father's grave is made of paper. He lies amid hundreds of letters that crumple under his weight. Over the years, my father ceased to have a physical existence, I wouldn't know how to describe his eyes, his mouth, his hair, his gait. Even when I look at photographs, I see only a ghost dressed in words. These words that he gave me in a language I have already forgotten, these words poison my life. They speak of my betrayal, my desertion. Twenty years, twenty years, I tell Sirius, I have been fleeing the ghost of my father. As long as my father lived, his words arrived muted. As long as my father lived, his words couldn't kill. Now that his letters have stopped coming, now that I hold in my hands the papers that make up my father's archives, I seem to hear a voice rising from them, a voice that judges me, condemns me. He died alone, he lived alone. His solitude accuses me. I could have returned to the country of my childhood, to the house where my father was waiting for me. But I stayed on this side of the ocean. I left him to die alone and I never saw him again. The day my father died, the telephone rang very early in the morning, and a voice read a telegram to me. The phrase, in Vietnamese, spoke not of death but of loss. My father was lost en route, wandered away, couldn't find the path home. I stifled a cry, tears. My father lived again. He

had been dead for twenty years of separation. His death revived him in me. I sat on my bed without moving. From the moment the telegram announced his disappearance, the dead man entered my room, took possession of me. He was there, at the foot of my bed. He came and went, opened my books, rifled through my drawers, fingered my clothes. His laugh resonated like a *Too late! a Never again!* His sarcastic ghost circled me. I didn't move, I was frozen by fear. The dead man murmured disjointed words, the rebel called out his insurgence. I had abandoned him. On his hospital bed, he had wanted to scream, to call my name, to demand to know when we would join hands again. But he said nothing, only that he loved the sad rain that was falling outside, as if the sky were raining on the fate of men who are lost en route. And he was there, in my room, a ghost in rags begging for some leftover tenderness. The last letter he wrote to me spoke of his longing to come to me in the country of my exile, as I was taking so long to return to the house where he sat waiting for me. I didn't answer his last letter. I was taking my time when he no longer had any. We never imagine that the words *Too late!* will come to slap us in the face. Missed meetings are our fate, remorse the cup from which we sip. In his hospital bed, my father's lips turned pale. I wasn't there to breathe the life back into him. I wasn't there to cover him with a sheet, to rest my hand on his hair, to wipe the sweat from his forehead, I wasn't there, I tell Sirius, to tell him about life outside, the bird song, the tumult of traffic, the cries of street peddlers. The dead won't let us go, Sirius. You know, it's the dead who accompany the living, not the living who accompany the dead. Since his death, my father walks by my side. He is here, in this room, he hears what I tell you, which is meant for him, too. But what good is this impromptu monologue, this letter I am writing to replace all the letters I didn't write when he was alive? It's not him I miss, but his voice, his words. Never again will I receive a letter from the country of my childhood, never again will I hear the voice that has supported me for the last twenty years. Half of myself has died. I have survived this silence by rereading the letters. They console me now, though during my father's life they sometimes brought me only irritation, the boredom of having to respond. My father's letters were concise, dry. He gave little news of himself and asked for news of me. I was silent about most of my life, didn't tell him about my loves, the last love, which crushed me, made me forget that he existed, made me neglect his

letters. I didn't write about the long hours I spent waiting for a man I nicknamed Morgue, because all of my illusions had died in him, because in him I had found devastation. I lost my strength in the void of Morgue's eyes, that self-love that gave itself only to take itself away and that killed by disappearing. It was an ordinary passion for a married man. In Morgue's eyes lies my youth, in Morgue's eyes lies my beauty, in Morgue's eyes lies my reason. I almost lost my mind when I lost him. I stopped writing to my father. I wrote to Morgue instead, letters in which proud Solitude spoke of her distress; I wrote like a beggar of love, parading words of love I thought were new. But it had all already been said, love, death, the death of love, and the love of death that haunted me, the desire to throw myself out of the window, to jump from a train, to open my veins, to brand on my body the stigmata of a love undone. My father knew nothing of this. Now, thinking of the time when I was silent, when I left him to worry, I would like to recite to him the words of the blind poet:

> Let weakness, then, with weakness come to parle,
> So near related, or the same of kind;
> Thine forgive mine, that men may censure thine
> The gentler, if severely thou exact not
> More strength from me, than in thyself was found.

Translated from the French by Deborah Treisman

Lang Syne

The accents of childhood, its

BRUCE BEASLEY

language: lang syne, long gone by.
Landscape of half-stalks, swamped
crops, from the locomotive's

window-flash. In frost,
the swathed peach-orchards.
Southward, & past-ward, past

what lost Macon drawl
hangs, barn-lantern, filaments
un-candescent. Take me back

there, where the boiling
peanuts thump their tin pot,
where sugar-cane's slashed

open in the sun.
Necklace of a thousand snake's-rattles
stitched together, the gone

goes, & as it goes, goes on . . .

Amen

Cage, in the dead-room,
the anechoic
chamber, hearing

only his blood-rush & his nerves.
Unstoppable
self-noise. Offering up
intention, as a sacrifice:
The essential meaning of silence is
the giving up
of intention.

No one means
to circulate his blood.

"Room
hermetically sealed
against contingency & echo"

Unidentified
quotations, sounds
disconnected from the occasions
of their audition—

Hallelujahs
continual from the amen corner

Amen: half-man, half-ram
His name
means Hidden One

To reproduce
silence: Cage's
projected *Silent Prayer* for Muzak, four
minutes of dead air

Hallelujah
Amen

Let us close our mouths, & pray

Why do we say, the mystic said,
I think but not
I am beating my heart?

To surrender
all intention
not to mean

to mean

All the tacit
All the blown
trumpets of ram's horn

All the fallen
walls

THÉÂTRE DU SOLEIL

SOLEIL

TAMBOURS SUR LA DIGUE

DIRECTED BY

ARIANE MNOUCHKINE

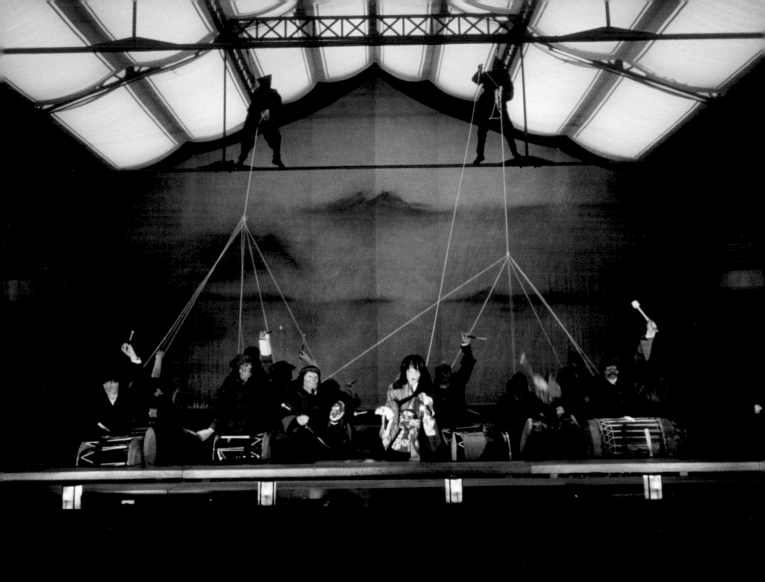

Théâtre du Soleil, *Drums on the Dike*, written by Hélène Cixous, directed by Ariane Mnouchkine, Cartoucherie de Vincennes, Paris, 1999. The drummers.

As the waters of the river rise, the ruling Lord Khang faces a mortal struggle between the faction of his court that is plotting to open the dikes, thus sacrificing half the population, and the peasant resistance intent on safeguarding its land and lives.

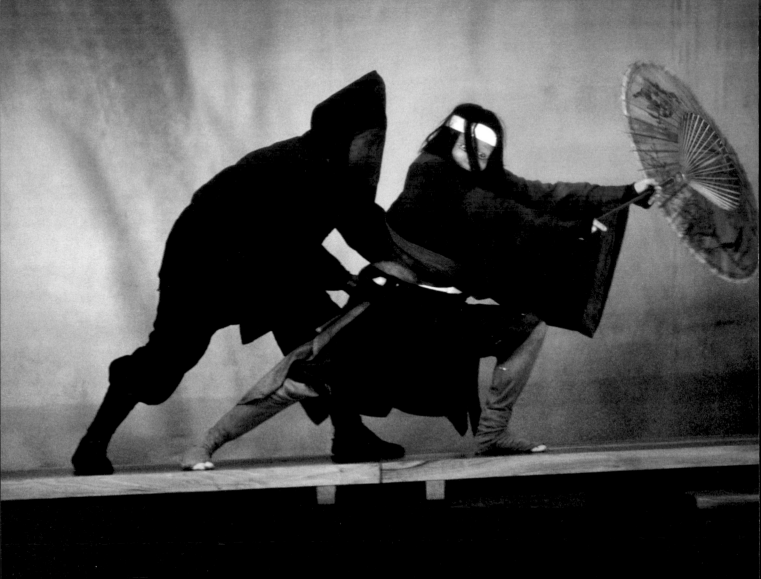

ABOVE:
Duccio Bellugi Vannuccini plays Liou Po.

RIGHT:
The Chancellor's men. Backdrop painting by
Ysabel Maisonneuve and Didier Martin.

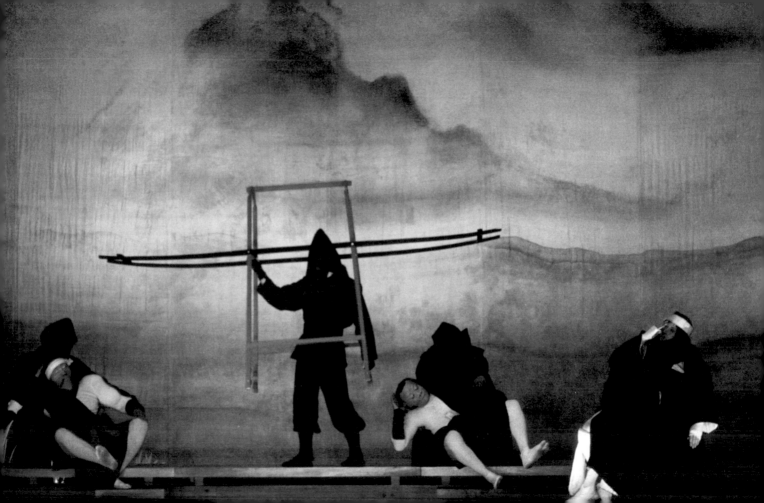

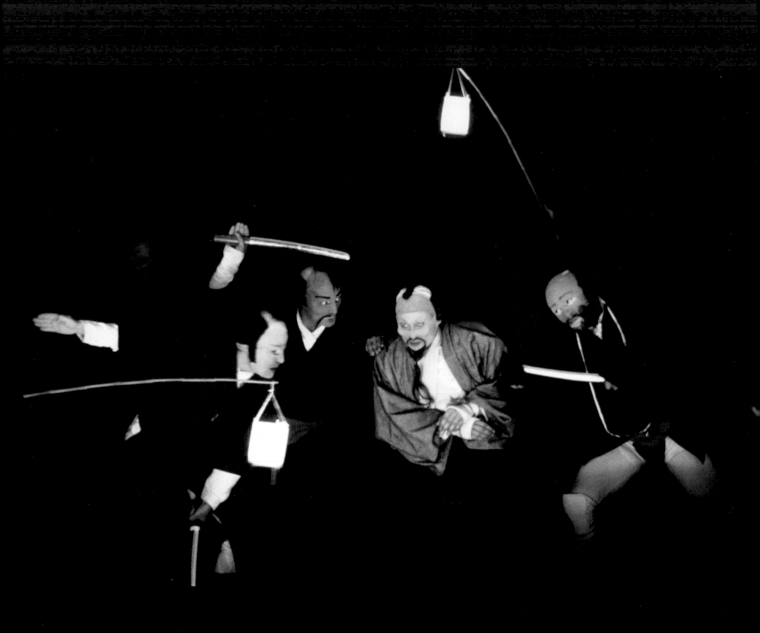

Sava Lolov plays the Architect
threatened by the intendant.

All photographs by Martine Franck.

Ariane Mnouchkine

In fall 1999, the Paris-based Théâtre du Soleil performed Hélène Cixous's Tambours sur la digue (Drums on the Dike) at the Cartoucherie de Vincennes in Paris. "An ancient piece for marionettes played by actors," Tambours sur la digue is set in a nameless Asian kingdom where the people live in fear of a deadly flood. Inspired by the floods that devastated China in the mid- to late 1990s, Cixous's play offered Ariane Mnouchkine, founder and director of the Théâtre du Soleil, the opportunity to pay homage to Asia, the "kingdom of theater" that has influenced her work for so long. The following interview was conducted by Laurence Marie for Le Nouvel Observateur in September 1999.

Laurence Marie: What was the starting point for *Tambours sur la digue?*

Ariane Mnouchkine: The floods in China: that incredible moment when the Chinese government decided to flood certain regions of the country in order to save the cities, but without warning the population. We decided, with Hélène Cixous, to work on this theme, but in the form of an ancient Asian play.

Laurence Marie: So, like your plays that deal with the contaminated-blood scandal of 1999 (*La Ville parjure*) and undocumented immigrants (*Et soudain des nuits d'éveil*), *Tambours* is also based on current events. . . .

Ariane Mnouchkine: *Et soudain* was not about undocumented immigrants—though it was a good thing that the audience interpreted it that way. Nevertheless, for me these situations are less a matter of current events than they are of history. The floods in China and the recent earthquake in Turkey, for example, are the kind of catastrophes that have been happening since the Industrial Revolution and the widespread urbanization that followed.

Laurence Marie: Why did you choose China? Why not Kosovo or Rwanda, which are perhaps closer to us?

Ariane Mnouchkine: Because I feel I have a duty to work on a theme that is a little more distant. *L'Indiade* was related to Kosovo in some ways, even though the India of Gandhi had nothing to do with the Serbia of Milosevic. Perhaps one day I'll deal with Yugoslavia. But it will take a little more time before we can view the situation there clearly.

Laurence Marie: How do you explain the persistent influence that Asia has had on your work?

Ariane Mnouchkine: I believe that Asia is the kingdom of theater. Artaud said that the theater is Asiatic. Over the years, Asia and the puppet theater have inspired a great many dramaturges, Brecht among them. *Tambours* also tells the story of a certain theatrical exigency. Puppets have always been the actors' masters everywhere that the art of acting is held in the same esteem as the art of playwriting and directing. In the Asian countries, puppets personify the gods and heroes. Actors turn to them for inspiration in order to release themselves from realism. Sometimes they even play the puppets' roles. Contrary to *Et soudain*, which dealt with the interiority of a troupe, our new production—an epic drama—is an homage to these actors' ancestors.

Laurence Marie: This is the fifth production that you have directed from a text by Hélène Cixous. Has your work method evolved?

Ariane Mnouchkine: We always develop the theme together, and sometimes part of the script. Then it's Hélène who writes it. The genesis of *Tambours* lasted a year, eight months of which were taken up by rehearsals. The development of this production was

very difficult. Hélène's enormous manuscript provided much food for our imagination. However, the performance will last a maximum of two hours and forty minutes, because puppets require ellipsis, speed, brevity.

Laurence Marie: Are you interested in the texts of other contemporary dramaturges? Or are your only alternatives Cixous or Molière, Cixous or the Greeks?

Ariane Mnouchkine: Of course not! But I really like to work with Hélène, because she knows how to write for a troupe. And I haven't yet received any other texts that respond to what I'm looking for. I'm receiving fewer and fewer, by the way. Perhaps because people know now that I won't put them on. But it's true that I should try to read more manuscripts.

Laurence Marie: Do you feel that you are always marginalized?

Ariane Mnouchkine: I don't feel marginalized. *Others* feel that we are marginalized. I feel that I am at the heart of the theatrical adventure. It's true that, even if I dilute my wine with water, I still feel at a distance from mainstream theater. But then I'm also spared a certain disenchantment that I can see around me. One can despair of oneself, of one's own abilities, but not of the theater. The theater will live, regardless, with or without us.

Laurence Marie: What impact do you want to have on the audience?

Ariane Mnouchkine: I don't ask myself that question. We have prepared the boat, and now we must head out on a voyage together. I hope that our audience will leave our performance stronger, more confident in the qualities of man. Wanting to go to other plays, and not necessarily mine! The theater is a grain of sand, a battle against barbarity. Its influence is immeasurable. In a room full of six hundred people, you never know in whom a little flame will be lit on a given evening.

Laurence Marie: The Théâtre du Soleil is thirty-seven years old: Is it time to take stock?

Ariane Mnouchkine: I take stock all the time. But it's true that the moment has come to consider how much longer I'll be able to do this. The transfer of a venue like the Cartoucherie [the vast, hangarlike theater that is the company's home] should be affected naturally, in the same way that one hands down a farm. Perhaps, unconsciously, I am thinking of my replacement, because it's clear that I won't be able to continue in this line of work for another twenty years.

Laurence Marie: Have you given yourself a deadline?

Ariane Mnouchkine: Perhaps. But it's no one else's business. As Beckett said, "When the bag is empty, you can no longer go on." I don't believe that it's empty yet, but I must pay attention. Because, after all, I'd like to keep going a little bit longer. I would like, until the very last minute, to conduct myself as though each play were my first. Each time we begin work on a production, I have the impression that I know nothing. This attitude is instinctive, but it is also part of my method.

Translated from the French by Deborah Treisman

from
Winds Howl Through the Mansions

BEJAN MATUR

When we were born
Our mother
Had caskets made for us
She filled them with silver mirrors
Dark blue stones
And fabrics smuggled from Aleppo
Later
She would want to put us in those caskets
And whisper in our ears
Of roads
And winds
And mansions.
To stop us being lonely in the dark
She would bring in our childhood too
To comfort us
With that childhood.
But when we were left
In the long river whose waters streamed
With blood that poured from ritual razor-slashes on our backs
Our mother would never have wanted such an outrage
And that is why
We kept telling the waters
While she was sleeping
We moved far away.

What's left from that flight
Everything, everyone is here.
I am here
My brothers and sisters are here with their loss
My mother with her dresses
My brother with his fear of war
My father's here, not awake yet
Around me the world has shrunk
Everything like a dream
That hurts the longer it lasts.

Translated from the Turkish by Ruth Christie

THE BOY ON
THE SWING
(BARCELONA, 1981)
ENRIQUE VILA-MATAS

1

An employee of my father's, who works in an office next to mine—a man
who is held by everyone to be the most boring and most ordinary person in
the world—was unfortunate enough, as a young man, to be sent to Melilla to
do his military service, and there he had what for him was an extraordinary
experience, one that he never tires of recounting to us, as if nothing else had
ever happened to him.

Anyway, he was sent to Melilla and, far from being bitter, the Unknown
Soldier—that is what I'm going to call him because the man has an
unspeakable surname, Parikitu, as odd as it is ridiculous, a name which,
according to him, is Czech in origin and which, as well as being ugly
(in Catalan, it means "parakeet"), has, I think, influenced his whole life—
took the attitude that it's an ill wind, etc., and that his journey to Melilla
might be his chance to live out a passionate love story of the kind he had
so admired in the movie *Morocco*, in the last scene of which Marlene Dietrich,
who had always been cast in the role of man-eater, kicked off her expensive
heels to pursue the handsome legionnaire Gary Cooper in order to share with
him, like a humble Bedouin woman, the dangers and discomforts of the desert.

Or so reasoned Soldier—I'm going to call him that for short—when,
with admirable optimism, he set off for Melilla, convinced that far away
from my father's gloomy office—he has worked for him for forty years and
therefore no one will be surprised to learn that he will be retiring in only
a few days' time—a love story awaited him in which a beautiful, arrogant
woman would end up groveling in the desert dust for his sake. However,

Adam Fuss, *The Life of Guillaume Gallozzi*, 1995. 109

as soon as he arrived in Melilla, he realized that he could expect nothing good of that godforsaken town. Indeed, the sea crossing between Almería and Melilla had already clearly demonstrated to him the gulf that exists between the movies and life and, more specifically, between the cinema and the Spanish army. The voyage was simultaneously calm and agitated. Calm because Soldier was the only one of those on board who had taken seasickness pills and thus he remained in a state of perfect beatitude and inner well-being; agitated because of the repugnance provoked by what was going on around him, that is, the anarchic serial vomiting by both officers and men all that unforgettable night, during which he found it impossible to get to sleep, distracted as he was by the silent movie amiably provided by the vomiters (the pills had also left him deaf), and which, albeit spectacular, constituted a depressing prologue to the other movie supposedly awaiting him in the kingdom of Morocco.

When he reached Melilla, he was overwhelmed, almost to the point of despair, by the sight of a few legionnaires (none of whom bore any resemblance to Gary Cooper) or, rather, of a collection of scrawny human flotsam, bald and toothless, doing their best to provide a warm welcome with a rendition of traditional Spanish music played on fairground trumpets which they would occasionally toss into the air and catch before nonchalantly continuing with their version of *España cañí.*

Soldier saw at once that he was lost, for to make matters worse, each scrawny legionnaire had thought fit to turn up at the port partnered not by Marlene Dietrich, but by a wild nanny goat. A nanny goat? said Soldier to himself, and he immediately began thinking about how he could escape. My father's office must, at that moment, have seemed to him a truly marvelous place.

A nanny goat, said Soldier to himself, feeling utterly confused and terrified. And that gave him an idea. In the days that followed, he devoted himself to acting like a crazy goat. He began committing small but noticeable acts of madness each day—for example, giving the Arabs he was assigned to search as they crossed the frontier a quick kick in the ass—preparing the ground for the final, carefully planned (and, for him, painful, because he was always very proper) display of dementia in its purest form which, if it did not get him expelled from the army, would at least allow him access to the

military insane asylum in Melilla, a kind of health spa with a formal garden, and preserve him for a considerable time from the long period of training that awaited him and from the nightmarish barracks known as the Engineers' Regiment, where each morning he was forced to carry out the exhausting task of placing his rifle on his shoulder.

He had already earned quite a reputation for madness when, having gradually increased the number of kicks he dealt out to the Arabs crossing the frontier, he decided that the moment had come to mount his spectacular act. That day, he got up an hour earlier than everyone else and, hidden away in the barracks' pigeon coop, he took several seasickness pills, washed them down with a whole bottle of Pernod, and smoked a large amount of marijuana, so that by the time military training was due to start he had no need to pretend to be mad, because he was. In that strange, demented state, he had no difficulty, right in the middle of the training session, imitating a crow and hurling his rifle at a sapper who was engaged in the daily exercise of marching toward the humble trench, singing all the while.

There was general consternation. Eyebrows were raised, eyes were rolled, both by the captain of the company and Soldier's own long-suffering colleagues.

"Pacaritu!" the captain yelled indignantly.

"Parikitu," Soldier corrected him gently, giving the bitter laugh of a nervous old man, as if there were some mysterious connection between his difficult Czech name and his madness.

"Yes, of course, Parikitu—I want you to pick up that rifle right now," said the captain, somewhat perplexed.

Then, speaking slowly and calmly, Soldier uttered the words—the very simple words—that he had so often practiced in front of the mirror.

"Sir, oh, sir, I'm mad."

And he took one step forward. The captain took two, walked straight over to him, looked him in the eye, as if by doing so he could somehow scrutinize his mental health, and concluded:

"Mad people never say they're mad."

"That's because they're not as mad as I am," Soldier replied rather haughtily, quick to realize that he should not have given such a hasty and unrehearsed response.

111

He humbly lowered his eyes, and then, suddenly, almost like a miracle, a strange trembling shook his body. At the same time, an even odder phrase came into his head—doubtless the result of the explosive mixture of marijuana, fear, Pernod, and seasickness pills—a phrase that struck him as being truly inspired, although he had no idea what it meant, and which, from within his genuine madness, made him weep real, convincing tears as he said it:

"We all know Hong Kong."

There was something touching and persuasive about the phrase or about the way he trembled or, quite simply, about the way he said it, and the fact is that Soldier was quickly led away to the Military Hospital, to the so-called Annex for the Mad, where he was left in the care of a second lieutenant who was studying psychiatry and a nun who offered him some cookies. He refused to go beyond the courtyard, though, so they eventually left him outside and bade him good-bye, saying they would return.

"Good-bye," said the nun, giving him her last biscuit. "You just stand here nice and quietly in the sun. And when you get tired of standing by the door, just remember that inside you have your new home and your new family. You'll find your new friends are all good, kind people."

Soldier wondered if the nun, with her strange way of speaking, wasn't madder than the mad people she cared for.

"Good-bye," said the second lieutenant. "I'll come back in a while, and you and I can have a good chat, all right?"

Soldier, in his role as madman, decided to reply and at the same time surprise the future psychiatrist.

"Good-bye, stupid fly!" he said, brushing away a convenient fly that had landed on his nose.

They left, looking at him strangely and with real distrust out of the corner of their eye. Good-bye, second lieutenant, good-bye, nun, and I hope they box your ears on your way down to hell, thought Soldier. And he stayed there in the sun, delighted with life, beneath a perfect African noonday sky, gazing out at the sea beyond the palm trees and at the splendid formal garden.

Around mid-afternoon, he decided to inspect his new home, and he saw that there were only five other inmates. Five men with fierce expressions who, the moment they saw him come in, immediately turned away and stood

grouped around the window at the far end of the annex, staring with false, forced melancholy at the wall of the short cul-de-sac outside.

They're a bunch of pretenders, this band of madmen and criminals, thought Soldier. But then he saw that they were not a band at all. For they soon moved away from the window, and, as they did so, they ceased to be a compact group—madness always tends to difference. Soldier's attention was first drawn to a man known as Gin. He was a fellow in his fifties, a sergeant in the legion, whose nickname came from his old habit of mixing milk with gin and drinking six or seven liters a day of this singular and intoxicating brew. This man always wore six watches—three on each wrist— striding about inside the annex, from which he never stirred, not even to take the air in the garden, despite the fact that he greeted the coming of each new day with great enthusiasm; when he heard the bell rung by the nun for breakfast, he would comment out loud on how marvelous the morning light seemed to him, and he always did so with the same words:

"What a beautiful morning! Have a good day, sir."

The last phrase was spoken exclusively to himself, the former was addressed to the whole annex. It made no difference if it was hot or cold, if it was sunny or if the skies over Melilla were cloudy. Then he would sit up in bed and solemnly consult his watches, while the nun and her assistant, a very thin young Moroccan girl, served breakfast.

"Let's see what time it is."

And he would sit gazing ecstatically at his six watches, none of which had minute hands.

Another favorite of Soldier's was a Galician called Senén, who was the consummate writer of brief, mischievous messages that would turn up camouflaged among the breakfast cookies and the glass of milk that were served punctually by the nun and her thin Moroccan assistant.

It occurs to me that any reader who has got this far must be wondering how it is that I know these insignificant details of a story, which, incidentally, is not, contrary to appearances, just one of those silly adventures that belong to the clichéd world of military service and which are always so overrated by their protagonists.

Well, the answer is simple. I know this story by heart because I have had to listen to it hundreds of times in the office, which means that not only can

I reconstruct it with absolute precision, I can even improve on it, for the fact is that I tell the story—and forgive my immodesty—far better than that slave of my father's, who, until only a short time ago, I believed (as everyone here in the office continues to believe) had no other stories to tell. And why do I bother to reconstruct it or improve on it? That's easy enough: It's because, since that wretched supper for four the other night, *I* am now the one obsessed with the Melilla story, and, believe me, I have good reason to be.

2

So let me return to the Galician Senén and to those finely honed, mischievous messages that he slipped in among the glasses of milk, the dawn rosary, and the breakfast cookies. The message that Soldier remembers most clearly is this: "Would you be so kind, Señor Parikitu, to grant me an interview? Or perhaps you would prefer to receive a daily Slovakian whistle and, with a titter, include it in your innovative treatise, which no one here understands or ever will? Yours sincerely, Apprehension—for that and no other is the real name of your neighbor in the next bed and in despair."

Senén was, indeed, apprehensive. But when he wasn't seeing frogs everywhere or feeling apprehensive about the other madmen in the annex—especially the one whom the others called Screwball and who was a real gem, being both stupid and profoundly epileptic—Senén was quite a reasonable fellow who had found a way to enjoy himself by writing cryptic messages, all as enigmatically phrased as the one I reproduce above and which, as you can see, even I, by dint of hearing it over and over again, now know by heart.

Senén was the only madman in the annex whom Soldier could talk to. He had his eccentricities like everyone else—for example, he thought he could control all the madmen by pronouncing in a loud, affected voice the name of some famous musician—but, on the whole, he was perfectly reasonable, and on unforgettable evenings spent looking out over the garden, Soldier had many long, pleasant conversations with him about life and death.

Soldier even became Senén's staunch ally in the latter's attempts to achieve the near impossible—though he did achieve it once, albeit more by luck than judgment—lulling their wild companions and soothing their fevered brains

when it was time to turn out the lights in the annex and go to sleep, although there no one slept. It was the same every day. The nun would appear accompanied by her skinny Moroccan assistant and, after a hasty, muttered Our Father from the inmates, would turn out the lights. Then a kind of theatrical performance would commence. When the footsteps of the nun and her female assistant were only faint echoes in the distance, the darkness seemed to grow even blacker and denser than usual and one could hear even the weakest beat of the most irrational of anxieties: wild cries, people running up and down the corridors, buckets of cold water being thrown over the epileptic, grunts, songs sung by Bobby Solo (the alleged name of one of the other inmates), heartfelt laments, hysterical hymns ("The Bride of Death," for example), and other symphonic nightmares that took an eternity to die down.

An unbearable nightly horror, to which Senén managed to put a stop only once—and that was, I think, by pure chance. Taking advantage of a pause in that particular night's intolerable racket—a vile, clamorous game that consisted in Bobby Solo being violently beaten at unpredictable intervals—Senén adopted a loud, affected voice and said slowly to Soldier, who was in the next bed: "Friend Parikitu, what do you think of Richard Wagner?" Something strange happened then. It was as if his voice rang out in the annex with absolute authority, leaving the other inmates utterly perplexed, which convinced Senén (and he said as much to Soldier on innumerable occasions) that the other inmates could not cope with hearing the word "Wagner"— I tend to think that, by the same rule of three, it could just as easily have been the word "Parikitu," but never mind—and were so terrified by the sound of that intensely musical name that they were lulled into the deepest of sleeps and ceased to be a nuisance that night.

But that trick—always supposing it was a trick—only worked once. Senén refused to accept this. He became obsessed with the idea that the names of musicians might allow him to become the emperor of the annex and the artificer and jealous guardian of the most civilized of nocturnal silences. It was sad to see this otherwise intermittently intelligent, decent man wearing himself out at night, pronouncing the names of all kinds of famous and not-so-famous musicians (in his madness he even mentioned an accordionist from his own village) without achieving anything like the success of the

triumphant night of Richard Wagner. Often, when Senén was in the grip of this obsession—one should not forget that such obsessions have led many to the insane asylum—Soldier tried to help him by showing him that down that route lay madness.

On those occasions, recalling what the fans of a great bullfighter used to sing whenever he temporarily forgot his mastery and made eccentric passes before the bull, Soldier would sing to his friend and neighbor in the dormitory, by way of a serious warning: "Senén, Senén / there you go again." But that had no effect either, because Senén, the pigheaded creature, clung stubbornly to his obsession, calling out the names of famous and not-so-famous musicians in the midst of the general and uncontrollable hubbub.

With each day that passed, Soldier felt—and there is no reason to doubt this, since the prospect of returning to the barracks was far worse—happier and happier. The formal garden, the evenings, the dawn rosary, so comforting from the religious point of view, his amiable conversations with Senén, his own extreme idleness . . . In fact, he felt so happy that he began to worry that it would not be long before they discovered he wasn't mad at all and sent him back to the barracks. For each morning, giving him barely enough time to affect a state of profound dementia, they were all lined up at the door of the annex to be reviewed by the apprentice psychiatrist, that is, he would review the mood of each inmate by asking, always in a slightly different way, how he was feeling that morning. "Are you feeling better today?" he would ask, and it was as if in reality he were asking them: "Still as mad as usual, are we?"

Gin would respond: "Much better, sir." Then he would let his gaze wander down to the six wristwatches revealing that he was, in fact, mad, and that his madness was incurable. Screwball would say: "Much better. And the proof is that I got here on time." Everyone there knew what Screwball meant, because they all knew he was one of those people obsessed with punctuality and, indeed, he demonstrated this each day by always sitting down at the lunch or supper table before anyone else did.

As soon as Bobby Solo heard the question, he would move his lips as if he were about to burst into song, then, simulating an attack of the hiccups, say: "Per-fect." Senén would say: "Superlative, sir." "Feeling more cheerful every day, sir," came the reply of the fifth madman, whose real name was Rick, but

who was nicknamed Kick because of the way he was always kicking the epileptic Screwball.

Everyone said they were much better, all except Soldier, who even then was the most ordinary of men and who, therefore, experienced serious problems passing himself off every day as mad. His common sense told him that if, like the others, he said he was feeling much better, he would be sent straight back to the barracks, and this led him to be prudent and to remain anchored to what, from the very start, had proved to be a remark as fortunate as it was mysterious and which had instantly opened the doors of the asylum to him.

"We all know Hong Kong."

Soldier, however, soon came to realize that by repeating that phrase he might risk bringing about his own perdition, because it wasn't enough simply to repeat it every morning unless it was accompanied by a fiery glance, by strange bodily writhings, general delirium, and with Pernod and pills in his belly. And even then it was hard to imagine that, day after day, such an ordinary man could convince the apprentice psychiatrist when he asked him:

"Are you feeling better today?"

"We all know Hong Kong."

When Soldier began to consider changing the phrase, it was already too late, because the madmen had learned it by heart; and when it was his turn to answer the question during the morning review of the mad, his companions would beat him to it, and, as if they all wanted to denounce what to them was Soldier's obvious sanity—here in the office he's seen as the least mad man in the world, as a poor unfortunate, the most ordinary person one could hope to meet; everyone sees him this way except for me, because now I know exactly what my father's poor wretched slave is like—they would all chant together in merciless parody:

"We all know Hong Kong."

Since everything in this world comes to an end, the day arrived which turned out to be Soldier's last day of marvelous exile from the barracks. The apprentice psychiatrist asked him the usual question and, as usual, the madmen answered for Soldier, saying they all knew Hong Kong.

There was nothing new about that, but then the apprentice psychiatrist turned suddenly to the chorus of madmen and said:

"Of course, lads. We all know Hong Kong intimately. We all know its

117

harbor," and he burst into loud guffaws, "its junks, its modern buildings, its sampans, the good Chinese and the bad Chinese. Isn't that right? We all know Hong Kong, don't we?"

Soldier went pale with horror. The apprentice psychiatrist was mad too. And he was not the only one. The nun and her thin female assistant also began laughing wildly. Everyone there was mad but him. Gin began blithely bumping against the walls. Screwball rang a small bronze bell, as if announcing to him the imminent end of his stay in the annex. Bobby Solo and Kick sang a tuneless calypso. Senén and the apprentice psychiatrist, gripped by a strange fever, were weeping with laughter at the nun, who had dropped several cartons of cookies on the floor. In the midst of that clamor, Soldier realized he was lost, for there was no room there for an honest, decent man.

In desperation, in a final attempt to calm the wild beasts of the annex, he even resorted to Senén's obsession.

"Wagner! Richard Wagner! Chopin! Mozart!" he cried.

But no one heard him. The place was in complete uproar. When this had died down, the apprentice psychiatrist came over to him and said:

"I'll ask you the question again. And all you have to do is give your usual answer, but I just want to hear it once more. All right?"

"All right," said Soldier, knowing this was the end.

"Are you feeling better today?"

"We all know Hong Kong."

More bumping against walls, more frenzied ringing of bronze bells, more tuneless calypsos and roars of laughter. Complete pandemonium. An hour later, Soldier was back in the barracks.

We've heard this story thousands of times in the office. "Go on, tell us again what happened to you in Melilla."

That's how we pass the time in the office at that awkward hour when the day's work is done, but we still have to wait for my father to come and tell us we can go home. Since he is always in the same mood, our man never minds repeating a fragment of the story at random and recounting it exactly as he always has. We listen fairly attentively at first, and then, since we know the story by heart, we start to laugh uproariously. That is how the day often ends in the office. Some bump against the walls, others sing tuneless

calypsos, and there are even some who pretend to be ringing small bronze bells, and so on, until my father comes and gives us permission to leave. Yes, many days at the office end like that.

"Go on, tell us about saying good-bye to the garden."

And every time he tells it to us, we kick up a tremendous racket and roar with laughter and call him Hong Kong.

3

He was Soldier when he told us about his time in the asylum in Melilla. He was Parikitu when I saw him as a poor unfortunate, for forty years my father's most loyal employee. He's Hong Kong when I remember that I thought of him as one of those very ordinary people who, for lack of other experiences to recount, always tell you the same story, until last Sunday, one of those awful evenings that seem to drag on for ever, and which you spend slumped on a sofa knowing that no one, absolutely no one, is going to phone you and that if, by chance, someone did, your pulse would quicken imagining that something very bad had happened, and you would hurl yourself on the phone believing you were about to hear the announcement of the end of the world. And then I did, in fact, get a call.

"You get it, will you?" shouted Alicia from the bedroom. "It's bound to be for you."

"Why should it be for me?" I protested, feeling equally disinclined to leave the bedroom I had improvised for myself in the living room.

Both of us, Alicia and myself, were suffering from bad hangovers because the previous night we had spent desperately celebrating my fortieth birthday with some friends.

"You get it," insisted Alicia.

"Hello," I said timidly when I picked up the receiver.

"Is that Señor Esteva?"

It can't be, I told myself, for I had just heard Hong Kong's voice.

"Señor Esteva?" said the voice again. There was no doubt about it. It was Hong Kong. I remained floating on a cloud of astonishment and incredulity. I was filled by a sense of profound embarrassment, a bit like the unease I feel

sometimes when I'm walking along and I bump into a waiter out of uniform whose face is familiar but whom I can't place in any particular bar.

"Hello," I said again in the vague hope that it might be a joke.

"Who is it?" yelled Alicia from the bedroom.

"It's Parikitu," the voice said. "I'm calling with your father's permission. He kindly gave me your phone number. First of all, I wanted to apologize for not congratulating you yesterday on your fortieth birthday."

This wasn't a joke, it was real. Hong Kong himself was phoning me, because, as far as I knew, no one in the office had ever bothered to imitate his voice. I decided to remain calm and to pretend not to be in the least surprised.

"So, Parikitu, is there some emergency?"

"I expect you're surprised that I should presume to phone you . . ."

"Not particularly, Parikitu. But why exactly are you calling?"

Despite all my efforts, he could tell I was a bit put out. "The office hasn't burned down, has it?" I joked. "No, of course not. Though it would certainly be funny if it did." It's a fire insurance office. "Now, tell me, Parikitu, what can I do for you?"

It really was extremely odd that he should call me at home. Especially saying that he had my father's permission to do so—because that, I thought, was what he had said.

"I discussed this with your father first," he said, "and he was all for it. Indeed, he said he thoroughly approved of such an initiative, because he's always in favor of improving relations among his employees."

I had no idea what he was talking about, but I felt obliged to clarify one point.

"I'm not one of my father's employees," I said.

"Who is it?" Alicia yelled again from the bedroom.

"I know that, Señor Esteva. Perhaps I didn't express myself properly. One gets so nervous making a phone call like this . . . Now, as you doubtless know, I will be retiring in four days' time. After forty years of service to your father and, of course, to you as well, I would not want to leave the office by the back door. I mean I do not want simply to retire and feel that's an end to it, that one closes the office door for the last time and that's all there is. For that reason, my wife and I would be most honored if you and your wife, if you . . ."

He had run aground. I helped him out of the mire.

"Calm down, it's all right."

"Well, what I wanted to say was that we would be very pleased if you would accept our warm invitation to dine at our house on a night of your choosing—any night from tonight on, whichever date suits you best, I know how busy you both are, the first free night you have, any night from now on would suit us fine."

I hung up. I was too stunned to say anything, and so I pretended we had been cut off in order to give myself time to respond and at least have a few seconds to think. I was utterly confused, and my hangover only compounded the feeling. Hearing the sudden silence, Alicia resumed her attack from the bedroom.

"Look, who is it? Is something wrong?"

The telephone rang again. I hadn't had a single second to think.

"It seems we got cut off, Señor Esteva," Parikitu continued. "Anyway, my wife says that you don't have to give us an answer now. We very much hope your answer will be in the affirmative, but I know you have a lot of commitments and things to do, so give me your answer when you can. I just wanted you to know that in my opinion and my wife's . . . I mean that we can think of no greater honor . . . In my view, it would be a fitting end to all those years on the front line. But don't worry, don't let the military metaphor fool you," he said lamely, "old Hong Kong isn't about to tell you the Melilla story yet again."

"What the hell is going on?" Alicia said, coming into the living room.

"My wife isn't at home right now," I said. "I have to consult her first, because she has a lot of work commitments." I was lying through my teeth— she has never worked in her life—but my hangover was giving me wings to try to escape from that situation. "You know, business suppers, meetings, all the usual things you'd associate with the fashion industry."

"Of course, I understand. But as I said," his voice sounded slightly troubled, "you needn't give me an answer immediately. I just thought it best to ask you over the phone because it's always awkward in the office. It's awkward enough over the phone."

He seemed hurt, not because he realized that Alicia was at home, but because he sensed no enthusiasm on my part. I tried to change the subject

and inquired about the thing that most intrigued me. I asked if I had heard correctly, if my father really had been pleased about this initiative.

"Yes," said the voice, incredibly sure of itself this time. "Your father wants to usher in a new era of employee relations in the office."

"There you go again," I protested. "I've told you already, I'm not an employee."

I began to wonder if behind all this lay some grave, treacherous act of provocation. On the eve of his retirement, having put up with my father for forty years and with me for twenty, the man wanted his revenge. The way he kept apologizing over and over did not put my mind at rest. My agitation came from the fact that, deep down, I knew that, however I tried to deceive myself, I had been nothing more than an employee of my father's all my life. Wasn't that what Alicia accused me of whenever she got drunk and started hitting me?

"Who the hell is it?" she shouted, this time standing right by the phone so there could be no doubt that she was at home.

I thought of telling Hong Kong that my wife had just got back, but then I would have to give an answer to his invitation and I didn't want to do that at all; it would be best to keep putting it off until the man retired and disappeared from sight.

"Señor Esteva, are you there?" I heard him say.

I hung up. With a bit of luck, I told myself, he might think I'm angry with him for calling me an employee and that way I'll avoid the bother of having to talk to him again. Shortly afterward, the phone rang.

"Good-bye, Hong Kong. No one calls me an employee, least of all you," I said and hung up again.

Now, I told myself, *now* he will think I'm angry with him and he won't call back. I felt very pleased with myself for having come up with a way out of that embarrassing situation. But the phone rang again.

"Look, Hong Kong," I said, slightly shaken, "don't you understand? You call me an employee, you insult me when I'm sitting comfortably in my own home, and you even suggest that my wife and I should pay you a social visit. I've got just one thing to say to you, Hong Kong: That isn't how one goes about things, do you hear? That isn't how things are done. So if you don't mind . . ."

I didn't even give him time to respond. I just hung up. I thought: That will be it, I can't believe he'll bother me again. I was right. There were no more phone calls. I told Alicia who I had been talking to. I just told her the name of the caller, nothing more, but that was enough for her to look at me, incredulously of course.

"Good God," she exclaimed, and announced she was going to put a cold compress on her forehead. "I'm not in the mood for any jokes from Daddy's little employee," she shouted, from the toilet. I guessed she had started drinking again.

After supper, when I least expected it, she returned to the subject.

"Did I hear you right just now? I thought you said something about that employee of your father's, about that Perroquet fellow. You did tell me"— she looked at me with deep distrust—"that his name was Perroquet, didn't you? You said that your ancient father's . . . I mean your father's ancient Czech employee called. Isn't that right?"

I knew what she was leading up to. She was going to hit me and I would have to defend myself and, as always, try not to hurt her, because that would be worse, much worse. And it was all the fault of that wretch Hong Kong. I furtively grabbed a silk cushion so that I could fend off the first Chinese vase that would come flying in my direction. I armed myself, too, with a great deal of patience. I did my best to avoid a fight, saying:

"I wasn't lying. Perroquet did call." Under the circumstances, there was no way I was going to tell her his name was actually Parikitu. "And if you'll calm down, I'll tell you what he wanted, because it's actually interesting. Apparently, my father"—and I said this very grandly—"wishes to introduce a new style of employer-employee relations."

"Well, that really is the limit. Are you trying to provoke me?"

"No, on the contrary, I just want you to calm down." I was using my most persuasive tone of voice; I was telling her this story about Hong Kong in order to distract her. "You're going to like what I'm about to tell you. I gave a flat 'No' to the idea, to the idea that Perroquet put to me. I'm opposed to the introduction of any newfangled employer-employee relations in the office."

"Are you telling me you said 'No' to your father?"

She seemed calmer, even rather pleased.

"That's right. I said 'No' to Perroquet's invitation to dine at his house.

Because he invited us to have supper at his house. Both of us. To have supper with him and his wife."

She got up from the table. She was clearly undecided: Should she throw a vase at me or go and get another cold compress for her forehead? She sat down again, as if overwhelmed by astonishment.

"This is too much. I've never heard anything like it. The Perroquets have invited us to supper? Is that what you're trying to tell me?"

Her perplexity actually helped to calm her. Assuming the threat of a fight was over, I turned on the television. They were showing a documentary about the—absolutely fascinating—world of nightingales in captivity. This program plunged her into a state of even greater confusion and perplexity and, gradually, with the inestimable help of more alcohol, she fell asleep on the sofa. I seized the opportunity to phone my father. To my surprise, he told me:

"You've got to go to that supper. That man has been loyal to me for forty years. And it would be unforgivable of you to scorn honest Parikitu just because that wife of yours—I know she's behind this, you can't fool me— just because Alicia is a lazy slob or thinks it's somehow beneath her to visit a modest home."

"But you've never shown him any respect . . ."

"You must go," he replied in a fearsome tone of voice, at once severe and deeply enigmatic. "There are plenty of reasons why. Ethical reasons, for example. Do you know what ethics are? No, of course you don't. You're corrupt and superficial. But you'll go to that supper because I'm ordering you to. Yes, I know you're forty years old, that you're a grown-up now, but I have the right to give you orders about serious matters like this. And don't ask me why it's so serious. You should have realized by now. You've had the odd clue. So you'll go, all right? You'll go."

4

I *am* corrupt and superficial, and it doesn't bother me at all. What *does* bother me is that my father is not aging well. On Monday morning, when I went into his gloomy office, I found him wrapped in a blanket, lying on the hideous

sofa he's had installed next to the heater, with the blinds drawn (he's suddenly taken against the Church of the Sagrada Familia and can't stand the sight of it anymore); in short, he was in a strange state altogether, bordering on the unhealthy I think, wallowing in what he describes as his terrible loneliness and pain since Mama died.

"Come in, son, come in," he said, comically covering his head with the blanket I had given him as a present from my honeymoon in Scotland.

"A blanket," I felt obliged to tell him, "is hardly a suitable thing to have in an office."

"Anyone would think you were already running the business, boy. You're not even prepared to wait for me to die first! You're itching to be in charge of it, aren't you?"

There was an unbearable smell of pipe tobacco, Scottish blanket, and mustiness. And there was a smell of senility, too.

"How long is it since you let anyone clean up in here?" I asked.

"I don't intend to let anyone clean my tomb from time to time either. And now, my little tadpole"—that was his way of showing some affection for me—"listen to what your father has to tell you. Come over here, come on."

I stood in the doorway, not daring to go in. I stood there studying that old man who seemed to be enjoying his decrepitude. I told myself I would never end up like that.

My motionless stance in the doorway must have annoyed him.

"Come here!" he shouted suddenly, hurling the blanket at the blinds.

Troubled, I approached. I felt uneasy. I saw him get up and lean on the desk.

"I suppose you thought I couldn't stand up anymore."

I didn't reply.

"Well, as you see, I can. Your father has still got enough strength to tell you a few plain facts, whether you like it or not. Because you came here with the idea that I might change my mind about supper at Parikitu's house, isn't that right? You'd like it if my strength had ebbed away completely, and I'd collapsed on the floor, been wrapped up in your wretched Scottish blanket and carried off to the cemetery. That's what you'd like. But, as usual, I can read your thoughts! So watch your step. I'm still the stronger of the two of us. And you're going to go to that supper."

"I just don't understand why," I said.

"Yes, you do. It's just that you're worried about having to tell Alicia that you've both got to go, because you know she'll tell you to go to hell. It's shameful how little authority you have over Alicia. No one would think you were my son. But I *do* have authority over her. And I promise you she'll go to that supper. Tell her if she doesn't go, I won't pay for her expensive little caprices. Tell her if she wants to go on spending more than the allowance you give her for clothes and visits to the hairdresser's, then she knows what she has to do. She'll go to that supper, my little tadpole, you'll see."

Feeling once again profoundly humiliated by him, I bit my lip and lowered my head. I protested timidly, but I protested nonetheless.

"Is this your way of reaffirming your authority? What exactly have you got against Alicia anyway?"

"Everything," he said.

"Is this your way of feeling you're still in command? By forcing my wife to go to a supper that's of no importance, even to you."

I saw that my father was in a worse state than I had thought, because his reply was not just odd, it was crazed and violent.

"Feeling as if I were still in command? You listen to me, you little wretch. Just because she opened her legs, just because she lifted up her skirts, the filthy sow, the stupid drunkard, you surrendered to her like a fool. And in order to be able to screw her in peace"—he began emphatically stabbing the air with his index finger—"in order to fuck her at your leisure, you profaned your poor mother's memory and lay your father out on this sofa so that he couldn't move. But perhaps he can move. Your mother dies, and your poor father's left a widower with only you to console him, and he doesn't realize you're a traitor and will always behave like one. Your father could never have suspected that only a few days later, just because some woman was prepared to spread her legs for you, you would abandon him, leaving him entirely alone, hoping that he'd cash in his chips as soon as possible. Is that any way to treat a widowed father? You get married and all he gets is a rotten Scottish blanket. You strut around Barcelona closing deals that he set up in the first place, full of yourself, and then you come and stand before him wearing the expression of a man of importance. Is that any way to treat a widowed father,

126

by buying him off with a Scottish blanket? Is that filial love? Get out of here, you wretch, get out of my sight!"

I retreated to the door.

"No, stay," he said. "I need you to be my ally. Be my friend at least in this and I'll forgive you. Go to that supper, make her go with you. Be a man for once and not the puppet of a silly, perfumed woman."

He kept stabbing the air with his ridiculous finger, and all I wanted was for him to slump down onto the sofa again. I suddenly raised the blinds. The Church of the Sagrada Familia reappeared in all the splendor of that February noontide. My father cried out in horror at the sight. I lowered the blinds again.

"Fine," I said, "sit in the dark if you want. But I'm telling you, the employees are getting restless. Do you think they like having to come in here and do business, with you in this state? If you carry on like this, sitting in the gloom, you're going to end up with a mutiny on your hands."

"And they'll make *you* their boss, will they? I doubt it. They have no confidence in you whatsoever. You're always hoping for a coup d'état. But I'm still the stronger of the two of us, and don't you forget it. Even lying here in the darkness, I'm much stronger than you. It makes me laugh to see you so pale and thin. You haven't turned out like me at all. Do you realize that? You're not a bit like me. I've got all your new clients in my pocket and you don't even know it."

I looked at his ridiculous pocket, but I still couldn't bring myself to laugh at him, not even under my breath. That's because I remembered his terrible fists when I was a child, those clenched fists that he would thrust into his pockets when I was on the swing. I remembered the iron swing he built for me in the garden of our vacation home and on which I, tragically swinging, let the iron hours of childhood pass.

"Don't worry," I said, on my way out of the office, "we'll have supper with your model employee if that is your gracious will."

As I closed the door, I saw Hong Kong himself coming slowly along the corridor, carrying some enormous files as always and heading, with his usual resigned step, toward the office I had just left. And here's the man with only one story, I said to myself. Then I softened. Life hasn't been exactly kind to that poor wretched pensioner-to-be either, I thought. Overcome by a sudden

sympathy for the sad, touching figure of the man with only one story, I cursed the whole of humanity, and I did so above all because that same humanity invented both slavery and those fire insurance policies which, along with that terrible childhood swing—on which, by the way, even while I'm saying all this, I am, believe it or not, still tragically swinging—have, to put it mildly, destroyed my life.

For a few moments I wanted everything to go up in flames, but I continued walking calmly along the corridor until I drew abreast of Hong Kong, who said a reluctant "Good morning" to me as if he was still upset by my treatment of him on the phone the previous day. I looked him up and down as insolently as possible, putting on a superior air. This was my usual way of getting out of a tight spot, of covering up my timidity and, in this particular case, of ridding myself of a vague feeling of shame when I remembered how I had hung up on him.

Normally, in cases like this, and again out of timidity, I end up inflaming the situation by responding sourly—in that respect at least I am like my father—by saying terrible things, whatever comes into my head. But that morning, when I saw Hong Kong, I felt so touched and disarmed that I reacted completely differently.

"You do forgive me, don't you?" I said. "You're a kind man, I can see it in your eyes. It was very rude of me to hang up on you like that. Something just got into me, like it did with your friend in Melilla," I joked rather awkwardly. "You know: 'Senén, Senén, there you go again.'"

Hong Kong smiled diplomatically.

"I must tell you," I said, "that my answer today is a resounding 'yes' to your kind invitation of yesterday. Would tomorrow suit you?"

The sooner, the better, I thought. And I told myself that Alicia would agree with me, for I knew perfectly well that when I told her of my father's threat she would be the first to demand—after insulting me and trying to hit me—that we go to that wretched supper and not run any foolish risks, because she was and still is convinced that my father is looking for the slightest pretext—an arbitrary order, for example, that I might neglect to carry out—to disinherit me.

"Tomorrow would suit us fine," said Hong Kong. "And say no more about it. It will be a great honor."

He proceeded toward my father's office, and I knew that a smell of pipe tobacco, Scottish blanket, and obstinate mustiness would invade the corridor as soon as he opened the door to that dark cave.

I saw Hong Kong dozens of times during the day, which is hardly surprising since he spends the day carrying back and forth files containing his measured but implacable reports—his specialty—on presumed arson attacks. He kept giving me enigmatic, knowing smiles, which began to bother me when I realized that sooner or later the other office workers would notice this new and unusual communication between him and me. In fact, Hong Kong seemed determined that this should happen. My standing in the office was at stake and, as the day progressed, I reciprocated with increasingly chilly and indifferent looks, which he ignored, bestowing on me instead beaming smiles worthy of a Chinaman, as if wishing to do belated justice to his oriental nickname.

At about seven in the evening, the waiter who brings us our coffee announced, between jokes, that there had been a coup d'état in Madrid. At first, everyone took it for another of the waiter's jokes, but as he provided us with more facts, it became clear that it could not all be a mere product of his imagination (which was, anyway, pretty minimal) and that what he said was being reported on the radio was probably true.

Soon enough it was confirmed that some terrorists disguised as civil guards had hijacked Parliament. We were astonished. A coup d'état, everyone kept saying. Even my father showed interest and, leaving his gloomy office, he ordered someone to buy a radio from the store downstairs—the cheapest one possible—in order to be able to follow the course of events.

A battered radio was brought up, and everyone listened to try to find out what the hell was going on in Madrid. I experienced a sudden wave of relief when I realized that this gave me the perfect excuse for not going to that boring supper at Hong Kong's house. Such was my relief that, without realizing it, I got rather carried away and, oblivious to the atmosphere of general consternation and uncertainty around me, I began gleefully recounting out loud the case of a civil guard who used to traffic in cheese and sugar and whom I followed one afternoon through the streets of Ceuta, curious to know how he spent his free time when he wasn't engaged in trafficking, only to find out that the man was happy sitting quietly in the shade beneath a vine trellis, drinking a glass of water.

"A bit of a shady tale really," I concluded, chuckling. The radio stopped working, and I became the focus of the anger and agitation of all the others, who, accusing me of being stupid and inconsiderate, looking at me as if I were a Chinaman, began addressing me as Hong Kong, to my natural distress.

5

When I woke up the following morning, the coup d'état was over. Since I had spent the night having a prolonged and ghastly nightmare about the wretched iron swing of my childhood, I woke up feeling stunned and anxious. Alicia told me that the rebels had surrendered and remarked:

"So you see, my dear, we've lost our splendid excuse. We'll have to go to that supper."

And trying hard not to laugh, she added:

"You'll just have to resign yourself, my dear."

She then burst out into that obscene, erotic, melodious, magnificent laugh of hers.

So early and drunk already, I said to myself. But at least she was happy, and that was what mattered. It's better this way, I thought. Perhaps my father's threat had had an effect.

"I've been thinking about it," she said, "and it might be quite a scream. It could be positively amusing, you know. You and me with Mr. and Mrs. Wallpaper."

"What do you mean 'Mr. and Mrs. Wallpaper'?"

"I don't know, that's just how I imagine them. I bet all their walls are papered"—she gave another fascinating ripple of laughter, followed by a hiccup, which I found simultaneously highly erotic and rather repellent—"with that paper with tiny flowers on it."

"Yes, it might be quite fun."

"After all, what would we have done tonight anyway? Just bored ourselves silly at the Nautilus, listening to the same stupid conversations."

The Nautilus is the place where we usually meet up with our friends. I explained that we would not necessarily have to give up our visit to the bar.

And I told her my plan: to eat as quickly as possible with no seconds (however good the food), have a coffee and a liqueur, half an hour of after-dinner chat, and make an exit. The shortest supper of the year. Enough—just enough—to please Hong Kong and, above all, my father. And we would still have time to ease our friends' boredom by surprising them with an account of what promised to be a most singular meal.

"But," I said, "you're quite right. It will be a bit of a scream. Because as you'll see"—I would say anything to encourage her to go to the supper—"it's very easy to make fun of poor Hong Kong."

"And why would you want to do that?"

I smiled faintly. I didn't know how best to answer her.

"Don't you do that every day in the office anyway?" she asked mischievously.

We laughed rather conspiratorially while we distractedly watched the television which, at that moment, was showing the first statements being given outside Parliament by the recently freed deputies.

"I had a far worse night than they did," I remarked.

"How come?"

I regaled Alicia with every tiny—and apparently unimportant—detail of my awful nightmare about the iron swing with which, for some time now, I have had to do battle in my sleep and in real life.

She, quite rightly, couldn't be bothered to listen. She went off in order to continue drinking behind my back, the same long-suffering back that has to carry that swing in my dreams.

"Darling," she said a little while later, when I was having my breakfast in the kitchen, "isn't it time you forgot all about that wretched swing? You're worse than Hong Kong and his one story about the asylum in Melilla."

I was being compared to Hong Kong again, and I didn't like it.

"I wonder what his wife's like?" she remarked suddenly.

"Whose wife?"

"Whose wife do you think? Hong Kong's of course."

"I don't know. I imagine she'll be very ordinary and shaped rather like a meatball. What do you want her to be like?"

"I want her to be like you," said Alicia, accompanying her remark by her most melodious and erotic laugh, but which revealed, nonetheless, that she was in an advanced state of drunkenness.

She wouldn't stop laughing and I had no alternative but to stick her head under the shower. And there we made love.

"If we're going to this supper," I said, while I was lovingly drying her hair and she was looking at me, half confused and half furious, "it would be best if you didn't drink any more. If you carry on like this, I hate to think what state you'll be in by the time we get to Hong Kong's house."

As I was leaving for the office, she came with me to the front door and gave me my briefcase and a kiss. She seemed to have calmed down.

"You're quite right," she said. "I shouldn't drink. But speaking of drink, do you think we ought to take them something? I think a bottle of wine would be enough. Or perhaps it would be better not to take anything. Oh, who cares. Anyway, do you think people like them drink wine?"

"I wanted to talk to you about that. I don't think they'll have a drop of alcohol in the house. And if that's the case, we might die of boredom. I think that's reason enough to take them something. But you've got to promise you won't drink it before we go."

She promised.

"Just in case, I'd take a bottle of whiskey as well. Just in case. Imagine getting there and finding there's nothing to drink! It would be like a funeral. Let's take two bottles of wine, one for each hour we're going to be there, *and* a bottle of whiskey. It's best to be prepared for every eventuality."

At the office, I immediately ran into Hong Kong, who received me with open arms. I couldn't stand the man. I asked him on what date he was due to retire. All I wanted—though now I'm not so sure—was to have him out of my sight.

"In four days' time," he said.

"I asked you for the exact date," I said, raising my voice.

"And I gave it to you," he replied, somewhat startled. "The twenty-eighth of this month. It's the twenty-fourth today, so, as I told you, in four days' time."

I bit my tongue. I said nothing for the rest of the day. I took no part in any of the dreary conversations about the failed coup d'état. I said nothing when the people from the store downstairs had the nerve to demand payment for the beat-up radio. I barely spoke to my father either, except to tell him that we were dining with Hong Kong that night and to ask him if he was pleased to

have gotten his way. As for Hong Kong, I didn't say anything—much as I wanted to—when, at the end of the day, he waxed even more repetitive than usual with his Melilla story, and we, feeling sorry for him and more out of habit, laughed halfheartedly.

As we were leaving, though, Hong Kong came over to me, and apropos of the failed coup, though without my quite understanding the connection between the two things, he told me that there were times when he felt profoundly Czech—which was hardly surprising since many of his ancestors were Czech. And he said that he was telling me this because he wanted to put an end to the idea, once and for all, that the Czechs give in easily to their enemies.

"Because it isn't quite like that," he explained, to my stupefaction. "It's just that our own peculiar vision of life means that we consider all acts of force to be ephemeral."

That, I think, is more or less what he was saying. That is what I seemed to hear him say. As is only natural, I felt both sad and very surprised.

"Where did you read that?" I asked, just to say something, because I was feeling extremely confused.

"I didn't," he said calmly. "It was something I realized when I finally visited Prague for the first time last summer."

"You've been to Prague?"

"Yes, and there I encountered that peculiar vision of life which all Czechs, or, rather, which all we Czechs share. It's what you might call a metaphysical vision, if you see what I mean."

"You've been to Prague? And I'm sorry, but did I hear you correctly, did you just say 'metaphysical'?"

"Oh yes. I can talk about other things than my military service, you know. I said 'metaphysical' and I've been to Prague," said Hong Kong with his most oriental smile.

Another surprise of an almost metaphysical nature awaited me at home. When I arrived, I found Alicia serenely preparing a lemon cake. In a bag were two bottles of white wine and one of whiskey.

"A cake for the Perroquets," she said, giving me a kiss. "There's no reason why tonight should be such an awful experience. If we choose, we could even enjoy ourselves. After all, the Romans used to amuse themselves with their slaves."

It was amazing. She was in an extraordinarily good mood, and I had no intention of casting doubt on her suggestion that we were Romans. I hadn't seen her so happy in ages. I smelled a rat, and it did not take me long— after a rapid inspection of her sanctuary, that is, the bathroom—to discover that she was taking uppers again. I didn't really mind. It was preferable to other things—for example, to her having spent the whole day drinking. Pills and a good mood were definitely to be preferred. But I warned her, without any hope that she would listen to me, that it was important not to mix pills and alcohol, because she might end up in a worse state than Hong Kong had in Melilla.

"And speaking of Hong Kong," I said, "the man with one story is not such a fool as I thought. He's a bit of a dark horse. He's been to Prague, you know."

She thought I was still trying to encourage her to go to the supper and said:

"I'm perfectly happy to go to their house. I'm even rather looking forward to it. I think we'll have a terrific time with those parvemus, the Perroquets."

"You mean parvenus," I said. And while I was correcting her on that point, I thought it might be an opportune moment to tell her that their name was not Perroquet. Their real name struck her as enormously funny, almost too funny, and she said it out loud several times, then covered her mouth with her hand and burst out laughing with a laugh that was as contagious as it was erotic and melodious. We made love right there on the sofa, which is our favorite place for making love. She was still laughing half an hour later, when we reached the house in Plaza Rovira, in the heart of the Gracia district, where Hong Kong and his wife live.

His wife, Paquita, opened the door and let us in, asking if we had had any problem finding the house. She was very thin, with rosy cheeks and sandy-colored hair streaked with gray. She was from Andalusia. I already knew that, but one could tell straight away. Her dark eyes betrayed her, as did her accent. She had a frilly white apron on over her blue woolen dress. Her legs were encased in black stockings and a couple of holes on the knees revealed white skin. She was dressed as a servant; to complete the effect all she needed was a little lace cap. I could find no reasonable explanation for her dressing like that in her own house.

"Do come in," Paquita said nervously, removing her apron. "No, you're not too early, not at all. We were expecting you. Oh, good gracious, you shouldn't have gone to the trouble of bringing us anything."

"It was no trouble," I said, as I watched Hong Kong approaching. He also had the air of a servant: Although his double-breasted gray suit was impressive, he was bearing a white china dish on which were arranged slices of cheese and some biscuits, salami (Hungarian, he told me), pickled cucumber cut in the shape of rather strange flowers (Czech, he explained), and plenty of smoked salmon.

He bowed his head slightly, like a butler, and when we had helped ourselves to hors d'oeuvres, he ushered us into the living room, where a slight mustiness emanating from some of the ancient objects in the room suddenly reminded me of the smell of a dark store owned by a Hungarian Jew, to which my father used to take me now and then when I was a child. And in a whirl of associations, it occurred to me that there must be many interiors just like this in the mysterious city of Prague.

6

Despite the fact that there remained only the faintest echoes of something as enigmatic for a child as a war and the attempted extermination of a race, an invincible sadness still hung about the Hungarian Jew's store, a sadness that seemed to come from somewhere far back in time and which he tried to attenuate by selling comics, old books, artifacts, and iron bedsteads, all imbued with a sour smell that mingled with the whiff of suffering and fear that lingered there, as well as the strong smell of lacquer and incense, the aroma of distant lands and of exotic merchandise that I imagined lay hidden in the foreigner's inaccessible back room: rare books, model ships, Meissen china, magical trunks, Bengal lights, old portfolios full of engravings and dazzling tales from Cochin, China.

It was in that very back room, at the express orders of my father, and in a matter of only two days, that the iron swing on which I would thereafter spend so many childhood hours was made. The Jew made the swing with extraordinary speed, and I still remember the day he handed it over to my

father and assured him it was his finest work ever. That is what my father told me the exiled Hungarian said. I remember because my father often repeated it to me. I remembered it when I entered Hong Kong's house and my eyes fell on a detail that stood out amid the otherwise hideous decor, on a par with the proletarian aesthetic that dominates in most humble homes. It was something which, seen in isolation, could have been worthy of any bourgeois interior in the mysterious city of Prague: Two floor-to-ceiling display cabinets crammed with music boxes from all over the world.

Apart from those cabinets, there was nothing else worth looking at. It was all plastic tablecloths, flowered wallpaper, and the usual paraphernalia to be found in the homes of that class of person. Alicia was so perplexed by the ghastly proletarian aesthetic of the living room that she did not even notice those extraordinary music boxes which, if one focused exclusively on them, allowed one to forget the vulgarity of the rest of the room and to imagine oneself to be in one of the most sophisticated of Central European salons.

Hong Kong indicated some bottles arranged on a tray on top of the television: vodka, whiskey, gin, and rum.

"We don't drink," he said. "We just keep some for visitors."

And he permitted himself what seemed to me like a superior smile, as if he were perfectly well aware of how much I and especially Alicia drink. Alicia was oblivious to everything. Although she had handed over the bag with the drinks in it, she was still nursing the lemon cake in her arms.

Paquita saw this and finally relieved her of the cake. She looked at it as if it were the first cake she had ever seen in her life.

"How very kind of you."

She raised the cake to her face and sniffed it.

Alicia grimaced. I pointed out the glass cabinets to her.

"She made the cake herself," I said to Paquita.

Paquita nodded and again sniffed the cake, and I was again aware of the sour smell in the living room that had reminded me of the Hungarian Jew's back room, and then she, Paquita, withdrew to the kitchen with the cake.

"What would you like to drink?" asked Hong Kong.

Alicia and I flopped down on the sofa. I got out my cigarettes. We both said "Whiskey" at the same time. Hong Kong brought us an ashtray.

"We've never smoked," he said. "But we don't mind other people doing so. We've even got ashtrays for our guests."

It was a glass ashtray in the shape of a saber. I lit my cigarette and dropped the match into the saber hilt.

"It's from Japan," said Hong Kong.

"The Philippines," Paquita said, returning from the kitchen.

"Oh, that's right. I always get confused. Some friends brought it back from Manila, along with two marvelous music boxes containing miniature dancers that whirl around inside the box."

We were clearly not going to be able to avoid a conversation about music boxes.

"You have quite a collection," I said.

"Do you like it?" asked Paquita, turning on the television.

"We're not going to watch it," Hong Kong explained. "It's just that my wife likes to know which numbers won the lottery."

"What was your question?" I asked Paquita. "Were you asking me if I liked the collection of music boxes or the television? They are, of course, two very different things."

Hong Kong reacted as if he had sensed a note of irony in my words.

"Whenever my wife asks a question, she always refers to two things at once. That's why it's so difficult to give her an answer!"

Alicia could not suppress a brief burst of musical laughter. She had just knocked back a whole glass of whiskey. I prayed to Providence to make Alicia notice the collection of music boxes and thus find at least one positive aspect to the house and its owners. If only she had my imagination and could pretend that we were inside some stately home in Prague. It's easy enough, I said to myself. You just have to look at those two great glass cabinets and forget about everything else. I was convinced that this helped one keep a grip on oneself. But Alicia could see only the lottery ticket, the flowery wallpaper, and her hostess raising the lemon cake to her face and sniffing it. Hong Kong, perhaps to save the situation, said that he loved the cinema and that he used to see so many movies a week that, over a period of many years, it was as if he were watching one continuous movie. He said:

"I know all the actors, even the extras, and I pay special attention to the actors in the minor roles; it's always such fun when you spot one of them."

"Well, lately," said Paquita, "all those faces have started to seem faded, flat, anonymous. I get bored."

Alicia poured herself another whiskey.

"Perhaps it's just that your eyesight's failing," she said and laughed again.

Paquita seemed quite hurt.

"Oh, come on," said Alicia, trying to smooth things over. "It was only a joke. It's just my way of talking. People who know me, my friends, just ignore me."

"Well," said Hong Kong, "I owe you both an explanation because you belong to a different world and you probably feel a bit out of place here with us, it's only natural. So, first of all, I would just like to thank you for coming. You've made me very happy. You have done an old man a great favor."

"You're not that old," broke in Alicia, rather inappropriately.

"I'm old," he said. "She's old. We're old."

"Don't exaggerate," I said.

He went on: "There's a difference of social class between you and this old man. There's always been a superficial relationship, but after years and years of working together, we hardly know anything about each other. There's nothing to be done about that now, but this supper might serve so that tomorrow, when you think of Parikitu, you will remember that he too had a heart. To put it another way, you won't just associate him with that story about Melilla which I often tell in the office."

"I've never heard it," remarked Alicia.

Oh God, I thought. I would have to do something to stop him telling it again.

"Have you seen the display cabinets?" I said to Alicia, changing the subject and trying one last time to make her notice the collection of music boxes.

"What's there to look at?" she asked.

"Can't you see? Aren't you interested in music boxes?"

She went very quiet and serious, as if stunned. Whenever she puts on that look of puzzlement, I always want to laugh. I controlled myself.

"Well, can you see them or can't you?" I insisted.

"We'll eat in about ten minutes," said Paquita. "I've just got to finish making a couple of sauces. I'll go and have a look at them."

I tried to pour oil on troubled waters.

"You were telling me your reasons for inviting us," I said to Hong Kong, "but there's really no need. Believe me, I understand. If you must know, it's a great honor to be invited to celebrate your retirement."

"Yes," said Alicia. "It's a great honor for us that it's a great honor for you that we've come to celebrate your retirement."

Alicia realized she had slipped up again and once more went quiet. This time I couldn't control myself and I laughed out loud. It seemed to me that, despite my best efforts, things were beginning to go wrong. I tried to put things right, but Alicia got in before me.

"Now that you're retiring, Señor Parrakitu, you can speak openly. What do you think of your boss? Don't you think that as both father and boss he is unnecessarily authoritarian? Although as a father, I must say, the authoritarian pig is just blindly authoritarian."

After the initial shock, Hong Kong reacted with great aplomb to the situation.

"I didn't ask you here," he said, "in order to speak ill of anyone; on the contrary, I want to cement relationships with everyone. Although I would add, and I say this without the slightest rancor at the moment of my retirement, that the boss is indeed somewhat authoritarian, and has always been. But that has fostered discipline among his employees, and the business has prospered. Besides, authoritarianism is a sign of a strong character. I only wish I had had a bit more of it myself. I wouldn't be where I am today, not that I'm complaining. I like my collection of music boxes."

"He made me spend my entire childhood on an iron swing," I broke in.

"He is, if you'll permit me to say so, a man of iron," said Hong Kong.

"My husband still dreams about that swing," Alicia remarked.

"It's like one long endless nightmare," I went on. "An iron upbringing, an iron job, and that wretched iron swing. What a life! But let's not talk about that. I haven't come here to criticize anyone either."

They announced the winning number on the television, but there wasn't time to write it down. A small drama ensued. According to Hong Kong, if Paquita didn't get the number, she would become hysterical. We had to invent a number and give it to her when she returned with the food and asked us to sit down at the table.

The supper was very difficult. In order to forget how much Alicia was drinking, I started to drink heavily as well. White wine, pear liqueur, and four

whiskeys with dessert. Indeed, by the time we reached the dessert, Alicia's laugh was at its most melodious—not to say frankly and irritatingly repetitive—and she said she would be quiet only if Hong Kong would tell her the Melilla story.

He flatly refused.

"Ask your husband to tell you," he said suddenly.

He was obviously angry. We had doubtless tested his patience to the limit. Especially Alicia. But I had contributed as well, with various sarcastic comments born of my amusement at the couple's utter sobriety—they hadn't touched a drop of alcohol. Then Paquita, who had not spoken for some time now, apparently wounded by our barbed comments, broke her silence to say that it was one thing for us to laugh at them and their humble state (in that aside she included our obvious distaste for her onion soup) and quite another for us to continue to insult them without the slightest sign of letting up. She added, suddenly addressing me as "tú":

"You're hurting your father."

Alicia gave a loud guffaw, without knowing what she was laughing at. (By that stage, she wasn't really aware of anything.) Her laugh angered Paquita still more; she turned to me and said:

"Listen. You no doubt remember the Melilla story. A thin woman appears in it. The nun's Moroccan assistant. She seems to be a minor character, but she isn't. She could be me, but she's not. I'm thin, but I'm not Moroccan. When my husband was in the asylum, he got her pregnant. He had a child by her. I bet you can't guess who his son is."

"The Aga Khan?" I said jokingly, although I was trying hard to conceal my inevitable agitation.

"No, you're wrong. You're that son," said Hong Kong.

And to my complete amazement, accompanied by the musical backdrop of Alicia's melodious laughter, as if trying to apologize, he added a remark that filled me with unending dismay:

"I sold you because I was poor."

7

Sometimes I wonder if I should feel ashamed of the fact that I had always considered Hong Kong to be merely a minor character in his own story, just as I had the nun's thin female assistant in Melilla. I have been a complete fool. I see all my office colleagues as fools too when, even now, if someone asks about Hong Kong, they immediately kick up their usual stupid racket and think themselves terribly funny as they chorus:

"We all know Hong Kong."

By this they mean that they all know Hong Kong the man, which seems, at the very least, utter foolishness, especially when I recall that curious moment at supper when—I remember it perfectly and will never forget it— the hitherto discreet Hong Kong saw fit to tell me:

"I sold you because I was poor."

He plunged me into a truly Hamletian state of doubt, with which I am still struggling, swinging back and forth on the most tragic of all swings.

"Your mother died in childbirth," Hong Kong told me. "She had no relatives, just the poor nun with her cookies and her dawn rosary. I can't tell you much more about her. And don't ask me for a photograph because I haven't any pictures of her. I haven't anything of hers. But, in case you're interested, I can tell you she was a Berber. From a village to the south of Marrakech. The village had a small mosque with a minaret and a lot of storks nesting on its towers. That's all she told me about her village. I don't know anything more. As you can imagine, I did not love her. It was just a mistake, a complete mess. The nun looked after you initially, so your first steps in the world were taken inside that insane asylum in Melilla that amuses you so much."

I was following his words with incredulity but with dismay, too, because I could not discount the fact that what he was saying might be true.

"When I was discharged from the army," he went on, "I caught the first boat back to Spain and took you with me to Barcelona, where all that was waiting for me was a job in your father's office. I must confess that more than once during the voyage I thought of throwing you overboard. No one would have known. But the profound Catholicism of my Czech ancestors prevented me. Because all I have ever had are ancestors. That has been one of the most

painful facts in my life. Only ancestors from a far-off country. But perhaps it's my Czech nature that has helped me get through all these years in which, slowly, I have grown fond of you, not that you have done much to deserve that fondness."

He began scrutinizing my face, centimeter by centimeter.

"Now do you understand why we invited you to supper?" Paquita said.

I was too troubled to answer. I heard all this with a mind enveloped in dense cloud, brought on by the alcohol, and everything seemed slightly unreal. As if that wasn't enough, I was doing my best to avoid Hong Kong's meticulous, centimeter-by-centimeter inspection of my face.

"Why *did* you invite us to supper?" asked Alicia.

"Because he wanted to say good-bye to you," Paquita said to me. "To see you one last time, or, with a little luck, to forge a friendship with you and have the chance to go on seeing you now and then, to go on seeing his son. He loves you."

"I don't understand one word of this, not one word," said Alicia. She had doubtless noticed that, for some time now, she had not been getting any moral support from me for her laughter, and she was making an attempt to rejoin the conversation and find out what the hell was going on and why everyone was talking so seriously.

"Anyway, let's just leave it," Hong Kong said with a tragic gesture, surprisingly histrionic for a discreet, gray clerk. "There's no point going over and over it. You're my son, but even that means nothing now. Forget it. Look, I'm going to show you something."

He seemed on the brink of tears. He got up and went over to the display cabinets, possibly in order not to cry, and returned bearing a splendid music box. On its lid were miniatures of three famous Prague automata. In the eighteenth century, Hong Kong explained, a fine clockmaker lived in the city, the disciple of a famous Swiss clockmaker. The automata represented a scribe, a draftsman, and a harpsichordist. They were the pride of the city, but they were lost somewhere on one of the long tours around Europe of these masterpieces. But in Prague the people never forgot about those three lost sons, and sometimes advertisements would be placed in local newspapers abroad asking for news of their whereabouts. Early in this century, they were found and brought back to Prague.

"I should also tell you," said Hong Kong, concluding what appeared to be a metaphor on the theme of the prodigal son, "that just like the original automaton, what the scribe on my music box is writing in eighteenth-century calligraphy are these words: 'We will never leave our homeland again.'"

Alcohol makes us sincere. It also makes us believe what others tell us. I was more and more convinced that, however strange it might seem, Hong Kong was telling me the truth. I kept remembering my father, in the office, saying to me: No one would think you were a son of mine.

"Is that the most valuable piece in your collection?" I asked, in order to say something.

He nodded.

"Did you really want to throw me overboard?"

"What was I supposed to do?" he said at once, eager to continue talking to me about the drama of being a father.

"You don't know what it was like for him arriving back in Barcelona with you in tow," Paquita said.

"A single father then faced nothing but problems. I came back to a postwar Spain at its lowest ebb. Luckily, I had a job. Your father's office was there waiting for me. At least I had work, thank God. But everything else was a complete mess: drama, madness, disaster, ration cards and depression. Preparing baby's bottles, you waking up crying in the middle of the night, my appalling reputation in the boardinghouse where I lived, having to conceal the fact that I was a father from the people at work. One day, I couldn't take it any more and I burst into tears in the office of the man you have always thought of as your father. Yes, I broke down in tears like a child. I told him what was wrong and after a few days, he came up with a solution. He explained that his wife was infertile, that adopting children was very difficult in Spain and he offered to buy my son from me."

Hong Kong covered his face with his hands.

"Did I hear correctly?" asked Alicia. "Are they going to adopt a son?"

When she heard that, Paquita also covered her face with her hands. As if she were sniffing the lemon cake, a cake that we had already eaten.

Damn Hong Kong, the man with only one story to tell. That is what I thought when I saw that he wanted to go on talking. It was as if his life depended on it.

"I'll buy your baby. That's what your dear father said to me," he went on, becoming increasingly upset. "I told him my son wasn't for sale. Then you'll lose your job, he replied. And he offered me a sum of money and the promise that I could continue working in the office until you were older. He even increased my salary. That was what decided me and I sold you." He covered his face with his hands.

I began—who, in my place, would not have?—to drink like a fish, punctuating each sentence uttered by Hong Kong with large gulps of wine. He was still carrying out that centimeter-by-centimeter scrutiny of my face, as meticulously and precisely as he was telling the story.

"I sold you because I was poor. Eventually I came to regret what I had done, and the pain of remorse was compounded by the absolute certainty that I would never get you back, because I could not risk telling you the truth—that would have meant automatic dismissal. And life in postwar Spain was still very hard. Besides, your father, the Authoritarian, as I like to call him, renewed the contract. When you were seven, that is, when you first started swinging miserably back and forth on that iron swing, he renewed the contract and bought my definitive silence with a very large sum of money that I needed at the time to pay off a dangerously large gambling debt, because, in order to forget my sorrows"— again he hid his face in his hands—"I had sought solace in secret poker games and had lost money hand over fist and, what was worse, I had lost you forever."

He broke into convulsive—I would say spectacular—sobs. The Prague music box fell to the floor and a lovely melody began to play, a gypsy melody; or perhaps it was something Czech. And to put the final touch to what, by then, I was hoping against hope was pure fiction—nothing but a subtle act of revenge on the part of the Parikitus, at least that was what I was praying to divine Providence for—he said that life had been very bad to him, very bad indeed.

"Very bad," repeated Alicia.

Paquita put her hands to her head and then carried the plates out to the kitchen.

"Very bad indeed, Señor Parruqué," said Alicia. "Awful, in fact. I mean you didn't even give us napkins."

I felt that the time had come for us to leave. I was still relatively lucid, and I thought it best to withdraw. I was convinced—I needed to believe it was so— that they had simply been making fun of us. Yes, they had been making fun of us, and, later on, I would place the blame for that on Alicia. They accompanied us to the street door. I remember everything about that night and I tremble.

I will never forget it. I remember how Hong Kong, standing out in Plaza Rovira, kept scrutinizing my face. And the two of them innocently saying good night to us, when we had already got into the car. Hong Kong insisted on giving us the music box from Prague. He even said to me:

"Go back to your homeland."

In the car, Alicia sat close to me as we moved off. We went straight home, without stopping at the Nautilus. In rigorous, cautious silence. When we got home, I looked in the mirror and I saw my beard and I saw my Berber face.

I still catch sight of that Berber face now and then. I decided not to tell my father about any of this because, if it turned out to be true, if I really am Hong Kong's son, I would be disinherited. But if I'm not and I ask my father if he is, in fact, my father, he could disinherit me anyway, for being distrustful. Alicia says that everything I've told her about that supper is a lie and that the only thing she noticed was the Parruquets' uncontrollable drinking and, worse, their failure to appreciate her lemon cake. She also says my father has always been my father, and that's that.

I don't see it so clearly, though. My two fathers have condemned me to go back and forth, in a permanent, eternal state of doubt, on the most uncomfortable swing in the world. Seated on it, I have spent two whole days telling myself, bit by bit, this story that is driving me mad. I hear the creak of the swing even in my dreams.

Hong Kong retired today. He came and said good-bye to me a little while ago.

"I'm so sorry," he said. "Give my regards to your wife. Good-bye."

My colleagues asked me what the poor man was so sorry about. They also asked why he had passed on his regards to my wife. I had to come up with something quickly, so I told them I had gone to supper at his house—they all froze—and that it was very boring and that, apart from having to listen to Hong Kong telling all over again and with no variation the story of the asylum in Melilla, the onion soup had been absolutely disgusting. They rolled around laughing, some even bumped blithely against the walls, and all of them called me Hong Kong.

Translated from the Spanish by Margaret Jull Costa

from **Souls Over Harlem**

PHILIP SCHULTZ

10.
 My father's
immigrant eyes
flashed in the slats
of shivering rain
as he torched
a clothing warehouse
for insurance, while
I sat in the car, watching
his shadow sprinkle
a can of gasoline—poof
all six floors a blistering ladder of light
 climbing
the sky, floating
 deep inside
the grid of my ten-year-old eyes,
the ash cloud falling
over the night—wondering

what if people are inside
what if the police come
what if mother finds out
why he wanted a witness

boomboomboom
rain hammering the hood
like fists

23.

 Everything
goes round
 and round
like the earth
 around the sun
or is it
 the other way around?
All
 R ever wanted
was a proud spine,
 ain't like they
who got one
gonna miss a slice,
trick is
 never ask
for love
 while you're
on your knees.

ROBERT ZIEBELL

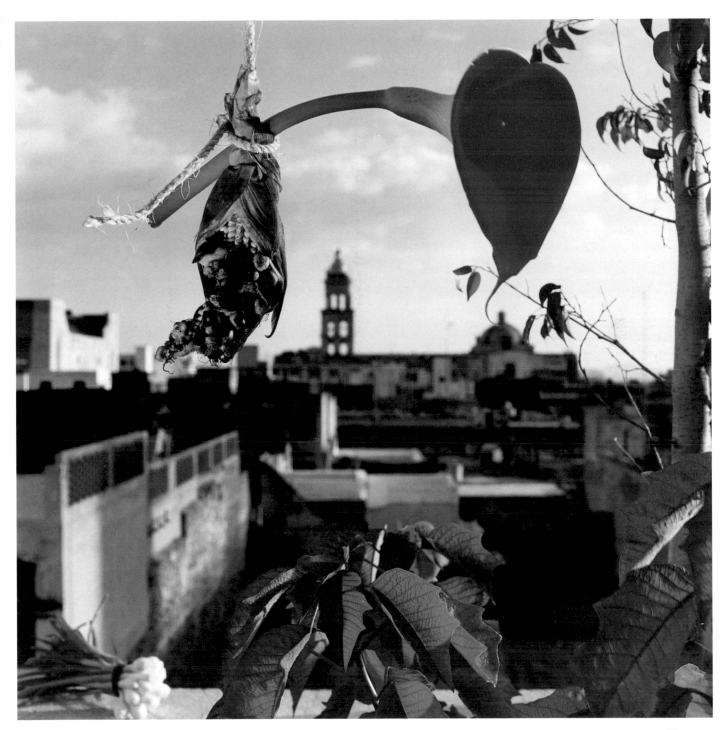

Puebla, 1995.

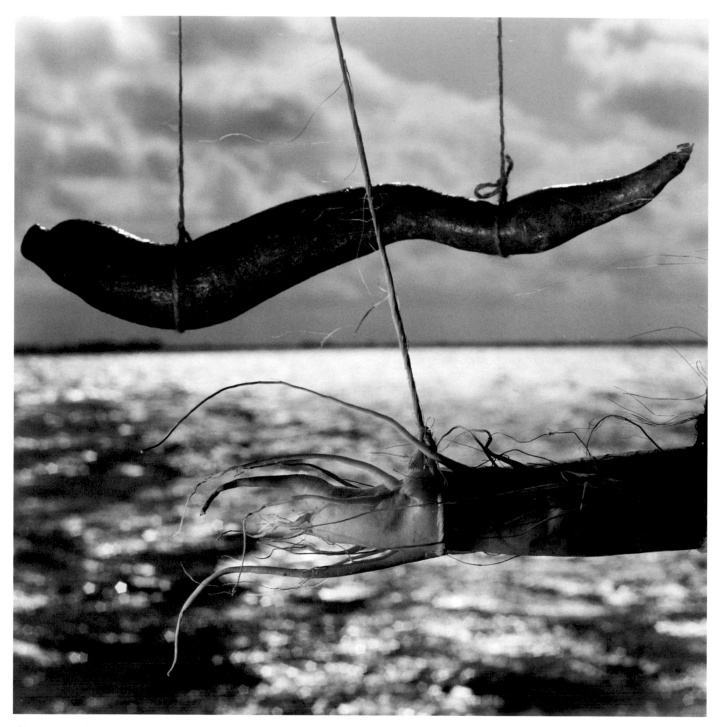

Chinquapin, 1996.

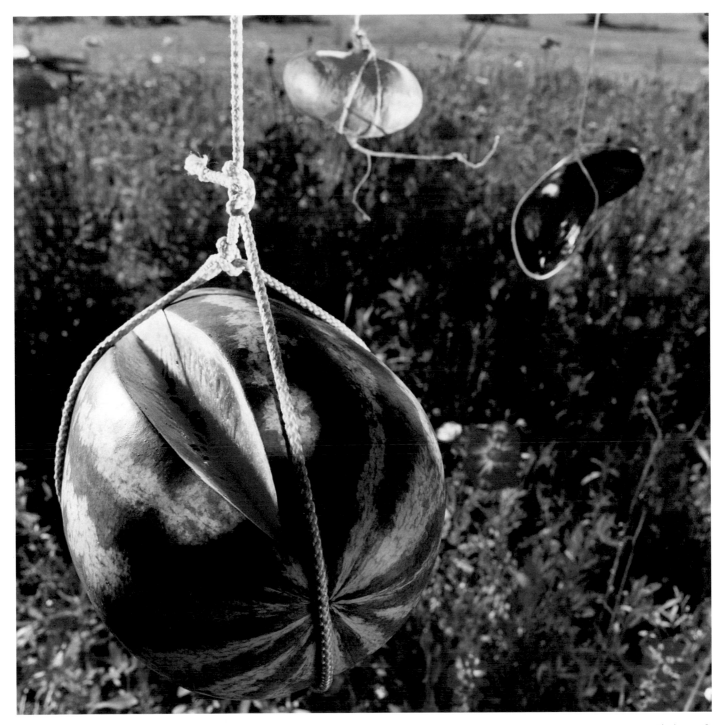

Picnic, 1996.

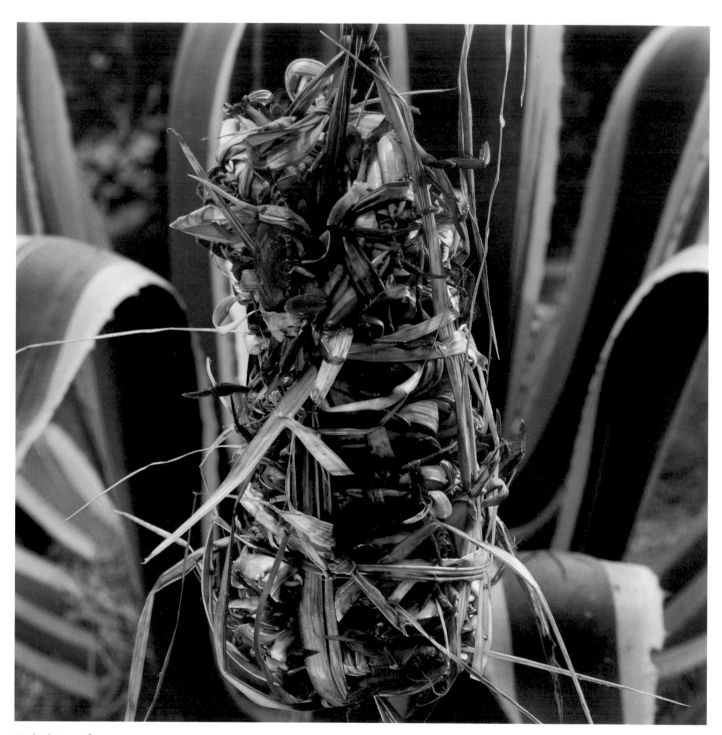

Huejotzingo, 1998.

Robert Ziebell

Robert Ziebell brings an innovative approach to his
primary subject: the still life. Rather than arranging
objects on a flat surface, he binds various fruits
and vegetables with rough hemp rope and suspends
them in air so that they are seen literally *against
nature*. Ziebell's influences range from the photo-
graphs of Man Ray to the look of Mexican *mercados*.
He can be as shrewd and inventive as Man Ray was,
but his work also has the earthiness that is known in
Mexico as *el sabor de la mano*—the flavor of the hand.

Walter Hopps

Where Was It

SHARON OLDS

Maybe it lived in a canopic jar
on her bureau, among the perfume bottles con-
cocted of crystals cut open to the heart,
or maybe it was down in the basement,
behind the furnace, almost the size
of the furnace, dressed in a lace of fuel-dust—
where was it, my mother's penis? Maybe
it was partway up the chimney, in the niche
of a fallen-out brick, herma of the hearth,
did it glow in concealed glory when there was
a fire. I hope when the Saint descended
he gave it little nuts and candies
at its feet, and a night-blue cloak to wear on the
cold dawns of summer. I don't think it was
ever in the kitchen, not even in the long-handled
tools drawer, with the spatula
and baster and the meat-tenderizer hammer,
never in the icebox or oven, but maybe it
went outside by moonlight sometimes
to lie under the blossom tree
and feel along its length the kisses whose
source had been in the earth. Did it go in the
garage at the hour of the wolf, and swim
in the hackles glamour under the car,
did it tremble if a neighborhood cat was out
moving between the heavy columns
of flowering stock? Now it passes back
in, through the locked door, and up
the stairs, revenant, amulet, it grows
small as a clitoris to enter their bedroom through the
polished keyhole, and then it is in
the arena, then it is home free
in the place of subjugation, and it rises,
and hardens, and rampages.

YANNIS KONDOS

Each night the woman

Each night the woman
from next door—I can tell it is a woman
from the sound of her hair—nails something
to the wall. Maybe her secrets, maybe
her kitchen utensils. No, she is nailing her hand
up high and thus, hanging, sleeps like a bat.

Translated from the Greek by Peter Constantine

LOBA LAMAR'S LAST KISS
(SILK CREPE RIBBONS AT MY FUNERAL . . . PLEASE)
PEDRO LEMEBEL

WHEN SHE THOUGHT UP THAT NAME, a stage name worthy of the seedy vaudeville theater where she was the star attraction, she displayed all the inventiveness of the streetwise faggot. Perhaps she called herself Loba Lamar because the glossy, seaweed black of her skin, bruised by all those sailors, reminded her of a seal—a *lobo marino*. But Loba Lamar was something else, too: a teardrop in black lamé, the trampled embers of Africa, an opaque glow among the harbor lights, when, on her way back to her dingy room, she stumbled and fell on the stairs, amid drunken laughter and the penetrating smell of Madonna lilies and cheap perfume. It was hard to remain standing at that hour in the morning, having mamboed all night in stilettos, with the AIDS-induced giddiness that blurred her vision and confused sky and sea, turning the waves into a vertigo of stars. At the time, Loba had believed it was the end—quick, painless, and sudden, as if dying from AIDS were just like tripping in the middle of the stage, a little path of sparks across the Caribbean Sea marking the way into the next world— a moon shining on the water, swept along by the epidemic's tropical, terminal beat. But, awakening, she found herself back in the same place, leaping from star to star, for that stumble on stage was not death at all, but a pallid return to life.

Loba never really understood what it meant to be a carrier, which was fortunate really, because, if she had, AIDS would have carried her off much more quickly—on a toboggan of depression. Although she kept turning the bit of paper this way and that, she just could not get her head around the mathematical exercise that made a minus of a plus, and no one could convince her that a positive result was actually a dismissal notice. She had

always been lazy at school, useless at studying and at understanding mathematical concepts. Plus-minus makes a negative, or minus-plus makes a positive, oh, fuck it, to hell with numbers.

We never saw Loba looking sad, but perhaps a dark cloud slipped into her mind. That's why she put away the piece of paper bearing the result and took a deep breath, sucking in the stale air in her room until she had tempered the gravity of the news. Then she went to the window and opened it to look out onto the rusty seaside roofs. She took a lock of her hair, stripped of its natural color by cheap dyes, and pulled it out with a sound like paper tearing. For a moment it shone copper-red in a ray of sunlight. Then she let it go and it floated off on the soft, feathery air of early evening.

Loba never let the depredations of the plague spoil her looks—the yellower her skin, the more rouge she put on; the darker the circles under her eyes, the more concealer she applied. She was never still, not even during her last months, when she was thread-thin, her butt pure bone and her gleaming skull covered only by a light fluff. And there she was shaped by the sun, "although it's winter in my heart," as she would tirelessly repeat when she was too exhausted to dance.

The rest of us drag queens who shared the room thought Loba must have made a pact with the Devil. How had she managed to last all this time? How could she look so pretty, even covered in scabs? How, how, how? No AZT, just effort and willpower, that was how she held out for so long. It was the sun, the good weather, the heat. She lasted, fresh as a rose, through the whole summer, and all of that mild fall; only when winter arrived, when the stiff, briny drizzle of Valparaíso set in, did she give signs that she was about to say good-bye. She took to her bed, once and for all. And then the torment began.

After the medical examination, La Lobita did not want us to take her back to the doctor. They're next-of-kin to the grave diggers, she used to say. She couldn't stand the idea of a hospice either: They were like concentration camps for lepers. Like in *Ben-Hur*, the only movie she had ever seen. She vividly remembered the young man's journey to the leper colony in search of his mother and sister, who hide from him so that he won't see them with their skin falling away in strips. They too had been beautiful once, royal and lovely, just lovely—but not as lovely as Loba Lamar, who spent her nights burning with fever, swearing that she was in a Roman galley alongside

Ben-Hur. She would make us row, perched on her bed, as the hot waves of fever made her cry out: Steady there, whores of the oars! Onward, mambo queens!

We took turns looking after her, washing her bottom as if she were a baby. We were her nanny, her nurse, her cook, a troop of slaves that the lovely Loba bossed around as if she were Cleopatra, but sometimes we had to count to twenty twenty times in order not to wring her neck. Just to keep her quiet and allow ourselves a little sleep during the long sleepless nights that her dying lasted. In her demented state as moribund queen she kept coming up with such weird ideas, such eccentric desires. At midnight, in the middle of winter, with the rain pouring down, she wanted to eat fresh peaches. And we, like idiots, pooled every cent we had and set off in the deluge down the deserted streets, getting soaked to the skin in the process, waking up all the fruit sellers in the port to ask if they had any peaches, walking up and down hills, until we finally found some canned peaches at a market. And when we got home, dripping wet, Loba hurled the can back at us because, by then, she had gone off the idea of peaches. Now what she wanted was orange ice cream. Orange? Couldn't it be something else, sweetheart? They don't make orange ice cream in Chile, Lobita. But she threatened to die right there and then if she didn't get a whiff of the bittersweet perfume of springtime oranges. And so we frostbitten queens once more braved the elements and finally managed to buy some ice cream from an ill-tempered Argentinean, who agreed to sell us a single cone, after we had sung him a sad tango about our mother on her deathbed. And even then Lobita couldn't sleep. She did not want to leave without first fulfilling all the frustrated desires that were drying her mouth. Because in hell there won't be any peaches or oranges. And all that heat must give you a thirst.

Ah, slaves of Egypt, bring me melons, grapes, and papaya, raved the poor woman, waking up the boardinghouse with screams worthy of a woman in labor. As if in the inferno created by her illness she had become pregnant with mourning, replacing life with death, the death agony with birth. To Loba, in her crazed state, AIDS had become a promise of life; she imagined herself to be the bearer of a child incubated in her anus by the fatal semen of lost love. That prince of Judea called Ben-Hur had planted the seed one night on the Roman galley and then disappeared at dawn, leaving her pregnant with her own shipwreck.

Night after night, we would hear her calling out to him, and we tried to satisfy the cravings of this Loba in labor. She decided she wanted to prepare a layette for the prince to whom she was about to give birth, and we all started knitting shawls and bonnets, little jackets and bootees for her baby. She made us sing lullabies and rock her, fanning her with feathers, as if we really were the slaves of a pregnant Nefertiti. At some moments, when we were utterly exhausted, she managed to draw us so convincingly into her fantasy that we almost began to believe the birth would actually take place. That is why we would get up, sneezing, regardless of the cold, and listen to her latest, insane ramblings, her voice growing ever hoarser, ever fainter, as though she was still trying to bellow out orders, haughtily opening her mouth like a hippopotamus on the Nile. Nothing would come out. Her Pharaonic orders went unuttered. And there we sat, having covered every mirror so that Loba would not go in search again of her own image, pleading, praying, begging for the prompt arrival of that airplane going nowhere. There we all were, wiping away Loba's sweat, reciting Ave Marias, and mumbling faggoty rosaries as background music, as pale and tremulous as Lobita herself, waiting for the moment, the second when she would die and the torment would be over. In that abyss, her silky skin glowed like a black lily. Like a swan made of dark mother-of-pearl, her jewel-encrusted neck curved like a ribbon. Then, through the open window, came an icy breeze like a blast from the tomb. Loba tried to say something, to shape her stiff lips into a howl. Her eyes opened very wide, as if she was trying to take away with her a last snapshot of the world. We saw her fluttering desperately so as not to be swallowed up by the dark. We felt that icy air which left us frozen and speechless, unable to take our eyes off Lobita. We stood around like fools staring into the chasm of her mouth, as deep as a black well, in which all we could see was her tongue. Her lovely mouth blasted open like a tunnel, like a sewer that had carried La Lobita off into the filthy waters of a sinister whirlpool. Finally, we came to and ran to the edge of that ditch and shouted inside: Don't die, Lobita. Don't leave us, sweetheart. We sobbed as we peered down her throat, reaching into the darkness to grab her hair as she fell. All of us trying to reach in and bring her back to life. We took her hands, rubbed her feet, shook her, embraced her, covered her in kisses, weeping and laughing hysterically; we brought her water, and jostled each other, not

knowing what to do or how to deal with that inopportune visit from Madame Death.

And on that river of tears we saw our friend depart, in the AIDS airplane that carried her, open-mouthed, off to heaven. She can't leave like that, we, her fellow queens, said, now somewhat calmer. She can't stay with her mouth gaping open, like a hungry frog—not she who was so lovely, so concerned about her looks. Loba Lamar should be remembered as the diva she was. We must do something quickly. Bring a scarf so that we can close her mouth before she stiffens up. A scarf big enough to go around her chin and over her head. No, not yellow—that stands for scorn. And no polka dots either—Lobita would never have worn such a ridiculous scarf. And definitely not green—it would remind her of the cops, and you know how she hated them. What about that blue chiffon scarf with gold threads, yes, that one you're trying to hide, you tightfisted faggot—honestly, and your friend just dead. That one would suit her perfectly. And don't tie the knot under her chin either, as if she were a Russian peasant or Heidi. Tie it slightly to the side, toward one ear, the way Lola Flores used to wear her scarf, well, you know how Loba adored her. Tie the knot good and tight, even if it does slightly squash her face, and leave it like that for an hour, until her face sets and hardens.

For an hour, her friends washed the body with milk and starch as if she were a Babylonian queen, smeared her with hot depilatory wax to leave her as smooth as a nun's tit; one gave her a manicure, sticking on snails' shells and seashells instead of false nails, and another sawed away at her calluses and her corns, removing the calcareous grime from her feet. Because, my dear, you weren't really that dark-skinned, just not very keen on soap, preferring to plaster more makeup and perfume on top of the crud, said her friends as they scrubbed with bleach at La Lobita, who was gradually growing stiff, as they plucked her eyebrows and curled her eyelashes with a hot spoon. Then they removed the scarf from her face in order to do her makeup, and they were pleased to see that the pressure of the scarf on her chin had sealed her mouth as hermetically tight as a crypt. But as her facial muscles had tensed up, Loba's tight lips had set into a macabre smile. Oh, no, cried someone, my friend can't be buried like that, wearing that vampire grin. Bring some hot towels to soften her up. They can be as hot as you like, after

all, the poor girl won't feel a thing. But on contact with the hot towels, La Loba's lips drew back as if in a sinister laugh, her facial nerves tightening like springs. You'd think she was playing a practical joke on us, grumbled Tora, a burly queen who had been a wrestler in her youth. Leave her to me. And we fell silent because it's no laughing matter when Tora gets angry. We just suggested that she should treat Loba gently. Don't worry, said Tora, snorting, she's not going to beat me. And off she went and returned in her wrestling gear, a scarlet cape and a devil's mask that had earned her the name Lucifer, the Invincible Flame. Tora performed a few leaps, did a couple of push-ups, inviting applause. Then amid an uproar worthy of a bull ring in Andalusia, Tora grew serious and silenced the shouts with a Shhh! so that she could concentrate. Not so much as a fly buzzed when she knelt at the foot of the bed and made the sign of the cross. She leapt onto the corpse and began slapping its face. All we heard was the sound of slap-slapping as Tora beat Loba's face to a pulp. Then, with one giant hand, she squeezed Loba's cheeks between thumb and forefinger until Loba's lips looked like a pouting rose. Go on, suck in your cheeks, sweetheart, suck in your cheeks like Marilyn Monroe, Tora said and held her face for nearly an hour, until Loba's flesh regained its funereal rigidity. Only then did Tora let go, and we could all see the marvelous result of her necrophiliac handiwork. We stood there, our hearts in our mouths. Loba's lips were pursed, blowing us a kiss. We'll have to cover up the bruises, said someone, taking out an Angel Face powder compact. Why bother? Rose pink goes well with purple.

Translated from the Spanish by Margaret Jull Costa

Steam

LAVINIA GREENLAW

Petersburg breathed through Finland . . .
One traveled there to think out
what one could not think out in Petersburg.
 —Osip Mandelstam

I climb out of layers, wash off layers and take out my eyes.
Three times, back and forth in growing separation.
Under cold water, skin and bones; in the heat, all heart.
The sauna coals mutter like gods locked in the earth.
When I douse them, they blurt. They want to tell,
they want to tell and I breathe them . . .

It's not enough, only a few small steps
like those of the women picking their way
along a glazed jetty through sectioned light.
They folded robes, tested each rung
And half-entered a pool punched in three feet of ice.
Each swam a single circle, wearing slippers and gloves.

LUCINDA DEVLIN

THE OMEGA SUITES

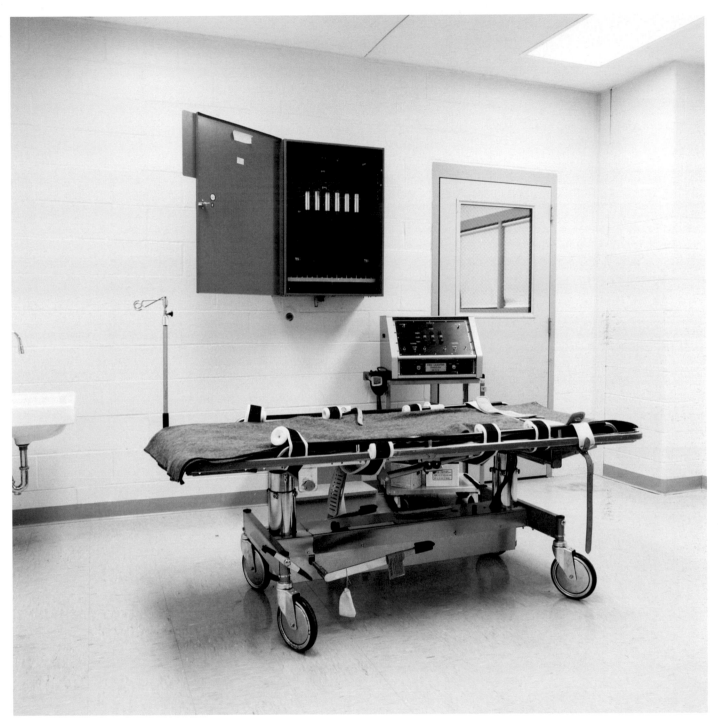

Lethal Injection Chamber, Potosi Correctional Center, Potosi, Missouri, 1991.

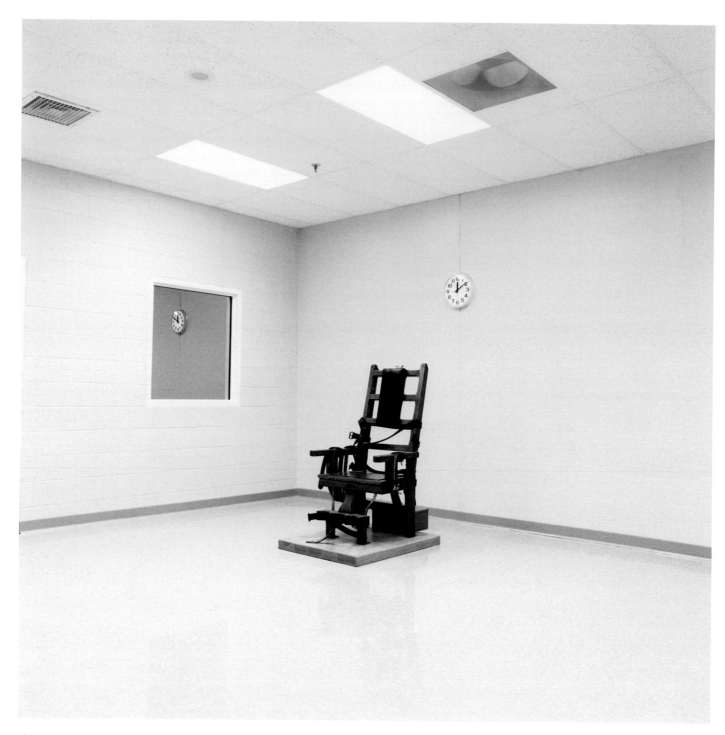

Electric Chair, Greensville Correctional Facility, Jarratt,
Virginia, 1991.

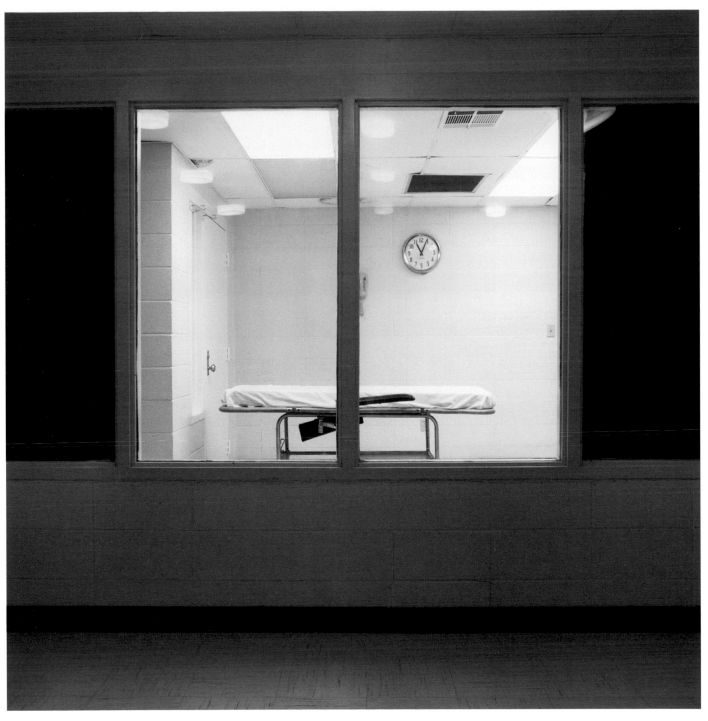

Lethal Injection Chamber from Witness Room, Cummins Unit, Grady, Arkansas, 1991.

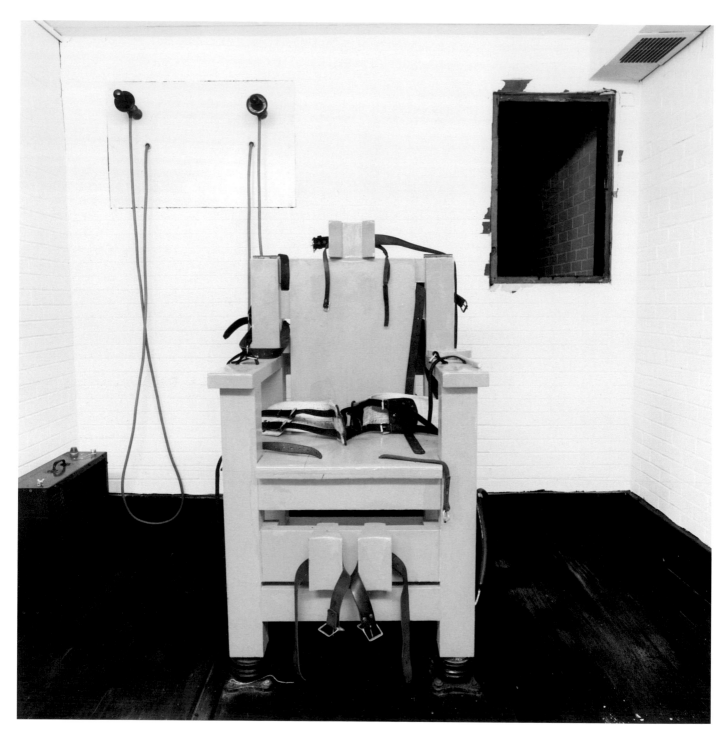

Electric Chair, Holman Unit, Atmore, Alabama, 1991.

Stephen Trombley

The Execution of A. J. Bannister

In 1991, after spending a week with Fred Leuchter, inventor of the lethal injection machine, I traveled to the Potosi Correctional Center, in southeastern Missouri, to visit that state's death row. Leuchter's machine had first been used there on inmate George "Tiny" Mercer. For the next two years I was a regular visitor at Potosi and struck up a relationship that would develop into a close friendship with Alan "A. J." Bannister. A. J. was condemned in 1983 for what the state called a contract killing. After spending a month interviewing most of the key players in his case, I had gathered evidence that cast serious doubt on Bannister's conviction for capital murder, evidence which showed that A. J., at worst, had shot a man accidentally, a second-degree murder. He was scheduled to die on December 7, 1994, but the evidence I gathered resulted in a last-minute stay from the U.S. Supreme Court. On October 22, 1997, A. J. again faced execution at 12:01 A.M. This time, the state prevailed. I was a witness, along with his brothers Brad and Craig, sister Adele, wife Lindsay, and spiritual advisers Vernon Sword and Larry Rice. A. J.'s school friend Karen Moewe, editor of their hometown newspaper, was a witness for the state.

At 10:15 P.M. on October 21, I drove the family witnesses to the prison. At the first of four security checkpoints, we were greeted by armed officers with assault rifles and side arms. They asked if we were there for the Bannister execution, then told us where to park.

We were brought to a checkpoint where we were searched. Prison guards dressed in jackets and ties led us behind Potosi's high fences to the "holding area." In the courtyard, we saw the coroner's vehicle that would transport A. J.'s body from the prison hospital to a local funeral home.

We were taken to a small, unheated utility room with two tables and seven chairs, where seven prison officers—five male and two female, one to watch each of us—were waiting. At the door we were handed paper bags with our names written on them. We were told to place the contents of our pockets in the bags, which were then locked in a small trunk.

We waited there for forty-five minutes. It is customary at executions for the warden to visit the family at this stage and to inquire if there is anything he can do for them. That courtesy was not extended to the Bannisters. I knew three of the guards who watched over us: the two women and one of the men. They appeared to be in distress. Of the others, one had the professional inscrutability of an undertaker, while the other two could barely suppress a smirk. One of the guards wore a headset from which he received the warden's commands as each stage of the execution protocol was put into motion. He was part of the inner circle of the execution team.

A. J.'s wife, Lindsay, asked if she could smoke. The guard who held the key to the locker allowed us to retrieve our cigarettes and matches, and we stepped outside into the cold. A male and a female guard accompanied us. I asked the male guard (one of the smirkers) how many executions he had participated in.

"One," he replied.

"Does it get any easier?" I asked.

"You fly a lot," he replied. "I couldn't get used to that."

Lindsay huddled against me, shivering.

At 11:45, the guard with the headset told us we would be brought to the execution chamber in the prison hospital. There were only six seats, so one of

us would have to stand. He explained that a curtain would be drawn at first and then would open once the execution had commenced. He told us that we would not be able to hear anything A. J. said, nor would A. J. be able to hear us. "You can mouth whatever you want," he explained. Then he warned: "You will sit back in your chairs. Do not lean forward. If you touch the glass, you will be removed."

We were herded out of the holding area and hurried through a courtyard to the prison hospital. Brad, Craig, and Adele walked in front. I brought up the rear, with Lindsay squeezing my hand all the way. Vernon, who walked with a stick, could not keep up with the pace set by the guards. Lindsay and I stayed with Vernon, matching his stride; the guards in front had to stand and wait.

We entered the brightly lit hospital, where three female nurses were seated at the patient reception area. They avoided my gaze. Opposite the door to the execution chamber sat Betty Weber, the prison psychologist whom I'd first met in 1991. She also avoided my eyes, but smiled all the same.

There were six plastic chairs on a plywood stage. I sat front left, with Lindsay, and then Vernon, to my right. Craig sat behind me, then Adele and Brad. Larry stood at the rear. On the opposite side of the execution chamber were the state witnesses— the press among them, including A. J.'s school friend Karen. To our right, at A. J.'s feet, were the Ruestmans, the murder victim's witnesses.

Lindsay held my hand so tightly that her nails cut through my skin. The guard with the headset gave a signal. The female guards, one of whom was positioned to my left, the other to Vernon's right, reached over and grabbed the cords of the

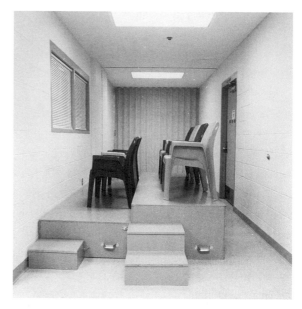

Witness Room, Potosi Correctional Center, Potosi, Missouri, 1991.

venetian blinds on the windows of the execution chamber.

Everyone took a deep breath, thinking this is it. But it wasn't. The guards kept the blinds shut for a full minute. The breathing of the guard closest to me was ragged, almost as if she were sobbing. I noticed that her fingers trembled.

The signal came silently—like all that was to follow save the sound of the blinds being raised.

When the curtain opens, the execution chamber is bathed in white light. A. J. lies on the gurney covered with a white sheet from head to toe, his head resting on a plumped-up pillow. (He's been lying that way for thirty minutes, waiting for the execution to begin.) A. J. has already turned his head in our direction. His gaze takes us all in. He looks calm.

He begins his mute conversation with us as he begins any other, with a brief nod of his head before speaking. Lindsay raises her hand and points to A. J.'s wedding band alongside her own. He nods his head and says, "I love you." He has prepared a brief word for everyone. To me he mouths the words, "Good friend." To Adele he mouths, "Tell mom . . . ," as the first of three lethal injections hits him.

A. J. takes a sharp breath, and his head snaps away from us so that he faces the ceiling. His eyes close immediately. He exhales and is completely still.

After a long minute, I began to look at the other witnesses: Karen was writing in her notebook; the other journalists' heads turned this way and that, searching our eyes for something to record.

My gaze returned, again and again, to my friend lying there, dying. I wondered how long it would take.

I looked over to the Ruestman family window. Tim Ruestman, nephew of the victim, tried to stare me down. Lindsay was weeping, clutching my hand tighter and tighter. Vernon, who had married A. J. and Lindsay—the execution was occurring one week before their fourth anniversary—was struggling to breathe. Behind me, I could hear Adele sobbing. (Newspapers reported later that the family "showed no emotion.")

The curtain closed as suddenly as it had opened. Before the blinds had hit the windowsill, the guard with the headset barked, "O.K. people, let's go." We were hustled out, and as we passed through the hospital I came face to face with prison psychologist Betty Weber. She was beaming.

The guards could not process us out of the prison quickly enough. They seemed to resent every second it took for us to reclaim our property from the locker. Change had to be put back into pockets, IDs retrieved, watches put back on, handkerchiefs held to eyes, car keys found: simple objects for living people.

AUGUST 1966
ABDOURAHMAN A. WABERI

Attacks

The fear that a poorly attached ceiling fan might fall to the floor at any moment was not exaggerated. People were afraid of finding their throats cut, of being executed by the sharp blade of a ceiling fan. Of course, this was not a gentle and easy death like having your mouth stuffed with soft cotton wadding. It was rumored that during the colonial conquest, French military intelligence had availed itself of these lethal ceiling fans to get rid of more than one activist. The same technique had been tried previously in Indochina, Algeria, and Madagascar: They slit throats the way you slit a ram's throat on the Prophet's birthday.

Off-season

During the curfew of the summer of 1966, ceiling fans were removed from practically every house in the city, because the fan was the brutal colonial power's best ally. The four-bladed fan had come to symbolize the fickle colonial authorities, now honey, now bile. Malicious tongues were quick to say that it reminded them of the sinister swastika of the Third Reich.

Didn't fans still hang high above the bars where hordes of hairy Legionnaires came to quench their thirst and hunt for whores?

France naturally derived economic benefits from its colony, but there were other advantages as well: The colony was a dumping ground for wayward sons, criminals, dialect speakers, arms dealers, revolutionaries, and other undesirables. Writers also came to apply their conventional wisdom and morbid imagery to what seemed to them a well-preserved specimen of some primitive era, a geographical mummy.

When the president, who was also a general, came to visit, everyone was surprised by the shower of imperial confetti. The president was on his way to Phnom Penh, to deliver the famous Phnom Penh speech that high-school students in France (and her colonies) would soon be required to learn by heart for their final exams. The text was already in his right pocket. He had wanted to make a stop en route, a state visit worthy of his rank, to inspect the acres of basalt officially known as French Somaliland. Still, the president did not conceal his utter contempt for these postage-stamp territories—territories that were the cause of so much trouble around the world, be it in the turquoise Caribbean, the so-called Red Sea, or the Indian Ocean.

For the governor in charge of confetti, an aficionado of the sugary candy known as "Turkish delight," there was no choice but to do whatever it took to get rid of any "troublemakers," to borrow the governor's nicely chosen word. Ceiling fans were used for this purpose, along with other occult techniques. In the kingdom of sand and stone, shrubbery suddenly flourished in a valley without water. People played parlor games with pebbles on a sandy square shaded by an acacia desiccated with age.

After the president's visit, many bodies turned up with slit throats in the city morgue. Mourners cried at ten-dollar funerals. Lots of troublemakers went into exile, becoming nomads on the roads of misfortune for years to come.

In back of a dive, a handful of troublemakers conspired. They aimed to strike fear into the president's heart and draw the eyes of the world to the social and political situation in the Lilliputian colony. Khalif had tapped himself for the role of kamikaze because he had been impressed, as he told anyone who would listen, by the Egyptian woman—"the female bombshell," as the unimaginative tabloids dubbed her—who had nearly managed to kill the commanders of the British and French armies during the Suez War. One political scientist specializing in the Middle East had written a paper on the incident titled "Archaeology of Terrorism."

Originally, Khalif had proposed taking the president's entourage hostage. In return for their freedom, he would then demand on behalf of his fellow citizens the liberation of all political prisoners, a ransom of several million

dollars, the sacking of the greasy-haired governor who was always crying "troublemaker" the way the little boy in the proverb cried "wolf," and immediate recognition of his country by the international community. Unfortunately, he had forgotten about the military intelligence bloodhounds, who had "turned" any number of comrades. And he had forgotten about the secret committee of the independence movement, which decreed at the last minute that there was to be no assassination of the august president and no hostage-taking. They opted, as the political scientist specializing in the Middle East might have put it, for "degree zero" of political activism. Nasr, Mahdi, Khalif, and the others were as disappointed as could be, for they were hungry for action. Zamzam: the blessed fountain of independence, the post-exile oasis—Zamzam would have to wait a while longer.

Local Color

No attempt was made on the life of the president, who mockingly extended by three days his stay in the colony that was a favorite of the Paris Geographic Society (headquartered on Quai Conti), of collectors of beautiful stamps (on Boulevard Brune), of the Salt Company of Southern France (headquartered in Marseilles), and of Albert Londres, the famous French war correspondent who had died somewhere in the vicinity.

Dead Season

On the eve of his departure, the president deigned to taste the meat of the oryx lovingly prepared for him by veterans of the Leclerc Division in the officers' mess on the Boulevard de la République, opposite the only high school in the colony, which had been founded by Vicomte Léonce Lagarde de Rouffeyroux. At eight o'clock he dined beneath a pergola of carnivorous plants. He loosened his narrow belt. The wider sword belt had vanished from the official dress uniform on the day that the president's girth expanded to the point where he could no longer wear it. At ten o'clock he took off for Phnom Penh. At noon the next day he delivered his speech to a crowd of raucous Vietnamese hecklers. Back in the colony he had left the day before, the governor returned to his regular shabby clothes, lethal habits, dog face, and vulture's eyes. The colony was lulled to sleep by the discreetly dolorous charm of the tropics. Nasr and Mahdi stopped delivering their fallen angel soliloquies. Nasr

dripped sand between his scrawny toes—the same sand the guides at the caravansary used to predict the future.

Once the president was gone, the men who had carried signs demanding total independence had their throats slit. We never did warm to that brass-hatted scoundrel. Zamzam, peace, and all the rest would have to wait another eternity. The city was reduced to ashes and tears. The liquid red August sky presaged nothing good. Groups of natives left for the desert, where they hoped to find God in person. Mahamoud Harbi, the leader of the men who had carried signs, was stabbed in the back. He just missed having his throat cut by a falling fan. Exile beckoned him with all her charms, and he could not resist. The postage-stamp colony gave off an odor of debauchery and confinement. In the beginning was everything that came after. It was back to square one, to mineral equilibrium. Sand and stone. Puffy clouds, yearning for eternity, floated off to parade their sorrows in other climes. Tomorrow teamed up with yesterday. The dead hand of the past would weigh upon the future for a long time to come: Nasr and Mahdi were no longer messiahs. The sea no longer baptized anyone. Nor did death forget anyone.

On hearing the news of the president's departure, Khalif, Nasr, Mahamoud, and their confederates fell into a funk. Hope was put in abeyance, independence postponed indefinitely. The heavens rumbled more than ever, as if thirty-three elephants had begun stamping their feet in cadence. For thirty-three days it poured, something seldom seen in the land of sunshine—sunshine that used whatever implements were at hand to torture its victims.

Nasr and Mahdi sat on thick-legged stools, facing each other. Their hair had begun to gray prematurely. Their shirts, with sleeves too large for their wiry arms, covered protruding bellies, bloated with air and excess fat. Certain obtrusive ideas had taken possession of their minds, consuming them with their power. Their heads were filled with mad and obsessive thoughts. Between clenched teeth they muttered the same words—words that occurred only to the city's madmen. A defunct past poisoned their bodies, wore out their hearts, and dried up the fresh sap in the veins of those elderly adolescents. Did they still love their anxious and troubled past with tender hearts? Did they still drum the fortune-telling sands with pianists' fingers? They spoke to each other in

a kind of shorthand, but did they still understand what they were saying? Could they still hear each other? Cold death, as plump and white as a disgraced mistress, calmly awaited them like a ravenous spider. Many of us had sung hymns to death, hoping to hasten its coming. Now, though, time had come with its insatiable appetite. We were half-dead with fright. We were close to madness. The president had dismissed the hopes of the men carrying signs with a wave of his hand. He had refused to recognize their status as a people with rights. Screams could be heard from Gabode Prison as the young men were sliced up. The governor was a butcher whose shop window, part burlesque and part horror show, featured the insignia of the president mixed in with native bosoms and cigar butts.

Return

Had the president planned this impromptu visit, or had some well-meaning adviser pushed him into the arms of the colony that had the smile of Medusa? A tragic farce awaited him on the Place Rimbaud: Men who the governor believed had come to welcome the head of state carried signs demanding immediate and total independence for their tiny country. What nerve! My God, what an insult to the general, what impudence, what naïveté! The president ducked the issue with some fancy footwork, and then, hurt, took off for Phnom Penh. The governor clapped the city in irons for all eternity. The demolition specialists from Indochina surrounded it with barbed wire to which fragmentation grenades were attached at intervals. The home office sent the governor a Photomaton "to photograph a thousand people in six poses during a regular working day." This useful tool had delighted the Nazis in 1941 and the French Army in 1945 when it was ordered to put down an uprising in the Setif region of Algeria.

Khalif, Nasr, and Mahdi sank into an endless soliloquy. The governor had performed lobotomies on all the men so they would never again have to whisper the painful secrets of that August 1966. To his great misfortune, he had forgotten the babies—tomorrow's promise, tomorrow's menace. I was one year old.

Translated from the French by Arthur Goldhammer

Deux Ex Machina-One

MICHAEL SYMMONS ROBERTS

As the cold war is converted
to a multimedia museum,
pika—looking old on photographs—
is now at work on origins, not ends.

In a Long Island laboratory,
tests begin on a nuclear accelerator,
a Relativistic Heavy Ion Collider
a Big Bang Machine.

One October day—when leaves
reveal their paper imagos—
Long Island starts to replicate
the moment of creation.

Atoms of gold are skinned
and smashed into each other
at light-speed. Each collision
generates a fireball of plasma,

hotter than the hearts of stars
—a trillion degrees—hotter than
anything has been since
the universe was born.

As the plasma cools, it breathes
a shower of particles
and suddenly—a risk the physicists
assessed and found too small to heed—

strange quarks are formed,
the unstable agents of creation
and apocalypse. There is no time
for rescue or repentance.

Pika is glimpsed on Long Island,
then grows in an instant
to overwhelm us all: the world
consumed by its beginning.

Pika

Elusive, witnessed first on paper,
then in deserts, then one whole city.
Those on the outskirts called it
pikadon: flash-boom in Japanese.
Those who saw it closer shortened it
to *pika*: a flash without a voice.
Survivors said it entered them
through eyes, then mapped them
in an instant—silver and alive.
After that it went to one more city,
then back to sands and seas.

New Year's Day, Hiroshima, 1945:
Outlandish snowfall for a warm
delta city. Seven great rivers,
seven dark threads in the blanket.
Bridges fill with marvelers.
Believers in ill omens keep
their mouths shut, for fear
of *tonarigumi*: keepers of morale.
Come summer everyone would know
that *pika* had prepared its way
with ice and painless beauty.

PETER GOIN
NUCLEAR LANDSCAPES

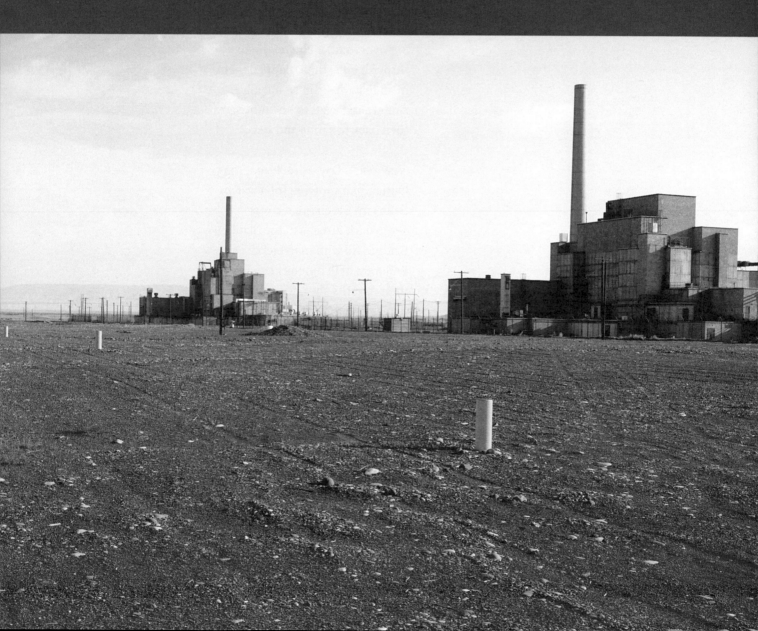

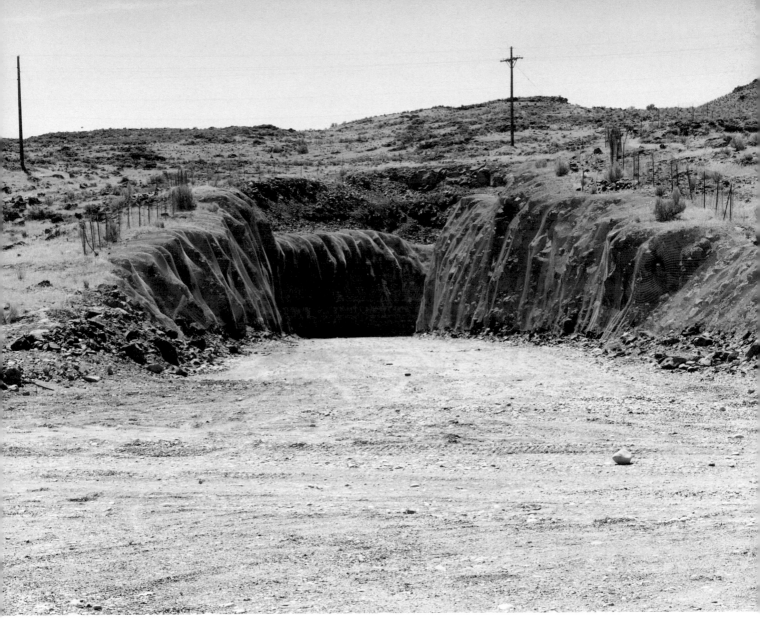

ABOVE:

Potential Nuclear Waste Storage Area, Hanford Nuclear Reservation, Washington. During the 1980s, the Department of Energy chose Hanford as one of three possible national sites for the long-term underground storage of high-level nuclear waste. Plans for storing waste in this area have since been suspended, in response to objections voiced by Washington State's political delegations.

LEFT:

Nuclear Reactors D and DR, Hanford Nuclear Reservation, Washington. These reactors are now decommissioned. D Reactor was one of the three original reactors built between 1943 and 1945. The yellow posts mark the locations of buried radioactive waste and areas of potential surface contamination.

ABOVE:

Cables and Nest, Bikini Atoll. An unsealed bunker on
Lele Island, Bikini Atoll, has become a refuge for island
creatures. A tern has built its nest on a pile of abandoned
electrical cables.

RIGHT:

Nuclear Bunker Complex, Bikini Atoll. This bunker complex was
a photographic and optical station used during Operation
Redwing (1956) and subsequent operations on Aomen
Island, Bikini Atoll. Lead bricks used to construct radiation
barriers can be seen at the water's edge in the center
foreground.

Sedan Crater, Nevada Test Site. This crater, 635 feet deep and 1,280 feet wide, resulted from the Plowshares program, which tested the peaceful use of nuclear explosions. The operating hypothesis was that a nuclear explosion could easily excavate a large area, facilitating the building of canals and roads, improving mining techniques, or simply moving a large amount of rock and soil. The intensity and distribution of radiation proved too great, however, and the program was abandoned.

All photographs from the series "Nuclear Landscapes," 1986–90.

Nuclear Landscapes

The Hanford Nuclear Reservation

Located in Washington State, Hanford was the site of the world's first nuclear reactor. Its plutonium was used in the first successful test explosion of a nuclear weapon at the Trinity Test Site in New Mexico on July 16, 1945, and in the bomb that exploded over Nagasaki on August 9, 1945. Eight reactors were eventually built; all of them are now decommissioned. The site contains an estimated 30 million cubic feet of nuclear waste and perhaps 100 times that amount of contaminated soil. Conservative estimates made by the Department of Energy predict that a cleanup would take 30 years and cost between $45 billion and $55 billion.

While photographing the Burial Gardens at Hanford's plutonium-finishing facility, I was told not to touch anything, including the blacktop pavement. After I had packed up my gear, my guide said he wasn't sure if the area was safe. "What do you mean by *safe*?" I demanded. "Well," he answered, "they have had a few contamination problems here lately." He told me we should have a Geiger counter "survey" done of my body, clothes, and equipment. If any object proved to be contaminated, it would have to be buried. Oh great, I thought, there goes my camera. If I was contaminated, I would have to strip and submit to a full body scrub. My guide asked if I was wearing a bathing suit under my clothes. He mentioned that many Hanford employees wear them under their work clothes at all times, since all the decontamination staff were women. How was I supposed to know? Fortunately, I escaped without needing the scrub. But that experience informed my photography: The sense of fear is a compelling characteristic of the nuclear landscape.

Bikini and Enewetak Atolls

Between 1945 and 1963, when the Limited Test Ban Treaty went into effect, the United States conducted 106 nuclear tests in the Marshall Islands, located 2,400 miles southwest of Hawaii. The Marshall Islands sites of Bikini and Enewetak atolls, tainted by 66 nuclear detonations, have since undergone a massive, U.S. government-sponsored cleanup campaign. Most of the radioactive debris and soil has been scraped up and buried in crypts or craters, and the islands have been planted with rows of coconut trees. However, the coconuts that now grow there are contaminated and even a cursory examination with a Geiger counter produces the chatter that indicates above-normal levels of radioactivity three to four inches beneath the topsoil. The Bikinians make ceremonial visits to their atoll, but realize that they will never permanently return.

The Nevada Test Site

Covering almost 1,350 square miles, the test site lies in the transition zone between the Mojave and the Great Basin deserts. The area is arid basin-and-range country with three large valleys: Frenchman Valley, Jackass Flats, and Yucca Valley. At Frenchman Flat, my guide refused to leave the vehicle and nervously watched the clock. I was told that I could have no more than two minutes of exposure to the area, and I attempted a world-speed record in 4 x 5 photography. The dust that collected on my boots made me anxious. I recalled Tom Lehrer's lyrics about a cowboy riding around the test site in his lead BVD's, but I couldn't remember the melody. I was glad when I was back on Highway 95 headed home toward Reno.

All of the sites I visited elicited a similar response. Nuclear landscapes are landscapes of fear. The source of that fear, radioactivity, is not easily recognized: We cannot see it, hear or smell or feel it. The Hanford Nuclear Reservation, Bikini and Enewetak atolls, and the Nevada Test Site are restricted areas, closely monitored by the Department of Energy. Crossing into them, we feel alien. These "political borders" sharpen the sense of omnipresent physical threat that has become part of each site's atmosphere.

At each of these sites, the landscape has been radically altered. At Hanford, yellow ropes and posts mark areas of radioactive contamination that will last hundreds, perhaps thousands, of years. The Nevada Test Site is still littered with debris from the above-ground tests conducted before 1963; within a thousand feet of my tripod, ruined structures bear silent witness to the almost unimaginable force of these blasts. The vine-covered bunkers at Bikini and Enewetak look like temples from a lost civilization. These nuclear landscapes provide a unique visual metaphor for the legacy of our atomic age.

P.G.

MARK RUDMAN

Cloud in a Bottle

Nature loves to hide.
 —Heraclitus

For Sam, age fourteen

It's a blankness I aspire to
in the open. Close-cropped
mountain trails, undulant hills
in the gradual falling away.

The silence unreal.
We don't want to move,
not while foxes and coyotes
are out wandering too.

In the dusk the hard, carved
clouds appear to hold their shape forever.
My teenage son drops
his cool, opens his arms

and exclaims, wouldn't it be great,
if we could just put them in a bottle.
His joy is so intense
I wish I could lengthen this instant.

To know that the days grow
shorter in August doesn't
cushion the blow
when the fields

disappear
and we've no choice
but to feel our way
back to the car.

GENES, PEOPLES, AND LANGUAGES
AN INTERVIEW WITH
LUCA CAVALLI-SFORZA

If it sometimes seems as though the future of science is taking place on an ever-shrinking scale—mapping the human genome, for example, or developing the latest unit of "nanotechnology"—the eminent population geneticist Luca Cavalli-Sforza is here to prove otherwise. His most recent book, Genes, Peoples, and Languages, *summarizes forty-plus years of research into human evolution and the migrations that populated our world—the evidence of which, Cavalli-Sforza and his colleagues argue, persists as barely discernible traces in our languages, our cultural artifacts, and our blood. His approach unifies the disparate fields of genetics, sociology, anthropology, linguistics, and archaeology into a single practice: the pursuit of a living past.*

The discussion I had with Dr. Cavalli-Sforza, who is professor emeritus of genetics at Stanford University, ranged from race to the so-called mother tongue to the Lemba tribe of Ethiopia and to Shakespeare's influential lexicon.

—Benjamin Anastas

Benjamin Anastas: One of the most striking arguments in your book *Genes, Peoples, and Languages* is that traditional racial classification according to skin color, eye shape, hair type, and body and facial form is scientifically invalid and essentially arbitrary, and, by extension, that racial purity is a myth. Can you briefly describe the process that led to these conclusions?

Luca Cavalli-Sforza: Basically, the fundamental knowledge of an individual is the genetic one, and that may be quite different from what we see on the surface. Certainly skin color is genetically determined, but it is not entirely so—we know that everybody tans in the sun, even blacks. So there is an environmental component to this characteristic as well as to many other traits. When one is interested in racial differences, though, it is necessary to stick to heritable differences, to look at DNA. We find a lot of differences among individuals when we follow this course.

There are two explanations for physical differences observed among humans. One is adaptation to different environments, and I think many scholars accept that. The second explanation, which was espoused by Charles Darwin, among others, points to cultural tastes and their effect on sexual selection as a source of physical differences. But we cannot prove exactly what changes in taste have been involved in the process of sexual selection because it is difficult for us to know what tastes were fifty thousand or a hundred thousand years ago when racial differences were beginning to develop.

What we have found—and I wasn't the first to prove it—is that when you look at inherited differences, you find that the genetic differences among individuals are great, even in a small group. But when you look at the differences between two groups—groups that live on separate continents, for example, or in different regions of a continent—you find that the differences found between the two groups are small in comparison to those *within* each group. Statistically, the differences among individuals of a single population, even a small population like the Pygmies of central Africa, are 85 percent of what you would find if you looked at the same differences between two random individuals from anywhere in the world. Because the differences between groups are only the 15 percent that you don't see within a group, you can say that the notion of racial classification is a fallacy.

Benjamin Anastas: How do you see the Human Genome Project affecting the concept of race?

Luca Cavalli-Sforza: It hasn't so far. As of now, the project has analyzed only half of a single individual. And, actually, it's a composite individual, a mosaic made of pieces from different people, though there is probably a disproportionate amount of people of European origin represented—including North Americans, who are for the most part of European origin.

From the beginning, there has been considerable fear among scientists conducting this research of offending people because of political correctness, but it has finally been acknowledged that it is essential to study individual variation at the level of the genome. The Human Genome Project has recently made one small step forward in this direction. It generated a collection of DNA for 450 individuals who are residents of the United States, including African-Americans, European-Americans, Asian-Americans, and others. But because some of the donors expressed the desire to not be distinguished from the others, the Human Genome Project decided not to release the information on the ethnic origin of any of the DNA, and it does not allow researchers who use this collection to make inferences about the origin of it, either.

It's very important to know more about variation. There are now initiatives, organized by pharmaceutical companies, that study collections of cell lines of all origins from around the world. These companies want to know whether they are dealing with variants found in Africa, the Americas, Europe, or Asia. In fact, it's becoming clear that it will be important to know in as much detail as possible the specific origin of the DNA being studied, because traditional racial divisions don't carry enough information from a genetic point of view. Each population—and a "population" can mean groups numbering from a few hundred to hundreds of thousands of individuals—has specific diseases that depend on its genetic history. Medical geneticists prefer to study a disease found in an isolated population, because it is much easier to identify the gene or genes involved.

Benjamin Anastas: In your chapter on the origin of modern humans, you mention some common misconceptions about the evolutionary biologist Allan Wilson's so-called African Eve, in particular that as the mother of all surviving mitochondria, she was the only woman alive at her time, approximately 143,000 years ago.

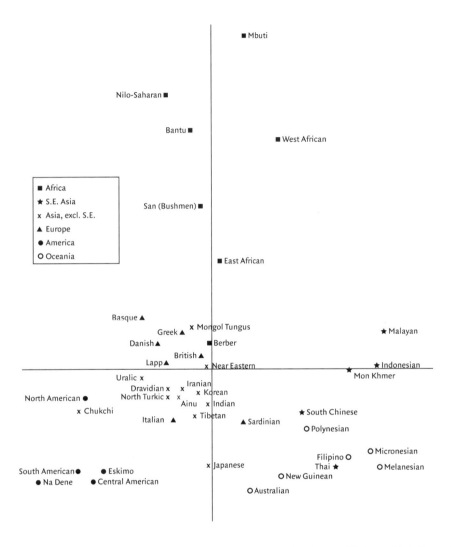

A synthetic view of 42 world populations, based on the genetic distances among them. The two-dimensional graph was built by multidimensional scaling, a variant of principal components analysis, and represents, with minimal loss of information, distances between pairs of objects (42 human populations in this case), calculated on the basis of many characters (110 genes). Populations are indicated by different symbols in order to distinguish the continents and subcontinents of origin. The only continents that are not differentiated by this analysis are Europe and Asia; an additional third dimension perpendicular to the first two would show that Europe is in a different plane compared to the rest of the world and differs less (on average) from Asia than the other two continents (Oceania and America), which were settled by migrants from Asia. (Computations by Dr. Eric Minch, while he was at Stanford University, using gene frequencies given in Cavalli-Sforza's *The History and Geography of Human Genes*, Menozzi, and Piazza, 1994.)

Luca Cavalli-Sforza: That's a common misconception. She was not the only woman living then, but rather the only one whose mitochondria have survived. If you go back in time, you will always find a single ancestor for a segment of DNA. The DNA of mitochondria is a fairly small segment that is inherited independently from the rest of the genome. If you go back far enough, there will be only one woman who generated all the mitochondria now surviving. In principle, this is true for every gene (a segment of chromosome with a specific function or functions), but in the case of mitochondrial DNA, which has a very small chromosome transmitted only from mothers to their children, this fact is especially informative. The same is true of the major part of the Y chromosome, which determines maleness and is transmitted from fathers to male children. Although one small part of the Y chromosome exchanges with the X chromosome to make another X chromosome, most of it never exchanges with the rest of the genome because there's only one Y chromosome in each male, and hence nothing to exchange with. And so with this major part of the Y chromosome—as with the mitochondrial DNA—you can reconstruct a genealogy that goes back to a single individual: in this case, a man.

Benjamin Anastas: This is the African Adam you mention in your book?

Luca Cavalli-Sforza: Yes, and this relates to the discussion of the Cohen surname among Jews. Unless there are illegitimate births, all the people who have the same surname have the same Y chromosome. If they do not have the same chromosome, it's most probably because there have been illegitimate births in one or more descendants. I don't know how many people with the surname Cohen there are—but let's suppose it's 5 percent of all Jews. They should all have the same Y chromosome. In fact, somewhere between 50 and 70 percent of them have the same chromosome, which means that there have been some—but not many—illegitimacies: less than one-half of 1 percent per generation, ten or twenty times less than the norm in other groups or countries. It turns out that the Cohens chose their wives very carefully, according to special rules—traditionally they are high priests.

Benjamin Anastas: So it was Y chromosome data that allowed scientists to verify the claim of the Lemba tribe in southern Africa that they are Jewish?

Luca Cavalli-Sforza: It was possible to show that some of the Lemba have Jewish Y chromosomes. But there are also some Jewish chromosomes that are shared by Arabs because of the common origin of Jews and Arabs. In practice, I think scientists have done enough work that they can separate Arab surnames from Jewish surnames and conclude that the Lemba, a black African population, have some Y chromosomes that are only Jewish.

Benjamin Anastas: In your book on cultural transmission, you mention a three-year sex taboo among Pygmies that keeps population growth at a manageable level and suits their nomadic culture. Simply put, Pygmies have children only once every four years, due to what you call "cultural selection." Given the recent decline in birth rates across Europe, do the Pygmies have anything to tell us

about cultural transmission in the industrialized world?

Luca Cavalli-Sforza: We can't look to the Pygmies for an answer because their culture is so profoundly different from ours. A Pygmy woman who lives until menopause will have five children on average. But as many as three of them might die before they reach marriageable age. This is, of course, an oversimplification, but if every married couple produces an average of two married children, the population will not increase in number. Pygmies live in an environment, the tropical forest, that is slowly but progressively being destroyed by lumbering. If the forest is destroyed, it will cause such a profound change in the Pygmies' way of life that they wouldn't be recognizable anymore as Pygmies.

Benjamin Anastas: Your assertion that the development of language was as crucial to the first human expansions as the advent of travel by sea or the development of an advanced set of tools rings true in an age where language has been defined as a "technology" by scientists and literary theorists alike. But is there any evidence of this in the cultural record in the same way there would be proof in the genetic record?

Luca Cavalli-Sforza: Although they are very different, the languages that exist today still have elements in common. But languages diverge so fast that in a thousand years once related dialects become mutually incomprehensible. Something like 15 percent of words are eventually replaced by words that have different roots—these are greater changes than what you find in *mother, madre, mutter*

and so on, which clearly have the same root. But as time passes it can even become difficult to understand words that have the same root. I should add that this statistic of a 15 percent difference between two languages relates to a selected list of words that is relatively stable. One can find a few very basic words that are even more stable, which leads one to believe that there might have been a single mother tongue.

This conclusion is something that few linguists accept, but only a small number of them work on the remote origins of language. The majority work on very small changes over a very short period, so perhaps they are not really interested in considering what has happened over a long period of time. I am not a linguist, but from what I have read in work dedicated to this problem, it seems possible that there was a single language at the origin of linguistic history, which might have been about fifty thousand to a hundred thousand years ago. The words that are still common to many languages— there are about thirty of them—are those that for some reason tend to change less than others, probably because they are so important. *Aqua* is a root you find in most languages, though of course in English you find what is perhaps an alternative root for water—*wasser* in German. In French water becomes *eau*, but linguists accept that *eau* derives from *aqua*.

For a geneticist like me, it is easy to accept the hypothesis that the 6,500 or so languages spoken today come from one language. Genetic study has convinced scientists that the original population that expanded from East Africa to the whole world, beginning around one hundred thousand years ago, was very small, about the size of a small tribe. It must have spoken a single language. It is also clear

that the possession of a highly developed language might have played a crucial role in this population's expansion to the rest of the world.

Benjamin Anastas: In a review of Frank Kermode's *Shakespeare's Language* in the *London Review of Books*, the writer estimated that the *Oxford English Dictionary* uses thirty thousand passages from Shakespeare's plays to define words in English. This made me think of the "charismatic figure" you bring up in the chapter on cultural transmission, who plays such an important role in spreading knowledge from generation to generation.

Luca Cavalli-Sforza: This may be an interesting example of "horizontal" transmission. In my book *Cultural Transmission and Evolution* [Princeton University Press, 1981], which I wrote with Marc Feldman, we explored the evolutionary consequences of two basic modes of cultural transmission, which we called vertical and horizontal. The first is a transmission that takes place from parents to children, or more generally, within the social group represented by the family. Aided by the fact that learners are of a very young age, this kind of teaching is almost like an imprinting. The kind of culture transmitted in this way is evolutionarily very stable. Later in life, one begins to accept teaching from unrelated people, of any age, and this "horizontal" transmission can allow for rapid change. Here "charismatic figures"—and, more generally, people who have considerable prestige, power, or authority— can cause rapid, even radical changes in popular behavior in a very short period of time.

Benjamin Anastas: In his essay "Tradition and the Individual Talent," T. S. Eliot describes a literary process that seems to follow your model of cultural transmission. The poet, according to Eliot, must write with a "historic sense, with a feeling that the whole of the literature of his own country has a simultaneous existence and composes a simultaneous order." It would seem that science and literature are alike in this regard.

Luca Cavalli-Sforza: I can give you a less elegant but more down-to-earth example. I wrote another book in which I cited a study of evolution similar to those we analyze in genetics, but which comes from the literary field. The book is called *The Great Human Diasporas* [Addison Wesley Longman, 1994] and I wrote it with my son Francesco. To reconstruct the sources and history of manuscripts one uses the same methods and thought processes that are used in genetics. I'm speaking of ancient texts that originated in the Middle Ages and were copied from one manuscript to another. In each copy, a few changes were introduced by the copiers, either by mistake or design. You can reconstruct the history of manuscripts by looking at the history of errors. This is exactly the same principle used for reconstructing the evolution of DNA.

Benjamin Anastas: So there's a philological aspect to your work.

Luca Cavalli-Sforza: This example testifies to the unity of science, of course, but also to the fact that some literary research is basically scientific. You are on safer ground if you use reasonable scientific criteria to decide whether a play was written by Shakespeare or Marlowe.

Corruption

SRIKANTH REDDY

It was light. Whoever it was
who set it under the gum tree last night
forgot to close the gate. This morning when I stepped
onto the breezeway I had to shoo off a she-pig
and some ragpickers before I could tell
what it was they were carting away
through the leaves. I had the houseboy bear it
into the sunroom. After attending to my and my employer's
business, I returned sometime after midnight
to examine it. A pair of monkeys
were hoisting it over the threshhold
toward a courtyard of fireflies. When I shook my fist
they dropped it, and I settled down at last.
It was gilt. It was evening with stars.
Where a latch should have been, a latch
was painted on. Over the lid, a procession.
Chariot. Splintered tree. Chariot. Chariot.
In the lamplight the hollows
of the footsoldiers' eyes were guttering.
I'd say they looked happy. Tired
and happy. Their soil-flecked boots sank
down to the buckle in weeds
and lacquered nettles, six men
to a burden. It was light. I could see
in the middle distance
a bone priest picking his way through crop rows
toward the wreckage of an iron temple.
Scarlet clouds moving out. Jasper clouds moving in.
Here, on a cistern, a woman
keeps nursing her infant. She is diseased.
The workmanship is astonishing.
You can pick out every lesion on her breast.

Mostly, I am alone.

CORNELIA HESSE-HONEGGER

Seed Bug (Lygaeidae), 1997–98. Collected in
Springdale, Utah, northeast of the Nevada Test
Site. Disturbances of chitin on thorax and wings.

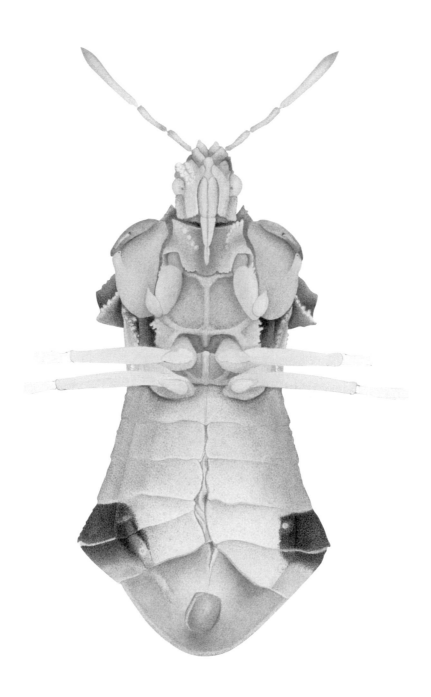

Ambush Bug (Phymatidae), 1991. Collected in an
area above the Peach Bottom Atomic Power
Station, Pennsylvania, south of Three Mile Island.
Uneven and asymmetrical stomach segments.

Stink Bug (Pentatomidae), 1997. Collected in Cedar Breaks, Utah, northeast of the Nevada Test Site. Edge of right side of thorax is deformed.

Ladybird Beetle (Coccinellidae), 1998. Collected in Richland, Washington, south of the Hanford Nuclear Reservation. Uneven wings and asymmetrical brown dots.

Cornelia Hesse-Honegger

I was trained as a scientific illustrator at the University of Zurich's Institute of Zoology. After working for several years at various marine biological stations, I returned to the institute and worked there as an illustrator for more than twenty years. The scientific experience I had greatly influenced my artistic development. By 1968, I was aware of advances in the field of gene manipulation and was drawing chemically mutated lab flies for my own interest.

In 1974, I moved to the country and became increasingly sensitized to the ecology of the insects that I now collected on a daily basis. Poisonous man-made chemicals and radioactivity and their effects on nature and people became a deep concern of mine. When the Chernobyl catastrophe occurred in 1986, European experts assured the public that the radioactive fallout would be too minimal to cause damage. I was skeptical, and in 1987 I went to study insects in the area of Sweden hit hardest by the Chernobyl fallout. This was my first excursion into irradiated territory. I found many insects with sausage-shaped feelers and crippled legs and wings. Publishing the results of my work incurred heavy criticism from some scientists—who insisted that the "low" levels of radioactivity could not have harmed the insects—but these kinds of deformations do not occur naturally in such quantity and with such severity.

I went on to study insects from the environs of nuclear power plants in Switzerland, the Sellafield reprocessing plant in Great Britain, and Chernobyl itself. In the proximity of those power plants, I discovered that the most badly deformed bugs (Heteroptera) could always be found in the path of the dominant wind direction.

In 1991, I went to the United States to study insects around the Three Mile Island nuclear power plant, where the cleanup of the 1979 nuclear accident was still going on, and around the Peach Bottom Atomic Power Station. Just east of Three Mile Island, close to the plant, I found a large number of badly deformed insects. Further down the Susquehanna River, near the Peach Bottom plant, almost every insect I examined had been affected: They showed strange growths out of the wings and thorax and deformed segments on the belly. However, the insects found in areas upwind of the nuclear plant were mostly normal.

Since then, I have continued my research— in Utah and Nevada in 1997, the Hanford Nuclear Reservation in Washington in 1998, and La Hague in Normandy in 1999. My observations of insect and plant life around nuclear power stations have convinced me that even low-level radiation, far from being harmless, has a damaging effect on the environment, and, by extension, on us. If we are to use nuclear power for energy, we need to study its effects. We should not allow our genetic inheritance to be changed without knowing the consequences for humanity and nature.

C.H.

EGG

SHELLEY JACKSON

PART ONE

I now look on the day the egg arrived as the most unfortunate of my life.
I did not see it this way at the time; then, the egg seemed like the culmination
of a long, confused, but mostly steady progress, which required only that
punctuation to make sense. Like everyone I knew, I had always thought
I would do something more important later on. Now later on had come.
How stupid I was!

Had I been happy before then? I would scarcely have said so. I was restless
and embittered by this or that nuisance of everyday life—my coworker Marty
(in Cheese), the meter maid with a grudge against me, the band (Joss Stick)
that practiced in the apartment beneath me, afternoons.

Yet I think I *was* happy. The world seemed open at the edges, fenceless. I
was more or less what I seemed to be, and now I suspect this was happiness.
Then the egg was lowered in front of me, like bait.

READING NOTES, JUNE 14—Nothing is more ordinary than the egg:
It appears in the hands of painted kings and saints, under the paws of stone
lions, and bouncing across a ballfield. Yet nothing is more mysterious.
People used to believe that toads lived far underground, deep in a world of
rock, and that inside each toad's head was a lump of gold. That gold is the
egg: locked away, rumored, precious.

My name is Imogen. I am thirty-six. I live in a run-down but pretty apartment
on the Mission/Castro divide with my roommate, Cass, with whom I have, as

Adam Fuss, *Untitled*, 1989.

they say, a "history." I work in an upscale organic grocery store, where I restock toothpaste, candles, hand-carved wooden foot-rollers. I use Crest and buy candles cheap at Walgreens, but I like to look at the jewel-like soap we sell, and the girls who finger it while gazing somewhere else entirely, as if waiting for a sign. I rarely speak to them. I'm not like them: They are sincere, optimistic, gentle. Sometimes they flirt with me, their open faces radiant and slightly spotty, their new piercings inflamed, but I have little will to carry things further. I have been "between" girlfriends for two years. I have my pride, and my disappointments.

READING NOTES, JUNE 17 — The egg eats. At least, it swallows things. You can watch them being expelled later. At first they are just shadows. Then they have color as well, and can be felt through the wall of the egg, like new teeth. Finally, only a tight skin like a balloon's covers the object, now perfectly visible. This splits and curls back, and the object falls outside the egg.

These discards do not seem damaged, but they are. They are different afterward, like food laid out for fairies. It's still there in the morning, but no good to anyone: Berries are blanched, butter will not melt, fresh-baked bread has no smell.

I lay on my bed with the window open and a washcloth over my eyes; it was the first day of a long weekend, and I was spending it with a migraine. Cass was driving up to the Russian River. Until the last minute I had meant to go with her, but by then I could scarcely move my eyes, and I gave up. All the incomplete and damaged ventures of my life came to mind one after another like broken toys. The poem cycle I would never finish. A friend in Boulder I was supposed to visit two years ago, whom I never called to let her know I wasn't coming. Learning to play the guitar. That girl I flirted with at Joanie's party, with the stupid name: Fury. I hid behind the natural sponges when she turned up at the store, but she saw me. That was the pattern: a moment of genuine interest, then a long, embarrassed retreat.

Finally I masturbated. Then I fell asleep with my fingers still stiffly crooked inside my underwear and my head thrust back into the pillow, as if someone had just punched me in the face.

I woke up sweating, with the feeling that I had just quit a dream of effortless energy, purpose, and interest—much more engaging than my real life. I thrust the covers off and fell back to sleep. When I woke again I was damp and cold but my headache was better. It was raining.

My washcloth was a hot wet mass under my right shoulder. I dug it out and scrubbed my face with it. My left eye was itching. In the bathroom, leaning into the mirror, the sink's edge cold against my stomach, I spread my eyelids to bare the eyeball and the lids' scarlet inpockets. I spotted the irritant, a red dot smaller than a pinhead, lodged under my lower lid near the tear duct.

I touched a twist of toilet paper lightly to it, and the dot came away on the tip. I didn't know that it was an egg. I thought it was something to do with my migraine—now that the object was gone, the pain was gone. I was so grateful!

I dropped the twist in the toilet. If I had flushed, that would have been the end of the story, or at least of my part of it, but I did not. Some hours later, I hurried into the bathroom and peed without looking first. It was only when I stood and gave the bowl that respectful, melancholy look we give our rejectamenta that I saw the egg. It was the size of a Ping-Pong ball.

I fished it out of the toilet with my hand, proof I was a little rattled, because I am usually fastidious. (I could have used salad tongs.) I washed the egg and my hands. The egg bobbled around my fingers. I felt no distaste or uneasiness. It's an egg, I said out loud.

My first thought was that it was meant for Cass, not me. Cass would know what to do, she always did. She was at home being human. My second thought was quick and spiteful; it was that Cass must not find out. Deep down I thought that it was right for me to have the egg, not Cass; Cass didn't need it.

READING NOTES, JUNE 18—By some counts, hundreds, even thousands of humans have been swallowed by eggs. Many cases are poorly documented, and we dare draw no conclusions from them. Some have acquired such a gloss of legend that it is difficult to sort out the fact from the fiction. But some are probably true. In a blizzard in the Himalayas in 1959, three novice climbers and a Sherpa guide survived by creeping into an egg. In 1972, one-year-old

Bobby Coddle crossed the Pacific in an egg, bobbing on the swells, and was pulled aboard a Japanese fishing boat, where he was extracted, in the pink of health, cooing with happiness.

I met Cass a long time ago, in college. It was the first week of freshman year and our residential advisers had organized a square dance to help us all get acquainted. I was leaning on the fence watching, and she came up and said, "I like you. You don't bother with this crap. You're like me." It wasn't true. I was wishing that I weren't so uptight, that I could whirl around with the others, but I just smiled, feeling myself become the kind of person who stood aloof, instead of the kind who was always left out.

We became friends. I never knew why. I tried to please her, of course (everyone tried to please her), but I didn't expect to succeed: I was too stiff, too dour, and too uncertain. Cass was the kind of person who always knew what other people were saying about things and whether they were right or wrong. And yet she changed her mind a lot and never seemed to remember that she used to hold the opposite opinion. But knowing this didn't keep me from being ashamed when I got caught holding the wrong book, the wrong snack, the wrong shirt. "Do you *like* that?" she would say. Or, "You're not going to *wear* that, are you?" I would drop the object in question as if it had caught fire in my hands. I was ashamed of this too; it was another thing Cass would not have approved of.

Cass discovered her lesbian tendencies after we graduated and immediately fell in love with the most beautiful girl I had ever seen, tall and stately, with long black hair and a fake ID (she was seventeen). I went out dancing with the two of them and got a migraine. Now Cass was seeing some guy with a goatee and I was the dyke, only I still hadn't met anyone who could pass the final test: make me forget Cass. I loved her, in a deep, unpleasant way, but I kept out of her bed. I survived her shifting passions by never becoming the object of them.

READING NOTES, JUNE 19 — The folklore of eggs is flush with lucky breaks, but there are dark stories of lost children, vanished lovers, and besotted girls wasting away beside them. Two-time Iditarod champ Cath Summers set her dogs on a rival who boasted about possessing an egg,

with fatal consequences (ironically, it turned out the rival was lying; the egg belonged to a neighbor, grocer Mary Over). In recent years, Professor Bev Egan, noted scholar of fascist architecture, starved to death during a vigil in the Santa Cruz mountains during which, she told friends, she expected an egg to appear to her.

I put the egg on a damp paper towel in the bottom of a mixing bowl and put the bowl under my bed, swathed in an old flannel shirt. By the time Cass came home the egg was as big as a baseball. I didn't show it to her.

It grew steadily. The outer surface did not appear to change. At one point I punched a small hole into it with a pencil and inserted a thermometer. The egg was almost body temperature. I wanted to insert the thermometer into the very center, to see if the temperature was higher or lower there, but no ordinary thermometer reached that far. The hole I had made filled with fluid and shone like a tiny eye. The meat around it grew swollen; finally, it swelled enough to close over the hole. I tried other experiments: I swabbed a small area with rubbing alcohol; I rubbed salt on another spot; I brushed the egg with oil; I spun it, and it rotated as smoothly as a planet. I would have held a candle to it but that seemed barbarous. Nothing seemed to affect it much.

After a few days, the egg began to give off a sweetly fetid smell. I heard Cass stamping around in the kitchen when she got back from work. Then she banged on the door. "Where are all these *bugs* coming from? Do you have fruit in your room, Im?"

I said no. After a while she went away.

That night I took the egg to bed with me. It was about the size of a bowling ball. Since it was moist, I put a towel down under the bottom sheet. Then I curled around the egg and took comfort in its warmth against my stomach.

In the middle of the night I awoke. My room seemed darker than usual. I realized that the egg had grown so big it blocked the light from the window. I could just make out its black curve against the ceiling. I was lying against it, almost under it, since as it grew it had overshadowed me. The shirt I had wrapped it in was in shreds around it. Maybe it was the sound of cloth tearing that had woken me. Fluid slowly spilled over my thighs and between them, and I thought for a moment, with prim displeasure, that I had wet myself in my sleep. But no. The egg had wet me.

I rolled out from under it and spent the night on the sofa in the common room.

READING NOTES, JUNE 22 — According to legend, the egg prevents canker sores and sudden falls, cures ringworm in horses, and kills mosquitoes. Whether or not these claims are true, the egg does bring undisputed benefits. Premature babies or patients recovering from surgery can often be coaxed to lick the egg for nourishment when they will take nothing else. Flesh wounds heal faster when bound against the living egg, and in many hospital wards one sees patients in their white gowns splayed against the red orb in awkward attitudes, as if held there by gravity. They look like souls in the ecstasies of their last days; whether blessed or damned it is hard to say.

When I woke on the couch, Cass was standing over me, arms folded. "What's going on, Imogen? You're not acting normal. Are you on drugs?"

I draped my blanket around me and shuffled toward my bedroom. Cass tried to pass me and I elbowed her back, but she got to my bedroom before me. She gasped out loud when she saw the egg.

Cass and I carried it down the stairs and into our tiny back patio in a blanket sling. We cleared a spot for it, and I draped the blanket over it so that no one would see it. I worried that they might try to take it away. I woke up three times that night to look out the window, but everything was quiet.

Cass came home the next day with a pile of books about eggs for me to read. I thought, *She's already trying to take over.* I thanked her.

"I might read them too," she said.

"I'll recommend one." I carried the pile into my room, shutting the door with my heel. I stuck them under the bed.

In the end I read them, of course. I studied them, even; I took notes. That was how Cass got her way.

READING NOTES, JUNE 26 — There are stories of an inner, essential egg, a sort of tincture of egg, which could perhaps be distilled from the egg, or that might be left behind if the egg imploded: a fragrant red crystal, which some, speculating wildly, propose is the "pill of immortality" described by Wei Po-Yang in the first half of the second century A.D.

I understood that the egg was mine to care for. I was to brood over it, the books said. What that meant was not quite clear. Was I supposed to sit on top of it? From the landing of the back steps I stretched one foot out to the top of the egg. My sneaker slipped off, and as I tried to catch it I banged my chin on the splintery rail. "What are you doing?" said Cass from above.

"Nothing," I said. It was almost a sob, but that was because my chin hurt. I sat down on the steps.

The books said that the egg would not grow without help, that it would be stunted, small, and hard. They described this "abortion" in almost identical turns of phrase, as if reciting a lesson: "The neglected egg is dense and hard as a croquet ball. Growth without understanding is flesh heaped on flesh, as a pearl forms in an oyster, or a tumor in place of a child, a clump of cells without differentiation."

READING NOTES, JUNE 29 — "The eggs are obviously spacecraft. Some are reconnaissance vehicles. Some are mobile homes. You see little pinks and long reds. They peek out the windows. Or they descend, on beams of light. The pinks are the clever ones. The master race, if you will. They study us. They judge us. But the reds are there to intercede for us, to plead for mercy."

Cindy Halfschnitt was abducted and returned to tell her tale: "I wasn't afraid. I knew—how shall I put it?—I was loved."

I would brood, if that was what the egg needed. It was a worthwhile thing to do—maybe the only worthwhile thing to do, even if I didn't know why. And though it required an openness and sincerity that didn't come naturally, well, for the egg I could learn to love without reserve. Maybe the egg was my chance at what everyone else seemed to feel all the time—a cozy feeling of being with someone or something, the worth-it-ness of love. But these thoughts were secondary. I would brood because I needed to. Being near the egg was like scratching next to an itch. The closer I got the more keenly I felt my separation from it.

My friends—Roky, Tim, Deedee—expected me to make a joke out of it, remembering how I had smirked at Deedee's chanting circle and Tim's banana-tempeh power drinks. Cynical Imogen. In fact I had been waiting, hoarding myself, for that call, for something to give myself to.

Yes, it was a burden. That thought did cross my mind. But once the egg had come to me, it was impossible to imagine a life that didn't contain it. I was an incubator now, an egg cup. "And when the bird hatches her eggs, motionless dead bodies, her love shelters them; her wings embrace them; she forms voice and life in their lifelessness; the liquidness of the egg takes on beautiful form and she awakens out of the shell the buried ones." How wonderful!

READING NOTES, JUNE 30 — Some say we are trying to hatch Christ. Like Phanes, Eros, Nangarena, incubator babies all. We'll keep going until we get it right. Christ, Antichrist, Big Bird, God, or Godzilla, who knows? We are undertaking a project itself entirely indefinite (yet with high, though vague standards), in anticipation of a result on which no one can agree. Why?

"Why?" asked my friend Roky. He turned the pegs on my dusty guitar, tuning it absentmindedly.

I could only answer that while the luster of adolescent fantasy might have dazzled me at first, it was the lusciousness and dignity of the egg that sealed my commitment to it. The egg was serious, even melancholy, but it knew how to play; it was quiescent and yet teeming with life, rich with invention and innovation. It made no scenes and did not argue for itself but answered all doubters by virtue of its unfeigned excellence.

"I don't know, I guess I'm curious," I said.

READING NOTES, JULY 3 — Since we turn food into flesh our whole life long, the doctrine of bodily resurrection presents at least one problem. We form enough new cells in the course of living to reflesh ourselves many times over. Are some cells elected to immortality and others extinguished forever? The ingenious deity of the heretic sect that called themselves the Ovaries (before they were wiped out in 1265) provides for those extra cells, lumps them together and gives them a new life—as guides, as judges, as spies. As eggs. One might also call them angels.

I took the pieces from my Mrs. Potato Head kit down to the back yard, and I punched two eyes, a nose, and a mouth into the egg. I kept the features

close together, a tiny face on the side of a planet, and then I sat down
on a cinder block and began talking to the egg's new face. Juice from the
punctures ran down the nose and hung off the tip.

"What are you?" I began. There was silence, which I had expected. I tried
again. "Who are you? What is your name? Rumpelstiltzkin? I'll have it out
of you in the end, old drippy head, your ghastly looks don't frighten me."
But the egg said nothing. The summer was passing, the egg was growing,
and I was no closer to knowing what to do with it. There seemed to be every
chance of failing decisively, while success was a mystery of which none of
the books ever speak, except in the most general terms.

I leaned against the egg, and sank a little way into the pink wall. It was
neither sticky nor slippery, just moist, like a healthy cheek on a warm day. I
stroked the egg, then began palpating it rhythmically with my fists. I pressed
my face against it until I needed air. I backed up, gasping. Its blush provoked
me. I was jealous of the flies that licked its crown, the ants that were already
tasting its effluvium.

I sat down in the shade of the egg. My mouth was dry. The egg was full
of water; each cell wall was healthily distended around a fat globule. I poked
my finger into the egg and the hole slowly filled with clear fluid. I slid the tip
of my tongue in the hole and lapped up the water. Then I sunk my hand in
and tore out a hunk. I chewed and swallowed until I had reduced the piece to
a wad of gum, and then I lay still, staring up at a seagull, which disappeared
behind the pink curve of the egg as if swallowed by it.

I got up.

But something stopped me from hurling myself headlong into the egg.
Instead I took a paring of its flesh, the size and shape of a minnow. I carried
it up to the kitchen, turned a burner on high and jostled it violently in a pan,
while it spat and seared and flung itself about like something cooked alive—
which perhaps it was, but better not to think about that—and then I clapped
a spatula on it and trapped it there, sizzling, and it was docile, though I had
to peel it off the pan, tearing it from the skin, which lay stuck in pink-tipped
peaks and tufts. I folded the morsel in a paper towel and sat in a corner of the
kitchen, sniffing it, running it under my nose like a cigar, dropping it, almost
on purpose, on my shirt, and picking it up again from the greasy patch it left.
Finally I stuck it in my mouth and chewed it up and ate it. It was linty.

The missing piece grew back. I was unchanged.

READING NOTES, JULY 5 — In children's storybooks, Bad Egg is black and devouring, a scorched, lascivious, oozing egg with a slurred voice. We are warned against it. (Of course, this propaganda does no good at all when the real thing appears, oozing a little, it's true, but pretty as a peach and smelling like spring.) Good Egg is white and floats in the sky like a bubble. Rotten Egg lives underground. It is black and stone-cold and silent, and to touch it is death.

I dreamed about a girl in a room. She was white as paper and skinny. There was a hollow spike stuck in her side, attached to a rusty hand pump, and she worked the handle vigorously while blood splashed into a bucket. When the bucket was full, she pulled the spike out of her side, unhooked the bucket, and hurried with it to a sluice that fed through a tumbledown place in the wall, and dumped it in. Then she went back and started over. It seemed impossible that she could have any blood left in her body, but more kept coming, thick and red. I was amazed she spent herself so unreservedly.

There was something primitive about the way I'd have liked to tear Cass breast from drumstick when I saw her cast a covetous eye on my egg. It would help if I were a more ironic person. It would help if I were more zen. There were other things in life: clever little shaggy ponies, surveillance devices, snowboarding. There were excellent curries. There was probably a girl reading Genet somewhere. She might like mid-century modern furniture, but she would come to understand my thrift-store armchair, in time. Compromises could be made. I understood.

That day had been hot, multicolored and banging, full of groceries and loud with basketballs. Spilled smoothies turned to fruit leather on the sidewalk. The smells in alleys and stairwells grew unbearable. At three the first of the bugs—winged ants or termites—were struggling out of cracks in the hot asphalt of Mission playgrounds, parking lots, driveways. They dragged their wings clumsily through the openings like ladies in fancy dress forgetting the girth of their skirts.

I had left the window open. When I came home, it was dark. The room was cool blue, with a slight burned smell of the city, of tarry roofs and exhaust. I went to the window. The light wind of my movement blew frail things like snowflakes along the sill and off it. They fluttered down into the darkness.

I turned on the light. There were insects all over my bed. Some were alive and still pirouetting, dragging their stiff wings. Most were dead.

The egg was covered with them—thousands of insects. Wing-thatched, it had turned white and opalescent. Some of the wings beat, others were still, pressed together like hands. The moon rose, and in its light the egg shimmered like a bride in a beautiful dress, and I made up my mind.

I took off my clothes and climbed in.

I say "climbed in." It was more strenuous than that. I lowered my head and ran at the egg, ramming my crown deep in the pulp. I got stuck there a moment, with my head caught, then slid my hands into the egg beside my ears, stretching the walls of the hole until I broke the vacuum seal of its skin. I felt the egg respond to the insult, fattening and stiffening around the cut, and in effect folding me in deeper, though perhaps the intent was to enclose me and keep me from doing any more damage. I pumped my hips and thrust my head and hands deeper, and though there was nothing to hold on to I managed to drive myself in farther, until I felt the ovum close over my toes. Then I swam toward its center.

PART TWO

In the center of the egg, immobilized by the clasp of its flesh, I felt incredibly calm.

In here I was to be digested, as in the athanor of the alchemists, itself egg-shaped ("it is an egg of great virtue, and is called an egg, and is not an egg"). But how hard I was, how gnarled and dry, like the pit of a peach. The sweet flesh was wet and clung all around me, but I was caught in a furious refusal, despite all my longing. Maybe it was the refusal all matter participates in, the refusal of the primal lump—a refusal to melt, to glow. I was like a shoe left behind in deep mud while someone, a child, who had been inside me, went

running lightly on. I was block heel and well-formed toe and crafty stitchery on yoke and tongue, but all that was nothing. Beauty was around me (the splendid surplus! A blazing chrysanthemum!), but I clung to my self like a scab.

Dear egg, melt me!

I was born fleshy and splayed, an open vessel. I have practiced permanence, yes, but only to keep myself for you. I would drop my bones in an instant to leap to your mouth in one soft elated blob. I could be yolk, albumen, and water; I could be the most delicate syllabub, scented with rose water and cardamom. I have waited my whole life for this. I think I would be sweet to taste, and I am not yet curdled.

But I proved incapable of yielding to chyme or chyle. I was hard as a tusk, I was horn and tooth, I was pumice, abrasive, porous, and light: a stone cloud, a dehydrated tear.

Refused.

When I emerged from the egg, disgusted and humiliated, dripping a pink syrup that now seemed filthy to me, nothing had happened. A cut on my arm had healed and my complexion stayed clear for two weeks afterward, but I had not entered it for a spa treatment.

I packed a bag and went to Boulder to visit my friend. She was pleased to see me, then slightly less pleased when she realized I didn't have plans to leave. After a while, I began to do some of the things I used to do before the egg came into my life: watch movies, read, write. I didn't call the store or Cass. I kept checking myself, to see if I was changed. Perhaps I had misunderstood, and the egg's rejection of me was itself a rite of passage I hadn't recognized, because I had my own idea of what translation should feel like. But there was nothing different about me except for this checking itself—the flinching and squinting and double takes in the mirror.

Maybe disappointment was enlightenment, and this acquaintance with futility was the closest I would come to God.

READING NOTES, JULY 14 — In cabalistic tradition, the number one is not an abstraction, but the proper name of the egg. We do not count *one*— any child knows you don't need an abacus to see how many one is—we call

out its name. Egg, two, three. This is not to say that two means two eggs. The egg is singular and sufficient. It is not a unit or a building block.

I returned to San Francisco on a windy, blond day: cotton shirts, flags, dog-walkers in shorts and mustaches. An old man stooped to pick up a hose as I walked past his yard. He had thinning yellow hair, and the rim of his ear was soft and red. He had a huge boil on the side of his neck by the collar of his turquoise shirt; it was so swollen it was almost spherical, and the wrinkled skin stretched over it until it was tight and shiny as a child's.

I passed the playground, where a few kids were working in the sandbox with bright blue plastic buckets and spades. A little girl looked up at me: a little girl with no face. A smooth pink globe seemed to supplant her head. Then the bubble collapsed, and she sucked it back into her mouth.

I walked past my house. I wasn't quite ready.

In the coffee shop, I noticed the cheeks of the girl working there, and her breasts, which strained the vintage print she was wearing, and her upper arms—she had cut off the sleeves of the dress—which swung vigorously as she frotted the steamer wand with a yellow towel. She had the thin white scars of a decorative cutting on her shoulder—a rough circle. Everyone is made of spheres, and the world is round.

Cass opened the door. "Imogen," she said.

I went straight through the apartment and out the back. She followed me. The egg still lay in the tiny backyard. It was even bigger than before, wedged half under the shed roof, with the clothesline cutting through it like a cheese wire. It seemed the worse for wear, and there was pink oil covering the concrete near it. Three large, nearly bald cats were lapping at the puddle.

Cass stepped over to a big enclosure of chicken wire. In it a pink mound like an exposed turnip broke the surface. She drummed her fingers on it and it contracted. The fleshy pink end of a worm, as big as a woman's heel, poked up through the surface, thinning and thickening in long shudders. "The neighbors complained, but it's perfectly harmless, except it pushes up the paving stones, so I made a box for it." She drew it gently out of the ground. "It's huge," she said, holding the worm in two places, while it weaved unsteadily in her hands and butted against her wrists like a blind puppy.

Cass was panting shallowly. Her cheeks were red and shiny and distended, her eyelids fat. Her eyebrows had gone pale, or perhaps even fallen out. She had drawn thin, brown, artful brows, but these, not perfectly symmetrical, did not work with her cartoon farmwife cheeks, her cherry lips.

"What's going on, Cass?" I said.

"What do you mean?"

"You look strange. I think you've been eating my egg."

"*Your* egg!"

"I grew it. It grew on me," I said.

"You walked out on it. And on me. I had no idea where you were. Just because—" she paused. I thought she might not say it, but she did. "Just because it didn't want you!"

I threw myself on her. The worm writhed violently between us, then escaped. We struggled on the ground in the syrup. The Mexican guys in the apartment across from us came out on their landing laughing and hooting. "*Putas! Marimachas!*"

Late that night I woke up and looked out the window. The fog was purple and mauve, saturated with city light. Across the way a light was on in an empty kitchen. Down in the yard I could see Cass leaning against the egg. She was licking it.

READING NOTES, JULY 15 — The egg might more properly be seen as the ambiguous zero, which sits at the center of the number line but is scarcely a number itself. The egg is a library, a battery, a wardrobe. The egg is a sneaky lady with a trunk full of green silks and sequins; she has a ring with a drop of curare in its center and a ruby for a stopper. In her hatbox is a hatbox, and in her hat a hat, her disguises are pregnant with disguises. Don't be surprised if there is a sapphire inside the teddy bear.

I dreamed Cass grew fat, shiny, red. As she waxed, the egg waned. At last she was almost spherical, a powerful figure, staring like an idol. The egg was the size of a malt ball, and she picked it up and popped it in her mouth. Then she turned toward me and opened her arms. Her sparse hair streamed from the pink dome of her skull, her eyes rolled, her teeth struck sparks off one another, and her hands were steaks, dripping blood. Now I knew her.

She was the egg. I turned to escape, but her arms folded around me, and I sank into her softness, and woke pinioned by my comforter, on the side of the bed.

What the egg wants of me—maybe a millstone around its middle and a good heave-ho into the bay—I'll never know. How I tried to find out! That was my mistake—to want the egg to want, to want the egg to want *me.* That is why I am now outside desire, in the wasteland. That's why the world is dust to me. Poetry: dust. The girl reading Genet: dust. Cass? Dust.

READING NOTES, JULY 18 — Ancient Persian mystics write that the universe is an oyster. Our incessant desires and demands annoy it; we are the itch in the oyster. Around our complaints a body forms. The egg begins as a seed pearl. It grows beautiful. For this treasure, princes would pauper themselves. To harvest the pearl, we would pry the earth from the sky, though the satisfaction of our desires would destroy the universe and us with it. But be warned. The egg is the gift that robs you, for its germ is pure need: gain it and you will lack everything.

After breakfast the next morning, I went down and unlocked the gate across the alley between our house and the neighbors'. There was a heap of splintery boards blocking the alley. I carried them back a few at a time and piled them in the yard. On the other side of the fence, the neighbor's dog went up and down the alley with me, whining softly. When the way was clear I went back to the egg.

I pushed it back as far as I could and stuck a board under it, and then I squeezed behind it and rocked it forward onto the board, and stuck another under it behind. Then I rocked it back and fit another board onto the first. In this way I raised it little by little. It took me several hours to raise the sagging center a foot off the ground. That was far enough. I got down on my stomach. Syrup hung in sticky cords between the bottom of the egg and the pavement. They snapped across my face as I squirmed beneath the egg. Once the egg's center of gravity was directly above me I gathered my legs under me. The egg gave slightly above me,

allowing me to crouch. The boards creaked, but held. I stretched my arms out to either side.

Somehow, I stood up.

I took a step. I was carrying it.

Little by little I made my way down the alley toward the street. The dog kept hurling itself against the fence beside me.

Syrup ran down my face and body into swaying, fitful strings on the sidewalk. My footsteps sounded like kisses. I left pink tracks.

"Imogen!"

I turned carefully.

Cass was standing at the top of the front steps in her dressing gown. "Wait, Imogen! Please!" She whirled; I saw the pink flash of her heel as she dashed up the apartment stairs.

I continued on my way. I turned left down Eighteenth Street. I crossed Church. Guerrero. Valencia. People made way. Someone dropped a burrito and it burst, black beans rolling across the sidewalk in front of me. Someone pushing a shopping cart fell in behind me; I could hear its wheels rattling.

When the light changed at Mission, I stopped too suddenly and the egg bounced over my shoulder, through the traffic, and fetched up in the doorway of a doughnut shop. The whores that hung out there gathered around it, touching it, then licking their fingers. Cass caught up with me, and when the light changed we walked together across the street.

The egg was torn when I reached it. Things were stuck to it: pebbles, bottle caps, lottery stubs, a blue condom, an empty popper, a parking ticket. I brushed it off. The whores helped me, dabbing it with napkins from the doughnut shop.

Cass waited.

I knelt down with my back to the egg while it was trapped in the doorway and tried to stand up, forcing it up the wall. When they saw what I was doing, two guys came forward and lifted it for me. I started off down the street at what was almost a jog, heading south now, out of the city. Some of the whores came too. The shopping-cart man was there. Two kids carrying a huge boom box between them trailed after.

Cass fell in behind.

The egg is my burden. I can bear it. The role has its compensations. Together we will go around the world. And then, when I'm bored, I'll take my egg and go where we can be alone. I'll sit down next to it, and I'll try to remember what it feels like to want something. And I suppose, my angel, that in the end you'll let me in.

GEORGANNE DEEN

Take This Dream, 1998–99.

ABOVE:

DON'T, 2000.

LEFT:

Til There Was You, 1997–99.

Bird (Schiaparelli), 1997–2000.

Georganne Deen

The Girlfriend and the Devil

The "Antique Digital Output" pictures began as studies for paintings and were created on two old pieces of equipment: an Amiga computer, circa 1986, and a Diablo printer from the same era—the girlfriend and the devil. The printer was yanked off the market in no time because it's nothing but trouble. Since it has been obsolete for over a decade, the fluids, inks, and paper needed to operate it are harder to buy than illegal drugs and more expensive. As a final insult, the ink fades away when exposed to daylight.

The "Vogue Book of the Dead" is a series of paintings made just after my mother died in 1997. They were the product of our inability to discuss anything but fashion right up to her departure from this world. I had a show to do in Venice and, as I was in a state of deep despair, all that came out were these odd little fashion ads that clocked my mourning with frightening accuracy. *Bird (Schiaparelli) (1997)* is a study for one of those paintings. The text reads:

Who Will Hold Your Hand As You Walk to the Grave?
The Falling Snow Answers:
STEROIDS PAIN KILLERS SCHIAPARELLI

I know it's bleak, but that really did sum it up.

The following years were a tangle of unintentional sexual disclosures, kicked off by a new body of work in which I simply pieced together images, words, and compositions I found interesting and the heck with the meaning of it all. Most of the prints shown here were produced during this period. Needless to say, I can't comment on these divinely guided Ouija Board confessionals. Except this one thought: Sex is really the plutonium of energy sources and easily as dangerous. Easily.

There's no point in trying to describe the latest work. *DON'T* (2000) is the only piece represented here. It has something to do with *amore*. And turning yourself around. I know—sounds like the Hokey Pokey. But that's what it's all about.

G.D.

FROM
INGRID CAVEN:
A NOVEL
JEAN-JACQUES SCHUHL

VOICES COME AND GO, they fly off, and they can be stolen.

Any number of people had borrowed hers. Transvestites in Berlin mimed her tunes. Plagiarists, copycats, and unscrupulous songsters mechanically imitated her timbre and intonation without the spirit, without taking any risks. Those lifeless doubles inevitably made her wince.

And then there was the time that somebody actually bought her voice: "On a fine afternoon in Munich, Rainer and I went to this place that had just opened, a fancy club with rooms upholstered in red velvet, that did screenings of porn films. That sort of thing was very fashionable at the time, and it amused him, despite his prudishness. He was always torn between his urge to know everything and do everything and his natural reserve; he was chaste and pure. He always liked taking me to new places: movie theaters, restaurants, bars, clubs. Like any loving husband, no? So there we were, sitting quietly on our Chesterfield sofas, drinking whiskey and fruit juice, when the room went dark and the movie began. It was called *The Devil in Miss Jones*. The star was Linda Lovelace, and, true to her name, she had a face like a Pre-Raphaelite angel, something out of Burne-Jones or Aubrey Beardsley, with long, wavy brown hair falling in cascades to her shoulders, framing ingenuous blue eyes, a mouth with nice thick lips, and a seraphic smile. She was done up in white lace; the only thing missing was the wreath of orange flowers. And the voice. No. At first she was silent; then she slices open her veins in the bathtub, so she goes to hell. Hell is a big office. She sits there quietly while one of the Devil's underlings, wearing a suit and tie, proposes a pact: She can return to earth, but only if she first engages in every sexual vice imaginable. And so the torrid acrobatics begins. This supposedly dead woman with the

figure of a Botticelli starts doing all these raw and crude and not very proper things. She even does things with a snake. Getting herself stuffed in every hole to win her ticket back home—a good subject when you think about it, sex as a way of assuring yourself of victory over death. As ingenious as Orpheus seducing the gods of the Styx with his poetry. And then she begins to speak, reeling off one horrible, disgusting thing after another, screaming abuse, moaning, shouting. And that voice—that voice. No! It was impossible, incredible. Yet if you heard it once, even for just a few seconds, you couldn't mistake it for any other. From the sound of the gutturals alone, you could instantly pick that voice out of a thousand, that hoarse but supple contralto. Yes, it was his beloved wife's voice, it was my voice, saying, 'Yeeessss, that feels so good. Fuck me in the ass!' Rainer was slumped down in his sofa. His face had gone pale, his eyes were fixed, he had begun to sweat, and he was all scrunched up, withdrawn. Suddenly he stood up, roughly pushed the heavy sofa aside, put his head down, and rushed out without a word as if he himself had just seen the Devil. He looked like James Cagney in that famous scene in the prison mess, when he learns the incredible news that his mother is dead. I sat calmly in my sofa: 'Why, sure.'" And while the luminous, diaphanous, delicious Botticellian figure did it every which way— sixty-nine, Chinese wheelbarrow, rose leaf, double Manila water lily, buddy full reverse (a rare delight, but you need at least three people)—she remembered her visit to New York two years earlier for the opening of La Paloma.

"Christopher, this friend of mine, was a nice boy who did a little of this and a little of that and always had a scheme or two up his sleeve. When he wasn't with the Sherpas climbing mountains in Tibet or dealing cocaine or driving heiresses wild with tantric sex—he could get it up whenever he wanted, one, two, three, like a fakir doing a rope trick, and keep it up for an hour at a time—he distributed porno flicks. Dub Linda Lovelace in German? Why not? It might be fun. So, OK, for a thousand dollars, between fancy cocktail parties and interviews where I had to give highfalutin answers to questions about my character, La Paloma, a fragile romantic heroine, a consumptive drenched in nostalgia, I found myself one autumn afternoon in a post-sync studio on Broadway, on the forty-third floor, dressed in a sweater and blue jeans and calmly going 'Ooh!' and 'Ah!' and 'Don't stop!' and 'I'm coming!' to say nothing of 'Stick it to me!' and 'I'm wet all over!'

I felt like I was speaking lines from the balloons over the heads of comic strip characters. I was having a good time.

"So, two years later, in this neighborhood in back of Maximilianstrasse in the building right next to the music store where Rainer bought me a harmonium—we were passing by one day and he asked, 'Do you like it?'—in that posh club with its Chesterfield sofas and waiters, my voice caught up with me. And you know, I think—yes, I'm certain of it—we were the only two people in that big room, that club. He had gone out with 'his wife' to treat her to a bit of an exotic show, something a little on the racy side. I was 'his wife.' At first it always used to surprise me whenever he said in his very petty-bourgeois, very proper way, 'Let me introduce you to my wife.'" It surprised other people, too, but it wasn't the same. It made them smile, and she knew what that little smile meant: "A marriage between a woman and a homosexual? It doesn't count. It's just for show." It was the smile of people who rejected femininity in men and couldn't see that maybe only a homosexual could love a woman to that degree, in such an exclusive way. For people like that, pleasures are supposed to be simple and straightforward. Whereas those two were trying to create something different, to reinvent themselves. You have to understand that with Germany in ruins, and themselves in ruins spiritually and physically, they started out with a certain advantage, which is to say, with nothing—less than nothing. That's what war and disease are good for. As their philosopher-poet Nietzsche used to say, "Where there are no ruins, there can be no resurrection." To invent something, a different sort of body; it hadn't lasted very long: "I'll say this," Fassbinder wrote in *Essays and Working Notes*, "of all the people I worked with, people who had set out to prove that utopia is possible here and now, the only one left today apart from me and Peer Raben[*] is probably Ingrid Caven."

"Let me introduce you to my wife! When I got married I said to myself, 'He's into boys. What we've got between us is love for sure, but he'll do his thing, and I'll have flings of my own.' But that wasn't the way it worked out, not at all. He didn't like anybody to hit on me. One day we were having lunch with the young actor Karlheinz Böhm, the conductor's son, and I guess Karlheinz must have been paying a little too much attention to me.

[*]Friend of Fassbinder and composer of his films' music scores.

Rainer said to him, 'Don't you think my wife looks awfully young for a woman of forty?' when in fact I was only thirty! Another time, when we were out walking in that big park in Munich, the Englischer Garten, he said, 'Take off that lipstick. All the guys are going to try to pick you up, and I'll have to fight them.' And it was out of the question that I should become an actress, 'a whore's profession.' 'My wife will go to the beach with sunglasses and a book while I work.' He made his whores work, and they didn't ask questions. *No problem.* He made them work at top speed, not a moment to waste, get the job done, assembly-line style. He looked at things in a certain way. He had his vision, certain visions of Germany that he absolutely had to film. He worked around the clock, gave interviews while playing pinball on the rue d'Antibes in Cannes. 'And your relations with Fraulein Caven?' the journalist from *Der Spiegel* asked him in the bar. 'Well, if the word—' he's holding a cigarette between two fingers while stabbing at the flipper of the machine. 'If the words *elective affinities*—' The ball shoots down the channel and hits the 1,000-points bumper. '—have any meaning—I would say that my relations with Fraulein Caven come close—' Tilt! 'And Douglas Sirk? His flamboyant melodramas?' Tilt! *Same player shoots again.* There was a certain bar in a tiny street near the Palais-Royal, the rue des Bons-Enfants, right near the hotel where we were staying, the Hôtel de l'Univers. He would come into that noisy place in the morning, punch up a couple of tunes on the jukebox, something by the Pretenders, maybe, or 'Oh, Diana' by Paul Anka, and write *The Bitter Tears of Petra von Kant* at top speed, as if it had all been mapped out in his head in advance, completely written, so that all he was doing was finishing up a kind of homework exercise. Settling an old score with God knows whom: Germany?

"And then to top it all off, one time when I ran off to Paris without telling him in advance, he sent two gorillas after me, real Mafia types, and I had to hide in the closet for a couple of hours. I was his wife for all eternity: He was sentimental when it came to that sort of thing. He wore white at our wedding, very official-looking, and at lunch he gave a toast based on an old proverb, *Glück und Glas, wie leicht bricht das,* 'Happiness and glass, how easily they break,' while I sang an old song, a song I used to sing as a child that made my grandfather happy: '*Es geht alles vorüber, es geht alles vorbei,*' 'Everything passes, everything goes by.' I was wearing a green silk dress with a Chinese

collar buttoned all the way up. That very evening—in those days, work and love were mixed up—we were shooting a scene for one of his films in a bar, and I sang on screen for the first time: *I was sitting by the river with my tears . . .* So anyway, to get back to what I was saying, when he heard my voice, the voice of a woman possessed, he was not amused.

"Of course, he knew a thing or two about dubbing, and for that matter about special effects of every sort and filmmaking techniques in general. He could have made a film all by himself. He knew everything there was to know about the business: You're there on a stool or standing in front of a screen on which the film is projected over and over in a continuous loop. Under the image they run a strip of white celluloid, a ribbon on which each syllable of the text is written in india ink with a special pen. Each syllable passes under a little red lamp, and depending on whether the writing is thick or thin, compressed or stretched out, wide or narrow, you adjust the modulation of your voice, so you get either 'Oh!' or 'Oooooh!,' either 'I'm coming' or 'I'm coooo-ming.' The scene gets looped two, three, four times, and you repeat the same words, the same alliterations, the same shouts two, three, or four times accordingly. That's the cue tape."

Rainer knew perfectly well that it was all cold and technical manipulation, but it didn't matter: He reacted as if to some sort of black magic, like a savage from the past, he was out of there like a shot. For a few strange and anxious seconds, he had been plunged several centuries into the past, back to a time when people still believed in spirits and ghosts. Probably he had both understood and not understood. A peculiar state: He recognized the voice, sure, but he also heard it as the voice of a doppelgänger, a ghost. And then, gradually, he must have come to his senses. But it left a trace, an aftermath. He would have found it far less disturbing if he had actually seen her being fucked, for real, on the screen.

Translated from the French by Arthur Goldhammer

Lagerfeld

VOLKER BRAUN
—1998

Rome: an open city A laager
Down the catwalk troop the fashions
Of the millennium, bulletproof vests
For copulation Two gladiators
Are fighting for the job, long practiced
In the tricks of throttling, they win applause
That's what they went to school for HIM OR ME
The stink of fear In his empire
Lagerfeld is making a dream come true A PACK
OF WOMEN THE PICK OF BEAUTY
The winter collection for the wars in Dacia
Has made him rich IT IS ENOUGH TO TURN YOUR STOMACH
They are bearing my ideas, these are summer clothes
To the spoiled world A festival of beauty
Helena Christensen in evening wear Meanwhile
The two craftsmen have not let go
One is Commodus, the wild son
Of a cool father, the mother's indiscretion
When he croaks the throne stands empty
And Septimius Severus the African
Will march with the XIVth from the wilderness of Vienna
Against the capital POOR ROME A barbarian
Emperor On his heels the rest of the world
Lagerfeld doesn't watch He has a problem
He can make them more beautiful but not better
More and more beautiful Outfit of the brute beasts
RICH AND POOR A divided clientele
ATROCIOUS Paying and thieving
I enjoy undivided attention But
He knows what's going on, he isn't blind
The fifteen-year-old killer from Springfield
A MOUNTAIN OF CORPSES IN THE HIGH-SCHOOL CAFETERIA
He has learned to lend a hand
He is in custody now in paper clothes
Another fashion from America Gangs of children
Are combing now North Rhein-Westphalia trainees
Looking for food at Hertie's and Woolworth's
A light-fingered tribe from the future
In the employment exchanges carrion
Is waiting to be recycled It will wait a long time

Those at work are waiting on machines
The others are waiting to be allowed to wait on something
Legions While the world turns black
As Africa VIOLENCE MUST NOT ONLY BE THREATENED
IT MUST ALSO BE USED The Foreign Office
Inwardly grinning states its position
On Bosnia We'll show you what work is
A machine with limbs sexually neutral
The mannequin for tomorrow's work
AT THE END OF THE DAY YOU ARE JUST ANOTHER PRODUCT
Thinking is, precisely, what I try to avoid
Day after day the covering of paper with print
Custody, to prevent the suicide of the species
I don't read it, I don't watch
A theater full of equanimity
THE ONLY PLACE I FEEL AT EASE
DESPAIR Kleist on the edge
At Stimming's Inn MY ONE TRIUMPHANT CONCERN
TO FIND A DEEP ENOUGH ABYSS he lends a hand
Two dots near Potsdam Waiting for nothing
That's the drama: there is no action
We know otherwise and refrain from action No
We can do no other The dress
Fits like a second skin NOWADAYS THEY DO EVERYTHING
IN HUMAN FLESH Goes on and on
Look at Commodus, a death off the peg/
Lagerfeld or Serenity He
Doesn't love the beauties he can have His heart
Seeks beauty everywhere Beauty
Is a son of the gutter, has previous convictions
See here, his description, black skin
I enjoy the luxury of having been expelled
An idiot in the third millennium A citizen of the world
Helena Christensen leaves the catwalk
Why should I become fashionable
In the throwaway society
The arena full of the last screams Ideas
Rome's last era, unseriousness
Now watch the finale ME OR ME
Greetings, barbarians

Oysters
(For Alain Lance)

It isn't often I live really, you
For hours now in my kitchen have been opening
The immigrant (with many papers) oysters and
With a hurting hand in a plastic apron

Singing. Take the Wolfs, all they can think
Of nowadays is eating, which they do,
Like everything they do, in depth. They're human beings.
And I, with a lot of lemon, I anesthetize

The naked little creatures then my palate
And swallow glumly. You meanwhile, with gusto and
Disgust, have slurped two dozen of these
Small cunts of the sea. Well then, I say

Let life melt in the mouth, a life
Between appetite and loathing, yes.

—1973

VOLKER BRAUN'S NOTES: Line 3: Importing living creatures
into the GDR involved a great deal of paperwork. Line 5: The Wolfs
are Christa and Gerhard Wolf (prominent writers in the GDR).

The Magma in the Heart of the Tuareg

With a German passport landing at Agadir
In the winter sun: a change of identity
Slaves are watching me and thieves
Prowling around my feet, who am I
A nomad in the 4-star hotel, room with a view of the sea
I can choose my season
LEISURE IS EPIDEMIC even in the gear
Of a tourist I'm on the dole and hanging around
In the last-minute lands LIFELONG
The throw-away man, only COCA COLA needs me
The tea-drinkers of Marrakesh have still to be converted
To the global gods, and I
No longer driven to find the place and the solving word
I belong to all the useless peoples.

—1996

VOLKER BRAUN'S NOTE: The penultimate line derives from
Rimbaud's *Illuminations* ("Vagabonds")

Translated from the German by David Constantine

GOOD LUCK!

DURS GRÜNBEIN
AND
VIA LEWANDOWSKY

Lisbon

February 18, 1994

While driving through the rain to meet a date, a mechanic, Jose V. (26), lost control of his Toyota on a slick road and hit a bicyclist. Panicked, he drove away, leaving the badly injured cyclist to die at the scene of the accident. Though the hit-and-run driver didn't realize it at the time, the man he'd killed was his twin brother, Jorge, who was also on his way to meet a date. The two men were planning to go out that night with two sisters, Valeria (21) and Isabel (23). Jose later testified that he had been in a hurry because he had to get cleaned up.

Oviedo

February 20, 1994

In Florida a stripper murdered her jealous boyfriend,
a drummer. After burning the corpse in a cornfield,
she tried in vain to get rid of the bones. In an absurd move,
she sawed up the bones, dipped them in cement, and
formed small balls, which she scattered along the highway
leading to Miami. After her arrest the skeleton balls became
the most damaging evidence against her.

Bremen

March 9, 1994

During a raid on an illegal bordello, the police surrounded
and stormed the two-story apartment house. Amid the
general confusion caused by shrieking women in bras
and panties, one of the girls panicked and jumped out a
back window directly into the strong current of the Ochtum.
She drowned. The water temperature was thirty-eight
degrees Fahrenheit.

Bay Shore
March 10, 1994

After being abandoned by his girlfriend, a snake breeder
(37) was in despair and decided to take his own life.
Using Cleopatra's method, the man provoked one of his
rattlesnakes until it bit him. He collapsed from cardiac arrest
as he attempted to escape from the apartment. Since he left
the front door open, the snake died as well—of exposure.

Translated from the German by Daniel Slager

STEPHANIE STRICKLAND

tone, as in
"Procne is among the slaves," that embroidered text
of a woman raped and her tongue cut out
by her brother-in-law. She is trying to address

her sister. And does. And they serve him
his child for dinner. And turn into birds.
Blank birds, they blend—into one name, Philomel.
Medieval story of the nightingale,

pressing her breast onto thorns, who can't remember
why she mourns. A real witch doesn't cry,
a real witch can't float.
Weight her down, if she drowns, you were correct

in your suspicions. Someone,
somewhere, saw, once, for the first time,
a rape, but which of them knew it?

GENERATION P
VICTOR PELEVIN

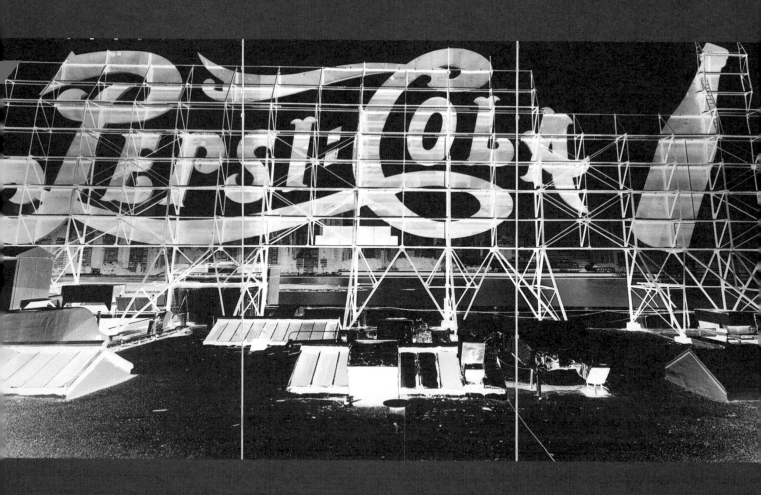

ONCE UPON A TIME IN RUSSIA there really was a carefree, youthful generation that smiled in joy at the summer, the sea, and the sun, and chose Pepsi.

It's hard at this stage to figure out exactly how this situation came about. Most likely it involved more than just the remarkable taste of the drink in question. More than just the caffeine that keeps young kids demanding another dose, steering them securely out of childhood into the clear waters of the channel of cocaine. More, even, than a banal bribe: It would be nice to think that the Party bureaucrat who made the crucial decision to sign the contract simply fell in love with this dark, fizzy liquid with every fiber of a soul no longer sustained by faith in communism.

The most likely reason, though, is that the ideologists of the Soviet Union believed there could only be one truth. So in fact Generation P had no choice in the matter, and children of the Soviet seventies chose Pepsi in precisely the same way as their parents chose Brezhnev.

No matter which way it was, as these children lounged on the seashore in the summer, gazing endlessly at a cloudless blue horizon, they drank warm Pepsi-Cola decanted into glass bottles in the city of Novorossiisk and dreamed that someday the distant forbidden world on the far side of the sea would be part of their own lives.

Babylen Tatarsky was by default a member of Generation P, although it was a long time before he had any inkling of the fact. If in those distant years someone had told him that when he grew up he would be a copywriter, he'd probably have dropped his bottle of Pepsi-Cola on the hot gravel of the pioneer-camp beach in his astonishment. In those distant years children

were expected to direct their aspirations toward a gleaming fireman's helmet or a doctor's white coat. Even that peaceful word "designer" seemed a dubious neologism only likely to be tolerated until the next serious worsening in the international situation.

In those days, however, language and life both abounded in the strange and the dubious. Take the very name "Babylen," which was conferred on Tatarsky by his father, who managed to combine in his heart a faith in communism with the ideals of the sixties generation. He composed it from the title of Yevtushenko's famous poem "Baby Yar" and the name Lenin. Tatarsky's father clearly found it easy to imagine a faithful disciple of Lenin moved by Yevtushenko's liberated verse to the grateful realization that Marxism originally stood for free love, or a jazz-crazy aesthete suddenly convinced by an elaborately protracted saxophone riff that communism would inevitably triumph. It was not only Tatarsky's father who was like that—the entire Soviet generation of the fifties and sixties was the same. This was the generation that gave the world the amateur song and ejaculated the first sputnik—that four-tailed spermatozoan of the future that would never begin—into the dark void of cosmic space.

Tatarsky was sensitive about his name, and whenever possible he introduced himself as Vladimir or Vova. Then he began lying to his friends, saying that his father had given him a strange name because he was keen on Eastern mysticism, and he was thinking of the ancient city of Babylon, the secret lore of which was destined to be inherited by him, Babylen. His father had invented his alloy of Yevtushenko and Lenin because he was a follower of Manichaeanism and pantheism and regarded it as his duty to balance out the principle of light with the principle of darkness. Despite this brilliantly elaborated fable, at the age of eighteen Tatarsky was delighted to be able to lose his first passport and receive a new one with the name of Vladimir.

For a few years after that his life followed an entirely ordinary pattern. He went to a technical institute—not, of course, because he had any love for technology (he specialized in some kind of electric furnace), but because he didn't want to go into the army. However, at the age of twenty-one something happened to him that changed the course of his life forever.

Out in the countryside during the summer he read a small volume of poetry by Boris Pasternak. The poems, which had previously left him entirely

cold, had such a profound impact that for several weeks he could think of nothing else—and then he began writing verse himself. He would never forget the rusty carcass of a bus, sunk at a crooked angle into the ground on the edge of the forest outside Moscow at the precise spot where the very first line of his life came to him: "The sardine-clouds swim onward to the south." (He later came to realize this poem had a distinctly fishy odor.) In short, his was an absolutely typical case, which ended in typical fashion when Tatarsky entered the Literary Institute. He couldn't get into the poetry department, though, and had to content himself with translations from the languages of the peoples of the Soviet Union. Tatarsky pictured his future approximately as follows: during the day—an empty lecture hall in the Literary Institute, a word-for-word translation from the Uzbek or the Kirghiz that had to be set in rhyme by the next deadline; in the evenings—his creative labors for eternity.

Then, quite unobtrusively, an event of fundamental significance occurred. The Soviet Union, which they'd begun to renovate and improve at about the time Tatarsky decided to change his profession, improved so much that it ceased to exist (if a state is capable of entering nirvana, that's what must have happened in this case); so any more translations from the languages of the peoples of the Soviet Union were simply out of the question. It was a blow, but Tatarsky survived it. He still had his work for eternity, and that was enough for him.

Then events took an unforeseen turn. Something began happening to the very eternity to which he had decided to devote his labors and his days. Tatarsky couldn't understand this at all. Eternity—at least as he'd always thought of it—was something unchangeable, indestructible, and entirely independent of the transient fortunes of this earthly realm. If, for instance, the small volume of Pasternak that had changed his life had already entered this eternity, then there was no power capable of ejecting it.

But this proved to be not entirely true. It turned out that eternity only existed for as long as Tatarsky sincerely believed in it, and was actually nowhere to be found beyond the bounds of this belief. In order for him to believe sincerely in eternity, others had to share in this belief, because a belief that no one else shares is called schizophrenia; and something strange had started to happen to everyone else, including the very people who had taught Tatarsky to keep his eyes fixed firmly on eternity.

245

It wasn't as though they'd shifted their previous point of view, not that—just that the very space into which their gaze had been directed (after all, a point of view always implies gazing in some particular direction) began to curl back in on itself and disappear, until all that was left of it was a microscopic dot on the windscreen of the mind. Glimpses of entirely different landscapes began to fill in their surroundings.

Tatarsky tried to fight it and pretend that nothing was actually happening. At first he could manage it. By keeping close company with his friends, who were also pretending that nothing was happening, for a time he was able to believe it was true. The end came unexpectedly.

When Tatarsky was out walking one day, he stopped at a shoe shop that was closed for lunch. Swimming around in the summer heat behind the glass wall of the shop window was a fat, pretty salesgirl whom Tatarsky promptly dubbed Maggie, and there in the midst of a jumble of multicolored Turkish handicrafts stood a pair of unmistakably Soviet-made shoes.

Tatarsky felt a sensation of instantaneous, piercing recognition. The shoes had pointed toes and high heels and were made of good leather. They were a light yellowish-brown, stitched with a light blue thread and decorated with large gold buckles in the form of harps. It wasn't that they were simply in bad taste, or vulgar; they were the clear embodiment of what a certain drunken teacher of Soviet literature from the Literary Institute used to call "our gestalt," and the sight was so pitiful, laughable, and touching (especially the harp buckles) that tears sprang to Tatarsky's eyes. The shoes were covered by a thick layer of dust: The new era obviously had no use for them.

Tatarsky knew the new era had no use for him either, but he had managed to accustom himself to the idea and even take a certain bittersweet satisfaction in it. The feeling had been decoded for him by the words of Marina Tsvetaeva: "Scattered along the dusty shelves of shops / (No one has bought them and no one buys!) / My poems, like precious wines, will have their day": if there was something humiliating in this feeling, then it was not he, but the world around him that was humiliated. But in front of that shop window his heart sank in the sudden realization that the dust settling on him as he stood there beneath the vault of the heavens was not the dust that covered a vessel containing precious wine, but the same dust that covered the shoes with the harp buckles; and he realized something else too: The eternity he used to

believe in could only exist on state subsidies, or else—which is just the same thing—as something forbidden by the state. Worse even than that, it could only exist in the form of the semiconscious reminiscences of some girl called Maggie from the shoe shop. This dubious species of eternity had simply been inserted into her head, as it had into his, in the same packaging as natural history and inorganic chemistry. Eternity was contingent: If, say, Stalin had not killed Trotsky, but the other way around, then eternity would have been populated by entirely different individuals. But even that was not important, because Tatarsky understood quite clearly that no matter how things panned out, Maggie simply couldn't care less about eternity, and when she finally and completely stopped believing in it, there wouldn't be any more eternity, because where could it be then? Or, as he wrote in his notebook when he got home: "When the subject of eternity disappears, then all of its objects also disappear, and the only subject of eternity is whoever happens to remember it occasionally."

He didn't write any more poems after that: With the collapse of Soviet power they had simply lost their meaning and value.

Translated from the Russian by Andrew Bromfield

CONTRIBUTORS

Benjamin Anastas is the author of two novels, *An Underachiever's Diary* (The Dial Press, 1998) and *The Faithful Narrative of a Pastor's Disappearance* (Farrar, Straus & Giroux, 2001). He is a former associate editor of *Grand Street*.

Miguel Arisa teaches art history at Technical Career Institute in New York City. His translations include poems by Paul Bowles and a collection of nineteenth-century Spanish Caribbean literature that has been distributed on CD-ROM.

Daniel Barenboim was born in Buenos Aires in 1942 to parents of Russian Jewish descent. He started piano lessons at age five with his mother and continued to study with his father, who remained his only other teacher. In August 1950, when he was seven, he gave his first official concert in Buenos Aires. Today, Barenboim is artistic director and general music director of the Berlin State Opera and music director of the Chicago Symphony Orchestra, and he was elected by the Berlin Staatskapelle Orchestra as chief conductor for life in 2000. In addition, he has a full concert schedule as one of the world's foremost pianists.

Virginia Beahan and **Laura McPhee** have been photographing together since 1987. They have received support for their work from numerous sources, including two fellowships from the John Simon Guggenheim Foundation and grants from the New England Foundation for the Arts, the Polaroid Corporation, and the English Speaking Union. Their photographs have been exhibited internationally and appear in numerous collections including the Museum of Fine Arts, Houston, the San Francisco Museum of Modern Art, The Art Museum at Princeton University, and the Los Angeles County Museum of Art. The five photographs that appear in this issue of *Grand Street* were originally published in the monograph *No Ordinary Land/ Encounters in a Changing Environment* (Aperture, 1998).

Bruce Beasley's poetry has appeared recently in *Kenyon Review*, *Ploughshares*, *Iowa Review*, *Denver Quarterly*, *Fence*, and *Pushcart Prize 2000*. His fourth collection of poems, *Signs and Abominations* (Wesleyan University Press), was published in 2000.

Ben Bennani is a professor of comparative and Arabic literature at Truman State University where he edits *Paintbrush*, a journal of poetry and translation, and *Bestia*, yearbook of the Beast Fable Society, of which he is the founding president. Bennani's poems, translations, and essays have appeared in literary magazines in the United States,

England, Canada, and India. His translated work includes *Splinters of Bone: Poems by Mahmud Darwish* (1974), *Bread, Hashish, and Moon: Four Modern Arabic Poets* (1982), and *Psalms: Poems by Mahmud Darwish* (1994). A new collection of Bennani's own poetry, *Primal Sympathy*, is forthcoming from Ishtar Press.

Roberto Bolaño was born in Santiago, Chile, in 1953. He has written five novels and five books of poetry. His short-story collection *Llamadas telefónicas* (Anagrama) won the prestigious Santiago de Chile Municipal Prize in 1997, and his novel *Los detectives salvajes* (Anagrama, 1998) won the Premio Herralde de Novela and Premio Rómulo Gallegos. The selection published in this issue was excerpted from his novel *La literatura nazi en América* (Seix Barral, 1996).

Volker Braun was born in Dresden, Germany, in 1939 and trained as a printer and machinist. He then studied philosophy in Leipzig and went on to become dramaturge at the Berliner Ensemble and the Deutsche Theater from 1965 to 1988. His honors include the Heinrich Mann Prize (1980), the East German National Prize (1988), and the Schiller Memorial Prize (1992). His collections of poetry include *Training des aufrechten Ganges* (1979), *Langsam knirschender Morgen* (1987), *Tumulus* (1999), and most recently *Lustgarten, Preußen: Ausgewählte Gedichte* (2000). Braun was given the Georg Büchner award, Germany's most prestigious literary honor, in 2000. The three poems in this issue were excerpted from *Tumulus* and *Lustgarten, Preußen: Ausgewählte Gedichte*.

Andrew Bromfield was born in Hull, England, and graduated in Russian Studies from the University of Sussex. From 1988 to 1993, he lived and worked in Moscow, where he was involved in founding *Glas*, an English-language journal of contemporary Russian writing, which he coedited. His translation of Victor Pelevin's *The Life of Insects* (Farrar, Straus & Giroux, 1998) was short-listed for the Weidenfeld Translation Prize in England.

Luca Cavalli-Sforza was born in Genoa in 1922 and has taught at the Universities of Cambridge, Parma, and Pavia. He is currently Professor Emeritus of Genetics at Stanford University and is the author of *The History and Geography of Human Genes* (Princeton University Press, 1994) and *Genes, Peoples, and Languages* (Farrar, Straus & Giroux, 2000).

Ruth Christie was born and educated in Scotland. Her published translations include Latife Tekin's *Berji Kristin: Tales from the Garbage Hills* (translated with Saliha Paker; Marion Boyars, 1993) and a selection of poems by Oktay Rifat (translated with Richard McKane; Rockingham Press, 1993). A major collection of Nazîm Hikmet's poetry (also translated with Richard McKane) is forthcoming from Avril Press. Christie lives in London.

David Constantine has published half a dozen collections of poetry, the most recent being *The Pelt of Wasps* (1998), all with Bloodaxe Books. A Fellow of Queen's College, Oxford, Constantine is a translator of Hölderlin, Goethe, Kleist, and Brecht, and of contemporary German verse.

Peter Constantine is the translator of *Six Early Stories*, by Thomas Mann, which received the Pen Translation Prize in 1997, and *The Undiscovered Chekhov: Thirty-Eight New Stories*, which received the National Translation Award in 1998. His most recent translation is *The Complete Works of Isaac Babel* (W. W. Norton, 2001).

Margaret Jull Costa has translated many novels and short stories by Portuguese, Spanish, and Latin American writers. She won the 1992 Portuguese Translation Prize for her version of *The Book of Disquiet* by Fernando Pessoa and, with Javier Marías, the 1997 International IMPAC Dublin Literary Award for *A Heart So White*. Most recently she was awarded the 2000 Weidenfeld Translation Prize for José Saramago's *All the Names*.

Mahmud Darwish was born in Birwa, a village east of Acre, Palestine, in 1942. Early in life, he became politically active through his poetry and his involvement in the Israeli Communist Party, Rakah, whose newspaper, *al-Ittihad (The Union)*, he edited for a period of time. Today, Darwish is one of the most widely known contemporary Arab poets. He has published more than thirty books of poetry and prose, and he was awarded the Lotus Prize for poetry in 1969 and the Lenin Peace Prize in 1983. His most recent book of poetry is *The Stranger's Bed*. Darwish lives in Paris and edits the prestigious literary review *al-Karmel*. The poem published in this issue of *Grand Street* comes from his collection *I See What I Want* (Dar al-Jadid, 1993).

Georganne Deen was born in Fort Worth, Texas. She has lived and worked in Los Angeles for the last twenty years. Solo exhibitions of Deen's work will open in February 2002 at the McKinney Avenue Contemporary (MAC) and the Barry Whistler Gallery, both in Dallas, Texas.

Lucinda Devlin was born in 1947 in Ann Arbor, Michigan. From 1991 to 1998, with the permission of local authorities, she photographed execution chambers in penitentiaries across the United States. *The Omega Suites*, a selection of thirty of these photographs, was published this year by Steidl Publishers. Devlin has received fellowships from the National Endowment of the Arts and the Aaron Siskind Foundation and has been an artist in residence in the Deutscher Akademischer Austauschdienst (DAAD), Berlin, Germany. She lives and works in Hattiesburg, Mississippi.

Haydar Dilaçar was born in Trabzon, Turkey, on the Black Sea. He works as a translator and lives in New York City.

Duncan Dobbelmann's translations have appeared in *Conjunctions*, *Harper's*, and *The Transcendental Friend*. He recently published *Tronie*, a chapbook of prose poems.

Martine Franck was born in Antwerp, Belgium, and raised in the United States and England. She studied art history at the University of Madrid from 1956 to 1957 and at L'Ecole du Louvre in Paris from 1958 to 1962. In 1963, she began her career in photography as assistant to Eliot Elisofon and Gjon Mili at *Life*, and went on to become a freelance photographer for *Life*, *Fortune*, *Sports Illustrated*, *The New York Times*, and *Vogue*. Franck was a member of the Vu agency in Paris from 1970 to 1971, and cofounded the Viva agency in Paris a year later. She became an associate of Magnum Photos in 1980 and a full member in 1983. Franck's photographs of young Tibetan tulkus (reincarnations of Tibetan spiritual masters) were recently shown at Tibet House, New York City. She has been a photographer with the Théâtre du Soleil since 1965.

Peter Goin is a professor of photography and video art at the University of Nevada. A recipient of two National Endowment for the Arts fellowships, he is

the author of *Nuclear Landscapes* (Johns Hopkins University Press, 1991), *Stopping Time: A Rephotographic Survey of Lake Tahoe* (University of New Mexico Press, 1992), and *Humanature* (University of Texas Press, 1996).

Arthur Goldhammer has translated more than seventy-five books from the French. He is currently working on a new translation of Alexis De Tocqueville's *Democracy in America*.

Lavinia Greenlaw was born in 1962 in London, where she still lives. She has published two collections of poetry: *Night Photograph* (Faber and Faber, 1993) and *A World Where News Traveled Slowly* (Faber and Faber, 1997). Her first novel, *Mary George of Allnorthover* (Houghton Miflin), was published in July 2001.

Durs Grünbein was born in 1962 in Dresden, Germany, and has lived in Berlin since 1985. He is the recipient of many prizes, including the 1995 Georg Büchner Prize, and is the author of five collections of poetry, most recently *Nach den Satiren* (1999), and a collection of essays, *Galilei vermißt Dantes Hölle und bleibt an den Maßen hängen* (1996), from which the essay in this issue of *Grand Street* was excerpted.

Andy Grundberg is an art critic, independent curator, and teacher whose writings examine photography's role in contemporary art and culture. His book *Crisis of the Real* was recently reissued by Aperture in an expanded, updated edition. He recently organized "In Response to Place," an exhibition of photographs commissioned by the Nature Conservancy, which will travel the country from 2001 through 2005. Grundberg lives and works in Washington, D.C.

Ara Guzelimian is the senior director and artistic adviser at Carnegie Hall in New York City. Since 1999, he has collaborated with Daniel Barenboim and Edward W. Said on a series of conversations—one of which appears in these pages—that will be the basis of a book to be published in 2002.

Stefan Hertmans is a Belgian novelist, travel writer, poet, and essayist, and has been nominated for awards in each of these genres. His most recent book is *Als op De Eerste Dag*, a novel in nine stories. The poem in this issue of *Grand Street* was taken from *Bezoekingen* (1988). Hertmans is a professor at the Academy of Fine Arts in Ghent.

Cornelia Hesse-Honegger was born in Zurich in 1944 and studied at the University of Zurich's Institute of Zoology and at the Ecole Supérieure des Beaux Arts, Paris. She has worked as a scientific illustrator at the marine biological institutes of Banyul-sur-Mer, France; Coney Island, New York; and Hawaii; as well as at the Institute of Zoology in Zurich. Hesse-Honegger has been a visiting professor at the Academy for Applied Arts, Vienna, and has also taught at the University of Mainz, Germany. She currently teaches at the Marine Biological Institutes in Bern. A solo exhibition of Hesse-Honegger's work was held at the Swiss Institute, New York, in 1993. *Heteroptera*, a collection of her paintings and writing, is forthcoming from Scalo Publishing.

Shelley Jackson is the author of the hypertext novel *Patchwork Girl*, two children's books, and many short stories, some of which are collected in her forthcoming book, *The Melancholy Of Anatomy* (Anchor Books, 2002).

Karl Kirchwey is the author of three books of poems: *A Wandering Island* (Princeton University Press, 1990; recipient of the Norma Farber First Book Award from the Poetry Society of America), *Those I Guard* (Harcourt Brace, 1993), and *The Engrafted Word* (Henry Holt, 1998). Kirchwey has been the recipient of grants from the Ingram Merrill and the John Simon Guggenheim Memorial Foundation as well as from the National Endowment for the Arts. He also received a Rome Prize in Literature in 1994–95.

Yannis Kondos is one of Greece's foremost contemporary poets and essayists. He has published twelve books of poetry, the most recent of which, *Ho Athlitis tou tipota*, was awarded the 1998 Greek State Prize for Poetry. Kondos lives in Athens where he works as poetry editor of Kedros Publishers and teaches acting.

Linda Lê was born in Dalat, South Vietnam, in 1963, and moved to France with her mother, grandmother, and three sisters in 1977. She published her first novel, *Un si tendre vampire*, when she was twenty-three, and has published eight others since then. The selection that appears in this issue of *Grand Street* comes from her novel *Lettre Morte* (Christian Bourgois, 1999).

Pedro Lemebel was born in Santiago, Chile, in the mid-1950s. In 1987, along with Francisco Casas, he created Yeguas del Apocalipsis, an arts collective that has developed an extensive body of work in the plastic arts, including photography, video, performance art, and installations. His articles have appeared in newspapers and magazines in Chile and internationally. The selection in this issue of *Grand Street* was excerpted from *Loco Afán* (Anagrama, 1996). In 1999, Lemebel was awarded a Guggenheim grant to expand a compilation of stories on homosexuality in Chile. He lives in Santiago, where he produces *Canionero*, a radio program for Radio Tierra.

Via Lewandowsky was born in Dresden, Germany, in 1963. He studied at the Hochschule für Bildende Künste in Dresden from 1982 to 1987 and has had arts residencies at P.S.1 Contemporary Art Center, New York (1991–2), and Banff Center for the Arts, Banff, Alberta (1994). He lives and works in Berlin.

Michael Longley was born in Belfast in 1939. His collections of poetry include, *Gorse Fires*, which won the Whitbread Prize for Poetry in 1991; *The Ghost Orchid*, which was short-listed for the T. S. Eliot Prize in 1995; and *Selected Poems*, published in 1998. His most recent book is *The Weather in Japan* (Wake Forest University Press, 2000), which received the *The Irish Times* Irish Literature Prize for Poetry, the Hawthornden Prize, and the T. S. Eliot Prize.

Laurence Marie is a reporter for *Le Nouvel Observateur*.

Julie Martin was born in Nashville, Tennessee, in 1938. She received a B.A. from Radcliffe College in 1960, and in 1965 she received an M.A. in Public Law and Government and a Certificate from the Russian Institute at Columbia University. In 1966 and 1967 she worked as researcher and associate producer at Canadian Broadcasting Company in Ottawa, Ontario, and at CBS-TV, New York. In 1968 she joined the staff of the foundation Experiments in Art and Technology (E.A.T.) and coedited (with Billy Klüver and Barbara Rose) *Pavilion*—a book about E.A.T.'s Pepsi Pavilion project for the 1970 Osaka Expo. Martin is the author (with Billy Klüver)

of *Kiki's Paris* (1989), a history of the art community in Montparnasse from 1880 to 1930. She and Klüver also edited and annotated *Kiki's Memoirs* and are currently working on *Art and Artists: 1945–1965*, a social history of international art communities.

Bejan Matur was born in 1968 near Marsaş in southeast Turkey. Her first collection of poems, *Rüzgar Dolu Konaklar*, published in 1996, won two major literary prizes in Turkey. In 1999, it was follwed by a second collection, *Tanri Görmesin Harflerimi*, which became a best-seller. Her poems have been translated into several languages, including French, Italian, Dutch, Arabic, and Persian.

Ariane Mnouchkine founded the Théâtre du Soleil in 1964. The troupe had its first big success with *La Cuisine* by Arnold Wesker and was installed at the Cartoucherie in 1970. *La Cuisine* was followed by several collective creations (*Les Clowns, 1789, 1793, L'Age d'or*) and classics by Molière and Shakespeare, as well as Greek tragedies. Mnouchkine's collaboration with Hélène Cixous began in 1985, with *Histoire Terrible mais Inachevèe de Narodom Sihanouk, Roi de Cambodge* and continued with *L'Indiade ou l'Inde de leurs rêves, La Ville Parjure*, and *Et soudain des nuits d'éveil*.

Terézia Mora was born in Hungary in 1971 and has lived in Berlin since 1990. She writes screenplays and translates from Hungarian into German. She was awarded the 1997 Würth-Literaturpreis for the script *Die Wege des Wassers in Erzincan* and the Ingeborg-Bachmann Prize for her short story "Der Fall Ophelia," which appears in translation in this issue of *Grand Street*. *Strange Matter*, Mora's first collection of short stories, was published by Rowohlt in 1999.

Fujiko Nakaya was born in Sapporo, Japan, in 1933. She received her B.A. from Northwestern University in Evanston, Illinois, and later studied art in Paris. While living in New York in the mid-1960s, Nakaya joined Experiments in Art and Technology (E.A.T.), and created her first fog sculpture for E.A.T.'s Pepsi Pavilion at the 1970 Osaka Expo. She has continued to create fog installations around the world, including *Foggy Wake in a Desert* at the Australian National Gallery, Canberra; *Cloud Installation: Skyline* at the Jardin d'Eau, Parc de la Villette, Paris; and collaborations with choreographer Trisha Brown and video artist Bill Viola. In 1976, Nakaya won the Australian Cultural Award for *Earth Talk*, a fog sculpture shown at the Second Biennale of Sydney; in 1993 she won the Isoya Yoshida Award for the concept and design of *Foggy Forest*, at Showa Memorial Park, Tokyo. Nakaya lives and works in Tokyo.

Sharon Olds's most recent book is *Blood, Tin, Straw* (Knopf, 1999). She teaches at New York University and Goldwater Hospital for the physically disabled on Roosevelt Island, New York.

Victor Pelevin was born in Moscow in 1962. He has received degrees from thc Moscow Institute of Power Engineering and from the Russian Institute of Literature. His work has appeared widely in Russian magazines and has been translated into French, German, Japanese, and English. His collection of short stories *The Blue Lantern* (New Directions) won the 1993 Russian Booker short-story prize, and his novel *Omon Ra* (Farrar, Straus & Giroux) was among those nominated for the 1993 Russian Booker Prize. The selection that appears in this issue of *Grand Street* comes from his forthcoming novel, *Homo Zapiens* (Viking, 2002).

Srikanth Reddy has written on the visual arts, film, and poetry for *The New Republic*, *The Chicago Tribune*, *The Harvard Review*, and *The Boston Book Review*, and has scholarly articles forthcoming in *The Wallace Stevens Journal* and *Journal x*. He lives in Paris, France.

Michael Symmons Roberts was born in Preston, England, in 1963. He has published three books of poems: *Soft Keys* (Secker & Warburg, 1993), *Raising Sparks* (Jonathan Cape, 1999), and *Burning Babylon* (Jonathan Cape, 2001). He has received the Society of Authors Gregory Award for poetry, and his poems have appeared in *The Observer*, *The Guardian*, *The Independent*, *The Times Literary Supplement*, and *The London Review of Books*. His work as a librettist with composer James MacMillan has led him to interests in opera, song, and musical theater. His oratorio "Quickening" will receive its US premiere with the Philadelphia Orchestra in April 2002.

Mark Rudman has completed his poetic trilogy (Wesleyan), of which *Rider* received the National Book Critics Circle Award. His new book, *The Couple*, will appear in fall 2002.

Edward W. Said teaches literature at Columbia University. His recent books include *Reflections on Exile and Other Essays* (Harvard, 2000) and *Out of Place: A Memoir* (Knopf, 1999).

Jean-Jacques Schuhl is a writer living in Paris. *Ingrid Caven* (Gallimard, 2000), the Prix Goncourt winner from which the selection in this issue of *Grand Street* was excerpted, is his third novel.

Philip Schultz is the founder of The Writer's Studio, a private school for writing in New York City. He

has won an American Academy & Institute Award, a Lamont Prize, and *Poetry* Magazine's Levinson Prize. The poems in this issue of *Grand Street* were excerpted from his latest collection of poems, *The Holy Worm of Praise*, which will be published by Harcourt in spring 2002.

Daniel Slager is an editor at Harcourt and a contributing editor to *Grand Street*.

Kiki Smith was born in Nuremberg, Germany, in 1954. A figurative artist whose primary focus is the human body and the natural world, she has worked with a variety of materials including wax, glass, paper, ceramic, and bronze. Smith's drawings, prints, and sculptures have been included in numerous group exhibitions, among them the 1991 and 1993 Whitney Biennials and the 1993 Venice Biennale. Solo exhibitions of her work have been held at the Museum of Modern Art, New York; the Wexner Center for the Arts, Columbus, Ohio; the Moderna Museet, Stockholm, Sweden; the Whitechapel Art Gallery, London; the Carnegie Museum of Art, Pittsburgh, Pennsylvania; and the Kestner Gesellschaft, Hannover, Germany; among other venues. This year, exhibitions of Smith's photographs have been held at the International Center for Photography and at PaceWildenstein Gallery, both in New York. Smith lives and works in New York City.

Stephanie Strickland's forthcoming book of poems, *V* (Penguin), won the Poetry Society of America's Di Castagnola Prize. Strickland's previous collections, *True North* and *The Red Virgin*, won three national prizes, and her new-media poems, *True North* on disk and *The Ballad of Sand and Harry Soot* online, have also won awards. Strickland will hold the

McEver Chair in Creative Writing at the Georgia Institute of Technology in 2002.

Deborah Treisman is deputy editor of *The New Yorker*'s fiction department and a contributing editor to *Grand Street*.

Stephen Trombley was raised in upstate New York but has lived in England for the last twenty-seven years. He directed three documentary films on the case of A. J. Bannister: *The Execution Protocol*, *Raising Hell: The Life of A.J. Bannister*, and *A Death in the Family*. His books include *The Execution Protocol* (Crown Publishers, 1992), and the forthcoming *Stockpile* (Little Brown, 2002), a behind-the-scenes look at nuclear weapons in Russia and the United States.

Kyoko Uchida's work has appeared in numerous publications including *The Georgia Review*, *Shenandoah*, and *Black Warrior Review*.

Enrique Vila-Matas was born in 1948. Since 1973, he has published numerous novels and story collections, including *Suicidios ejemplares* (Anagrama, 1991), *Bartleby y compañía* (Anagrama, 2000), and *Hijos sin hijos* (Anagrama, 1993) from which the story in this issue was excerpted.

Abdourahman A. Waberi was born in 1965 in Djibouti. Since 1985, he has lived in Caen, France, where he teaches English. His books include *Le Pays sans ombre* (Le Serpent à Plumes, 1994), *Balbala* (1997), and *Moisson de crânes* (2000). The story in this issue of *Grand Street* was excerpted from *Cahier nomade*, (1996), which was awarded the Grand prix de l'Afrique noire.

Levent Yilmaz was born in 1969 in Ankara, Turkey. He has published many articles of criticism as well as four collections of poetry and has translated numerous authors into Turkish, including Yves Bonnefoy, W. B. Yeats, and Petrarch. His most recent book is *The Last Country* (YKY, 2000). Since 1997 he has been the head of Dost, a distinguished Turkish publishing company. He also works as an editorial adviser for Actes Sud (Paris) and Yapi Kredi Yayinlari (Istanbul).

Robert Ziebell was born in Chicago, Illinois, in 1956. He received a B.F.A. from the University of Michigan School of Art in 1979 and moved to Houston, Texas, in 1983 as an artist in residence at the Glassell School of the Museum of Fine Arts, Houston. Ziebell's photographs were included in a group show of Texas photographers at the Contemporary Art Museum, Houston, in 1998; exhibitions of Texas artists at the Museum of Fine Arts, Houston in 1995, 1996, and 2000; and most recently in a two-person show at d berman Gallery in Austin, Texas. His feature-length film *This State I'm In* (1990) was recently released on video. Ziebell is currently teaching photography at the University of Texas, San Antonio.

For other works by some of these contributors, visit our website at: www.grandstreet.com

ILLUSTRATIONS

Front Cover
Peter Goin, *Railroad Trestle, Nevada Test Site*, from the series "Nuclear Landscapes," 1986–90. The only remaining section of an elevated railroad built for an above-ground test at Frenchman Lake, Yucca Flat. The detonation, code-named "Priscilla," generated thirty-seven kilotons of force. By comparison, the blast at Hiroshima measured thirteen kilotons. C-print. Copyright © Peter Goin. Courtesy of the artist.

Back Cover
Virginia Beahan and Laura McPhee, *Rooftop Garden, Lower East Side, New York*, 1997. Color photograph. Copyright © Virginia Beahan and Laura McPhee. Courtesy of the artists and Laurence Miller Gallery, New York.

Title Page
Cornelia Hesse-Honegger, *House Fly (Muscidae)*, 1985–86. Mutated by X rays at the Zoological Institute of the University of Zurich. Four mutations: yellow eyes and body, bent wings, and leg parts growing out of the feelers. Watercolor on paper, 17 5/16 x 21 5/8 in. Copyright © Artist Rights Society (ARS), New York/Pro Litteris, Zurich. Courtesy of the artist.

Table of Contents
Peter Goin, *Nuclear Reactors D and DR, Hanford Nuclear Reservation, Washington*, from the series "Nuclear Landscapes," 1986–1990. These reactors are now decommissioned. D Reactor was one of the three original reactors built between 1943 and 1945. The yellow posts mark the locations of buried radioactive waste and areas of potential surface contamination. C-print.

pp. 25–28 Four color photographs by Virginia Beahan and Laura McPhee. Titles and dates appear with images. All photographs copyright © Virginia Beahan and Laura McPhee. Courtesy of the artists and Laurence Miller Gallery, New York.

pp. 32, 35, and 36 Three black-and-white photographs by Hiroshi Sugimoto. Titles and dates appear with images. **p. 32** 16 x 20 in. Edition of twenty-five. **p. 35** 20 x 24 in. Edition of twenty-five. **p. 36** 20 x 24 in. Edition of twenty-five. All photographs courtesy of the artist and Sonnabend Gallery, New York.

pp. 41–44 Four photographs by Kiki Smith. Color prints, each 4 x 6 in. Courtesy of the artist.

p. 51 Courtesy of Elisabeth Furtwängler.

p. 52 Courtesy of Daniel Barenboim.

pp. 64–68 and p. 70 Six fog sculptures by Fujiko Nakaya. Titles and dates appear with images. **p. 64** Photo copyright © H. Shunk. **p. 66** Photo copyright © S. Ogawa. **p. 67** Photo copyright © Hammerman. **p. 68** Photo copyright © Erika Barahona/Guggenheim Bilbao. **p. 70** Photo copyright © Fujiko Nakaya. All photographs courtesy of the artist.

pp. 74, 108, and 202 Three unique Cibachrome photograms by Adam Fuss. Titles and dates appear with images. **p. 74** 12 x 12 in. Collection of the artist.

p. 108 24 x 20 in. Collection of the artist. **p. 202** 24 x 20 in. Private collection. All images copyright © Adam Fuss. Courtesy of the artist and Cheim and Read, New York.

pp. 101–104 Four photographs by Martine Franck. Captions appear with images. Copyright © Martine Franck/Magnum photos.

pp. 149–152 Four type C color photographs by Robert Ziebell. Titles and dates appear with images. All photographs copyright © Robert Ziebell. Courtesy of the artist.

pp. 165–168 and p. 170 Five color photographs by Lucinda Devlin from the series "The Omega Suites." Titles and dates appear with images. All photographs copyright © Lucinda Devlin. Courtesy of the artist and Paul Rogers/9W, New York.

pp. 180–184 Five color photographs by Peter Goin from the series "Nuclear Landscapes," 1986–90. Titles and descriptions appear with images. All photographs copyright © Peter Goin. Courtesy of the artist.

p. 191 From Cavalli-Sforza, Luigi Luca, *The History and Geography of the Human Gene*. Copyright © 1994 by Princeton University Press. Reprinted by permission of Princeton University Press.

pp. 197–200 Four watercolors by Cornelia Hesse-Honegger. Titles, dates, and descriptions appear with images. All works 16 1/2 x 11 11/16 in. Copyright © Artist Rights Society (ARS), New York/Pro Litteris, Zurich. Courtesy of the artist.

pp. 221–224 Four ink-jet prints by Georganne Deen. Titles and dates appear with images. **p. 221** Mixed media, 22 x 14 in. **p. 222** 22 x 16 in. **p. 223** 23 x 18 1/2 in. **p. 224** 26 1/2 x 19 1/2 in. Courtesy of the artist and Christopher Grimes Gallery, Santa Monica, CA.

p. 226 Photograph courtesy of the author.

pp. 237–240 Four color photographs by Via Lewandowsky from "Series Zero," 1995. Captions by Durs Grünbein. All photographs courtesy of the artist.

p. 242 Unique silver gelatin print by Vera Lutter, 87 1/2 x 18 1/2 in. Courtesy of the artist and Fraenkel Gallery, San Francisco.

drunken boat
online journal of the arts

web art
poetry
fiction
sound
photo/video
expository

www.drunkenboat.com

e-mail: editor@drunkenboat.com

GRAND STREET
BACK ISSUES

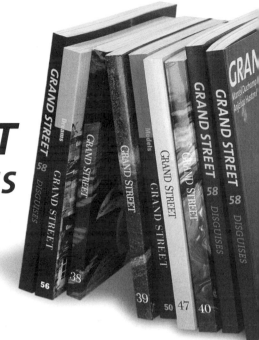

ORDER
WHILE THEY LAST

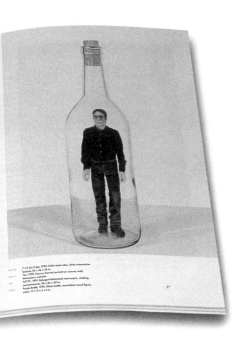

CALL

212 533 2944

Please send name, address, issue number(s), and quantity.

Back issues are $15 each ($18 overseas and Canada) including postage and handling, payable by check or money order in U.S. dollars.

Address orders to
GRAND STREET, Back Issues
214 Sullivan Street
No. 6C
New York, NY 10012

2wice

PICNIC

spring / summer 2002

Merce Cunningham, Mark Morris, Jamie Bishton, Henry Louis-Gates, Alexander Proia, Maya Angelou, and recipes.

the satisfying and delicious visual and performing arts magazine, available in fine bookstores, on amazon.com, and on the web: www.2wice.org